A BRICK AND A BIBLE

A *BRICK* AND A *BIBLE*

Black Women's Radical Activism in the Midwest during the Great Depression

Melissa Ford

Southern Illinois University Press
Carbondale

Southern Illinois University Press
www.siupress.com

25 24 23 22 4 3 2 1

Cover illustration: An illustration from the Communist journal *Working Woman* in 1933 depicts Black women and children protesting with the Unemployed Councils. *Artist unknown. From the photo collection held at the Tamiment Library, New York University by permission of the Communist Party USA. Cover background*: Adobe Stock image #166205268 by srckomkrit.

Library of Congress Cataloging-in-Publication Data
Names: Ford, Melissa, 1987– author.
Title: A brick and a Bible : Black women's activism in the Midwest during
 the Great Depression / Melissa Ford.
Description: [Carbondale, Illinois] : Southern Illinois University Press,
 [2021] | Series: Writing research, pedagogy, and policy |
 Includes bibliographical references and index.
Identifiers: LCCN 2021034522 (print) | LCCN 2021034523 (ebook) |
 ISBN 9780809338559 (paperback) | ISBN 9780809338566 (ebook)
Subjects: LCSH: African American women political activists—
 Middle West—History—20th century. | African American radicals—
 Middle West—History—20th century. | Radicalism—Middle West—
 History—20th century. | Feminism—Middle West—History—
 20th century. | Communism—Middle West—History—20th century. |
 Middle West—Race relations—History—20th century.
Classification: LCC E185.915 .F67 2021 (print) | LCC E185.915 (ebook) |
 DDC 305.420977—dc23/eng/20211116
LC record available at https://lccn.loc.gov/2021034522
LC ebook record available at https://lccn.loc.gov/2021034523

For Todd, my parents,
and
radical people everywhere

CONTENTS

Gallery of illustrations beginning on page 87

ACKNOWLEDGMENTS

"Nobody, but nobody can make it out here alone."
—Maya Angelou

First and foremost, I thank the Black women in this book. Through their struggles, their bravery, their voices, and their fortitude, I have benefited. I continue to be awed and inspired by Carrie Smith, Ida Carter, Cora Lewis, Rose Billups, Ida Carter, Eleanor Rye, Thyra Edwards, Mattie Woodson, Maude White, Romania Ferguson, and so many more women in history. I thank these remarkable working-class Black women and look forward to the growing scholarship that will continue to center radical Black women in American history.

Second, I must give thanks to everyone at Southern Illinois University Press for taking a chance on my work right out of graduate school. Through the thoughtful advice and encouragement of my wonderful editor Sylvia Rodrigue, the transition from dissertation to book was exciting and fulfilling. Jennifer Egan was especially helpful in guiding me through the world of image permissions, and with her assistance I was able to procure the fantastic photos you see here. I also thank the SIU Press editorial board for having faith in my work, and my readers, who offered invaluable feedback.

This work grew out of a seminar in my second year of graduate school at Saint Louis University. Heidi Ardizzone offered a course titled Many Mid-Wests: Race and Citizenship in the American Heartland, and as a native St. Louisan, I thought I could ace it easily. Of course, Dr. Ardizzone and the class opened my eyes to the rich, beautiful, ugly, and overlooked history of African Americans in the Midwest. Given my interest in the working class, it was only a matter of time before I began to explore working-class activism in the Black Midwest. I am grateful to Dr. Ardizzone for leading me to this remarkable area of study, but also rescuing me from what was probably going to be another dissertation on Marx. I further thank other professors in SLU's Department of American Studies: Matt Mancini, Ben Looker, Emily Lutenski, and Kate

Moran. I also thank my cohort, my classmates, and my writing group colleagues, specifically Alan Blair, Anna Schmidt, Karen Smyth Skinner, Nick Porter, Mark Koschman, Adam Kloppe, Mike McCollum, and Aretha Butler for all their emotional support and advice during the first drafts of this project.

As the project grew, I received support from other academics I greatly admire, and I thank them for taking the time to discuss big ideas and small details with a junior scholar. All of my chapters have benefited from in-person and email conversations with Erik Gellman, Karen Miller, Glenda Gilmore, Robin Kelley, Jennifer Carson, LaShawn Harris, Keona Ervin, Meredith Roman, Juliet Walker, Abdul Alkalimat, and Peter Filardo. I also greatly appreciate the efforts of academics and activists working to put the Black Midwest on the academic map, including Joe Trotter, Terrion Williamson, and the members of the Black Midwest Initiative. And I want to thank my former students at Saint Louis University and Harris-Stowe State University, who gave me a priceless education on the Black Midwest. Among these students were Ferguson and OccupySLU activists, who helped me make sense of Midwestern Black radicalism today.

I owe a great debt to all the librarians and archivists in institutions around the country. I would like to thank the workers at Chicago History Museum, Chicago Public Library, University of Chicago, University of Illinois-Chicago, Western Reserves Historical Society, Cleveland Public Library, Bentley Library at the University of Michigan, Walter F. Reuther Library at Wayne State University, Tamiment Library and Robert F. Wagner Labor Archives at New York University, State Historical Society of Missouri, the Western Historical Manuscripts at University of Missouri-St. Louis, and Washington University Special Collections. I am also greatly in debt to the nameless workers who have been diligent in digitizing archival manuscripts, newspapers, and documents, allowing research to happen from the luxury of my home. In particular, I greatly appreciate the workers at Marxist Internet Archive, who digitized *Woman Worker* and other American Communist publications. Your labor has not gone unnoticed and I thank you.

My research would not have been possible without the generous financial support of the Black Metropolis Research Consortium, Wayne State University, Saint Louis University's Graduate Student Association and Department of American Studies, the College of Arts and Sciences at Saint Louis University, and the College of Liberal Arts at Slippery Rock University. I also thank the Black Metropolis Research Consortium and the Labor and Working-Class History Association who generously provided me funds to travel to the annual

conferences of the Association of the Study of African American Life and History and the Organization for American Historians, respectively.

I could not have asked for a more welcoming and supportive department for my first full-time academic position. The Department of History at Slippery Rock University has been nothing less than ideal. Specifically, I want to thank Bill Bergmann, Lia Paradis, Aaron Cowan, Paula Rieder, and Alan Levy for their advice, mentorship, and examples of excellent scholarship. I am truly fortunate to be among such great colleagues. I am also grateful to Dan Bauer, dean of the College of Liberal Arts, and William Behre, president of Slippery Rock University (SRU). Support for scholarship of radical Black history and activism is not welcome everywhere, but SRU has been encouraging at every stage, and I look forward to our work on antiracism on campus.

I must thank my first teachers, my parents, Jim and Nanette Ford. Not many white girls from the suburban Midwest grow up listening to Pete Seeger, boycotting Shell and Nestle, volunteering at homeless shelters, and reading Marx. But as lifelong educators, you taught me to reach outside myself and find ways to see the world through others' eyes. You always encouraged me to be thoughtful and critical, and never stop learning, so it really is no surprise I ended up in academia. I also want to thank the other teachers in my family—my sister Amy, whose award-winning high school culinary teaching skills I will never rival, and my brother, who first taught me the word "communism." Additionally, I want to thank Annette Ford, Michelle Vialton, Bob, Vicki, and Evy Wermager, and Daniel Dreher. They always expressed interest in my work, and I am so thankful to have wonderful support. My family also extends to my incredible friends, Rachel Kohl and Alan Blair, who are always just a text away from making me smile. Thank you to all.

A simple thank you is not enough for my husband, Todd. He has been my anchor during times of chaos and disappointment, celebration and success, and is my reminder that life exists outside of academia. As my partner and best friend, his relentless love and support have given me confidence in my work and my life.

ABBREVIATIONS

AC	Associated Charities
AFL	American Federation of Labor
ANLC	American Negro Labor Congress
AWU	Auto Workers' Union
BSCP	Brotherhood of the Sleeping Car Porters
BWTA	Booker T. Washington Trade Association
CIO	Congress of Industrial Organizations
Comintern	Communist International
CPUSA	Communist Party of the United States of America
CRC	Civic Rights Committee
FMC	Ford Motor Company
FOL	Future Outlook League
FWIU	Food Workers' Industrial Union
HL	Housewives' League
ILD	International Labor Defense
ILGWU	International Ladies' Garment Workers' Union
IWW	International Workers of the World
LSNR	League of Struggle for Negro Rights
MSTA	Moorish Science Temple of America
NAACP	National Association for the Advancement of Colored People
NNC	National Negro Congress
NOI	Nation of Islam
NTWIU	Needle Trade Workers' Industrial Union
NWA	Negro Welfare Association
PME	Peace Movement of Ethiopia
PWA	Phyllis Wheatley Association

SJC	Social Justice Committee, St. Louis
SWOC	Steel Workers Organizing Committee
TUEL	Trade Union Educational League
TUUL	Trade Union Unity League
UAW	United Auto Workers
UC	Unemployed Council
UL	Urban League
UNIA	Universal Negro Improvement Association
YCL	Young Communist League
YMCA	Young Men's Christian Association
YWCA	Young Women's Christian Association

A BRICK AND A BIBLE

Introduction:
Midwestern Black Radicalism

For tens of thousands of African Americans living in the South in the first half of the twentieth century, the American heartland was the promised land. The urban Midwest spoke to ambitions and hopes of employment, free cultural expression, political rights, and racial equality. Cities like Detroit, St. Louis, Cleveland, and Chicago beckoned Black migrants from their homes in the South, representing a dream that could no longer be deferred. For one woman, only identified as a "Negro Woman Worker," the Midwest embodied the American dream. She had moved to Cleveland from a "hell-hole town in Mississippi" to seek employment, a better standard of living, and relief from pervasive racism. Yet, she could not find work, she often went hungry, and she could not afford heat during the winter months. She wrote a letter to the national Communist journal *The Working Woman* in 1930 to express her frustrations. She asked, "Why don't the government take care of us while there isn't any work, so that we don't have to freeze and starve?" Her frustration did not end at letter writing. She firmly declared she was "ready to fight," and that "the club and pistol were made for the working class."[1] Her story does not have a conclusion; there are no more records of this remarkable woman who went out of her way to document and share her ordeal as a Southern migrant in a Midwestern city.

Though an individual story, the "Negro Woman Worker's" experience paralleled that of thousands of other African American women in the early 1930s. These women, with dreams of racial equality and steady employment, flocked to Midwestern cities, but often found conditions not so different from those they escaped. However, as the letter writer from Cleveland demonstrated, the desperation of the Depression's hardest-hit population did not indicate apathy or indifference; rather, many Black women during this period represented

1

the fiercest champions of the working class. Due to sexist, racist, and classist systems of oppression, however, finding outlets for this radical activism was often a formidable challenge for these women. As the letter writer showed, though, the Communist Party of the United States of America (CPUSA) offered avenues heretofore unheard of for Black working-class women in the Midwest.

African American women who participated in Communist-affiliated activities blended their personal and regional histories, their lived experiences, and their ideas of gender and racial equality with party doctrine in a way that established them as important radical activists during the Great Depression. Every individual woman approached her activism differently: Ida Carter bypassed her local church leaders on Chicago's South Side and organized a strike in coordination with national Communist leaders, seeing it through to a successful conclusion. Carrie Smith stood in front of St. Louis's City Hall and rallied her fellow workers out of complacency and fear into militant action. She hoisted a brick in one hand, a Bible in the other, and declared, "Girls, we cannot lose!"[2] Mattie Woodson of Detroit officially joined the Communist Party and hosted clandestine meetings in her home, risking her life, job, and reputation. After an anti-eviction riot left her comrades dead, Maggie Jones in Cleveland organized a nurses' brigade trained in first aid to avoid future tragedy. Thousands of other Black women in the Midwest faded in and out of the Communist Party, attending rallies and protests, but never officially joining the party or making the pages of Communist records. These "Negro Women Workers," unnamed but no less essential in the struggle, incorporated their notions of race, class, gender, and region to exercise their interpretation of Black radicalism in the Midwest.

A Brick and a Bible documents how, in the span of a few years during the early Great Depression, thousands of African American women in the urban Midwest directly engaged with members of the CPUSA to fight unfair wages, substandard working conditions, and racial discrimination in the workplace as well as hunger, poverty, and homelessness in their communities. From Cleveland to St. Louis, from Chicago to Detroit, these women worked closely with the Communists, sometimes even joining the party, to achieve their short- and long-term goals. When examined through the lenses of gender, race, class, and region, the history of these women, Black radicalism, and the Communist Party in the early Great Depression takes on a new historical importance that challenges how we understand American racial and working-class history today. Because gender, race, class, and region are essential parts of this study,

yet were not always central to the CPUSA's activity, a new term must be realized for these women's activism. Therefore, I offer Midwestern Black radicalism, formulated as a distinct expression of praxis-based Black radical ideology informed by American Communism, African American community-building, Black women's history of resistance, and the lived experiences of Black women in the Midwest during the Great Depression. Midwestern Black radicalism directly relates to unique racial, political, geographic, economic, gendered, and spatial characteristics that make up the American heartland. These Black radicals both accepted and challenged the teachings of the CPUSA, while also creating something particular and unique. Midwestern Black radicalism refers to more than the location where these radical activists organized and agitated; rather this particular interpretation of Black radicalism is markedly shaped by many factors. Urban development, industrialization, patterns of migration and residency, and interactions of race, class, and gender in social spaces form the foundation for expressions of Midwestern Black radicalism; as well, individual stories make it come alive. And, most importantly, African American women are the heart of this overlooked radicalism in the heartland. As such, *A Brick and a Bible* and Midwestern Black radicalism interrogate the crossroads of African American history, gender studies, labor history, and Midwestern studies, calling for a profound re-imagining of how we remember and interpret these women's stories.

The burden of defining the Midwest has kept regional historians busy for decades, and though it probably remains an impossible task, it deserves a brief mention. R. Douglas Hunt warns that scholars should not place too much emphasis on geographical boundaries, as they are a "mental construct." Though climate, environment, geography, and location "set the parameters" for our regional understanding, the distinctiveness ultimately comes from a social and cultural understanding.[3] This study posits the Midwest as a shared cultural and social space marked by distinctive characteristics of residential segregation, migratory patterns, dependence on Black labor, light and heavy industry, virulent racism, and expansion of radical interracial coalition building. This study focuses on four Midwestern cities: Detroit, St. Louis, Chicago, and Cleveland, but the geographic understanding of the regional Midwest extends to Ohio, Indiana, Illinois, Michigan, Wisconsin, Missouri, Iowa, Minnesota, Kansas, Nebraska, North and South Dakota, and Western Pennsylvania. It is a seemingly simple geographic region ranging from the Rocky Mountains to the Appalachians, north of the Ohio River and the Missouri Compromise border.[4] It is known in

the popular American imagination as the land of "amber waves of grain," dairy farms, and conservative thinking. This region has never been known for its radicalism; in fact, in 1922 philosopher John Dewey observed that the Midwest "has been the middle in every sense of the word and in every movement." The region operated as a stabilizing force, whose people "never had an interest in ideas as ideas, nor in science and art for what they may do in liberating and elevating the human spirit."[5] This popular notion of an ordinary space and region only covers for a deeply traumatic past. Historian Brent Campney argues that the Midwest's claim to "pastoral meritocracy" was maintained through racial exclusion and bloodshed and documents a disturbing trend of violence, brutality, and lynchings in the region.[6] In her work on the Black Midwest, Ashley Howard adds that "economic and race oppression acted as co-conspirators," resulting in explosive conditions.[7] Though she specifically addresses urban riots post-World War II, Howard's observations on economics, race, and the Midwest are fitting for the first half of the twentieth century as well. The heartland is often synonymous with traditional white American values and politics, but the lived experiences of African Americans in the heartland, regardless of era, were marked by prejudice, violence, segregation, and struggle.

Economic potential brought migrants to Midwestern cities during the Great Migration, however prevailing racism limited economic opportunities. The influx of Black Southerners shaped the character of these cities in ways unparalleled in the Northeast. Midwestern cities were home to millions of people, thriving industries, vibrant cultural centers, robust political landscapes, and tumultuous race and class tensions. In 1930, the Midwest boasted four of the largest cities in the United States: Chicago (second, with 3.3 million people, 6.9 percent Black), Detroit (fourth, with 1.5 million, 7.7 percent Black), Cleveland (sixth, with 900,429, 7.9 percent Black), and St. Louis (seventh, with 821,960, 11.4 percent Black). While New York City certainly had a larger overall population and more African Americans called it home, the percentage of Blacks in the city in 1930 was only 4.73 percent, less than the percentage of Blacks in each of the ten most populated Midwestern cities. Out of the five boroughs, only Manhattan's percentage was greater, with an African American population of 12 percent in 1930.[8] While New York City has often received the most attention in terms of the numbers of Southern migrants, the drastic percentage increase of African Americans in Chicago, Detroit, St. Louis, and Cleveland significantly altered the economic, political, and social landscape in ways unseen in other urban areas.

Chicago, Detroit, Cleveland, and St. Louis showed striking similarities in terms of industry, population, neighborhood arrangement, and politics, as this book documents. As Cedric Robinson argues, Black radicalism begins with tension, and racial tension was the defining feature during the 1920s and 30s for Midwestern cities. Therefore, Midwestern Black radicalism begins with the Great Migration and gains momentum with the Great Depression. Thousands of workers poured into Midwestern cities in pursuit of jobs and a less racist social order, however they faced substantial challenges. While Jim Crow did not have legal standing in cities like St. Louis or Cleveland, de facto segregation practices prevented equal opportunity for the cities' newest residents. Unions habitually excluded Blacks from membership, restaurants and other public places still allowed segregated facilities, and discriminatory housing policies relegated working-class African Americans to the cities' least desirable areas. From Chicago's South Side to Cleveland's Central Area, and from East St. Louis to Detroit's Black Bottom, working-class Black Midwesterners experienced some of the worst living conditions urban areas had to offer. Lack of indoor plumbing, neglectful landlords, overcrowded apartments, and ramshackle buildings characterized many Black migrants' new homes. Recent migrants to the urban Midwest found their situation a far cry from the "paradise" that Black newspapers advertised, and, while improved in many respects, Midwestern urban areas still resembled those in the South. Yet each Midwestern city stood on its own, as each experienced race, class, and gender relations differently. The stories set in each city reveal certain aspects of Midwestern Black radicalism, and while many of the themes overlap, each city was unique. Midwestern Black radicalism during the 1930s necessarily involved organizing at many levels, addressing local politics, changing strategic tactics, and incorporating themes of motherhood, community, religion, and local politics. As these women show, adaptability to the city and the historical conditions was key.

This study is in a part a reclamation effort, but it is by no means exhaustive on the subject of Midwestern Black radicalism. Some Midwestern cities, such as Milwaukee, had a strong contingency of Black workers, yet Blacks were more apt to follow the Democratic Party rather than the Communist Party.[9] Other cities, like Indianapolis, were more integrated and Black communities enjoyed greater prosperity, leading them to eschew radical politics and third parties.[10] Many cities did not see the mass influx of migrants after World War I; in 1940, Minneapolis had a Black population of only 4,646, or about 1 percent of the city's population.[11] Does it follow, then, that Milwaukee, Indianapolis, and

Minneapolis did not experience Midwestern Black radicalism? Scholars will have a clearer understanding when Midwestern Studies and the study of Black radicals become more deeply integrated into the American historical practice, when more scholars rigorously interrogate common regional assumptions, and when more archival information is made available. The study presented here is only a beginning.

BLACK RADICALISM, BLACK LEFT FEMINISM, AND RESPECTABILITY

Midwestern Black radicalism draws from groundbreaking works on Black radicalism and leftism by scholars Cedric Robinson, Robin D. G. Kelley, and Mary Washington, more recent scholarship by Erik McDuffie, Dayo Gore, and Carole Boyce Davies, and new work on the Black Midwest by Beth Tomkin Bates, Joe Trotter, and Ashley Howard. In his foundational work, *Black Marxism: The Making of the Black Radical Tradition*, Cedric Robinson defines Black radicalism as a "negation of Western civilization," and a "specifically African response" to oppression wrought by European development.[12] But the negation is not a simple negation; instead, Robinson argues, the Black radical tradition is an oppositional response to, as well as evolution of, Western civilization. Black radicals are not only fighting against white capitalist oppression but fighting for a better and more just future. Black radicalism is constantly changing, as its proponents aim to respond to immediate threats as well as seek long-term solutions. The theory and practice must be examined in a particular context and intersection with history. The Black radical tradition, as Robinson writes, is made up of "daily encounters and petty resistances to domination" that have been collected over centuries, as well as the revolutionary theories and activism that envisioned enduring radical change.[13] At its core, Black radicalism, like Marxism, is a program for revolutionary change, one linked to working class solidarity, anti-capitalism, and racial justice.[14] In his monumental work, Robinson covers centuries of Black men's radicalism, leaving little room or consideration for the roles Black women played. As historian Robin D. G. Kelley notes, though, we must not blame Robinson for his focus on men, but just as Robinson went beyond Marx, we must go beyond Robinson.[15]

Recent historians have risen to this challenge and have demonstrated how gender was always a part of Black radicalism. In his study of Black women and the Communist Party, *Sojourning for Freedom*, Erik McDuffie writes the

activism of Black radicals is "invariably informed and shaped by a complex interplay of gender, race, sexuality, class, and politics."[16] Noteworthy historians of Black history have certainly addressed these issues; Gerald Horne's biography of Shirley Graham DuBois and Robin D. G. Kelley's *Race Rebels* produced foundational works in these areas. More recent scholarship such as McDuffie's *Sojourning for Freedom*, Dayo Gore's *Radicalism at a Crossroads*, LaShawn Harris's "Running with the Reds," Carole Boyce Davies's *Left of Marx*, and the edited volume *Want to Start a Revolution?* draws connections between Black left feminists of the 1930s to their heirs of the Black radical tradition in the 1970s and 1980s. Methodologies of resistance expanded and changed, and scholars such as Ashley Farmer, Keisha Blain, and Tiffany Gill look toward Black women's Black nationalism and international activism.[17] Recent biographies on Claudia Jones, Louise Thompson Patterson, Eslanda Robeson, Lorraine Hansberry, and Thyra Edwards contribute to the scholarship with remarkable individual histories of women who have helped shape and define Black radicalism in the twentieth century.[18] By recovering the history of Black left feminists, these scholars transform and extend Robinson's history of Black radicalism and affirm the Black radical tradition for Black women.

Building on this substantial scholarship, *A Brick and a Bible* recognizes and celebrates women who participated in Communist-affiliated labor and community organizing, who often did so with an understanding that race, class, and gender were interlocking systems of oppression. Black feminists in the 1980s would label this idea "intersectionality," and argue that for Black working-class women, race, class, and identity were closely linked.[19] Though unfamiliar with the term "intersectionality," Carrie Smith and others of her time had witnessed how their positions as working-class African American women often relegated them to subjugated social positions that included the most vulnerable and least desirable occupations. Yet the women examined here drew strength from this position, recognizing that at the intersection of race, class, and gender lies the potential for extraordinary activism. While most of the women in the 1930s and 1940s would not have identified as feminist, their model of activism suggests that, given the historical context, the term "Black left feminism" best suits them. "Black left feminism," a term coined by scholar Mary Helen Washington in her study of literature produced by Black women post-WWII, illustrates how principles of feminism and leftist ideology predate our modern conceptions of feminism.[20] Identifying these key components of these women's ideological positionings, Erik McDuffie argues that because they

understood gender, race, and class as overlapping identities, these women were indeed feminists, and that recognition would come in the 1970s with Black feminists reclaiming their radical historical foremothers.[21] By incorporating elements of Communist positions on race, class, and gender as well as their own lived experiences, Black left feminism illuminates Black working class women's radical politics, community-building, and workplace activism during the Great Depression.

The intersection of race and gender had long attracted Black women's activism, most notably the Black church and Black clubwomen's movement. Beginning in the late nineteenth century, educated, church-going, middle to upper-class African American women led and participated in a series of philanthropic activities to enhance the welfare of fellow African Americans. Many of these women followed social standards established by middle to upper-class African Americans, a practice historian Victoria W. Wolcott has called "bourgeois respectability," which allowed them to organize within socially accepted norms.[22] Conforming to class mores or the "politics of respectability" of the time while advocating an agenda of welfare reform, education, housing, and anti-lynching laws, enabled Black women at the turn of the century to connect their activism with the intersection of race and gender. As well, the politics of respectability was a strategy of resistance; Black women countered the racist, sexist, and classist stereotypes of the age by demonstrating proper domesticity, appropriate behavior, and faith in reform.[23] After 1929, many Black working-class women turned away from Christian-led reform movements to join militant actions that met their immediate needs. However, they never completely abandoned the politics of respectability. As scholar Cynthia Blair notes in her study of Black sex workers in Chicago at the turn of the century, traditions of respectability were a foundation on which African American women built and re-envisioned their roles in society. Black women from all walks of life were never completely isolated from family and community values. Rather, they held ties to their social connections, and regardless of their occupation or public presentation, supported their families, encouraged spirituality, were active in their community, and felt themselves part of a larger social network.[24] Historian LaShawn Harris adds that Black working-class women in particular negotiated the politics of respectability and held "fluid and shifting ideas about public correctness" based on their real life needs and desires.[25] Ideologies and practices of Black left feminism and Midwestern Black radicalism often incorporate elements of challenging or transforming traditional social

expectations, including those of bourgeois respectability. Black working-class women studied in *A Brick and a Bible* sought alliances with those previously eschewed by Black communities, namely radical organizations, unions, and individuals. They never fully abandoned all notions of the politics of respectability. They still adhered to middle-class expectations of clothing and style, appearance, hygiene, gendered roles in the home, and for some, Christian ethics. Their radical activity, though, necessitated a re-imagining of the roles and expectations of Black working-class women during the Great Depression.

As they negotiated their place in society with consideration of respectability politics, Black women experienced physical violence and terror that cast them first as criminals, second as people. Brutality against Black women is not new: Harris notes that throughout history "unfettered police repression and violence became a standard and pervasive practice against nonwhite women." Black women and girls have consistently been seen as hypersexual, pathological, criminal, and immoral, even as they fought against these stereotypes through bourgeois respectability. Historically, law enforcement acted as the enforcers of white supremacy, using violence to "exert power to control over Black bodies while terrorizing African American communities."[26] As Black working-class women began to radicalize and make use of the CPUSA's resources, police began to target them with a new purpose. These women were "Reds," un-American, and threats to the state in addition to being criminals by virtue of their race. As the stories of strikers, protesters, and innocent bystanders show in the following chapters, to be a Black working-class woman was to be less than a citizen and under constant threat of violence. Magnolia Boyington was a forty-eight-year-old unemployed Black worker who participated in a demonstration in St. Louis, and after a brutal attack by police, died from her injuries.[27] The dressmakers on strike on the Southside of Chicago were routinely beaten as they walked the picket lines.[28] The women fought back, as they always have. In one Chicago anti-eviction demonstration, a woman struck a police officer in the wrist causing him to drop his gun.[29] In another picket line in in 1937, Black Chicago women pelted police with eggs.[30] Other women wrote letters to Black newspapers and radical publications, offering testimony for the personal violence they experienced. Some women brought their husbands to the demonstrations as personal bodyguards. Physically, vocally, and through written words, they asserted their humanity and agency in a society that rendered their presence invisible. The violence perpetuated by the agents of white supremacy and the capitalist state often went unnoticed, but by recovering these stories

of Black radical women who did not back down, *A Brick and a Bible* shows their tenacity and courage in the face of racial, class, and gendered oppression.

THE AMERICAN COMMUNIST PARTY

Many mainstream, moderate leaders, both Black and white, questioned why, out of all the avenues for protest and redress, these women chose to draw on the traditionally white male-led Communist Party. In short, the CPUSA provided an avenue for Black women during the Great Depression to publicly assert their needs and demands as Black women living in the urban Midwest. The party's attention toward Black women was not accidental; it grew out of a many-years' debate about the roles of Blacks and women in the Communist Party, a debate often labeled the "Negro Question" and the "Woman Question." Only after the Soviet-based Communist International (Comintern) leaders passed official resolutions in 1928 and 1930 that addressed race did the Party state its explicit intention to reach out to the exploited Black workers in the Black Belt, or American South.[31] Most of what became known as the "Black Belt Thesis" emphasized a masculinist stance for Black liberation and self-determination, drawing on historical figures such as Toussaint L'Ouverture, Denmark Vesey, and Nat Turner.[32] Importantly, though, the 1928 Resolution was the first official Comintern document to address Black women, noting that Black women "constitute a powerful potential force in the struggle for Negro emancipation . . . It therefore becomes an important task of the Party to bring the Negro women into the economic and political struggle." The declaration continued to break ground in Communist literature, arguing that Black working-class women had been traditionally discriminated against "by reason of both their color and sex."[33] This sentiment, predictably, was limited throughout the document, without any specific call to action or recognition of Black women's agency. In no uncertain terms, the Black Belt Thesis prioritized Black liberation over "women's" issues, thereby placing the "Negro Question" above the "Black Women's Question." However, the inclusion of African American women alone provided an opportunity for Black women to begin to carve out their own space in the Communist Left.[34]

Though the 1928 resolution was the first time the Comintern addressed working-class African American women, two years earlier, the American Communist Party's daily newspaper, the *Daily Worker* noted organizing struggles of Black women. The newspaper devoted three articles to Black women who,

in Chicago in 1926, were striking a date-stuffing factory.[35] Though the *Daily Worker* often covered such strikes, the Party took unprecedented action. After two protesters were arrested, the Communist-affiliated International Labor Defense posted bond for their release.[36] While unionizing efforts and monetary support was often lacking for these Black women workers, the Communist Party, through the *Daily Worker*, continued to champion Black women workers: "Of all the working-class, the Negro woman is least organized. But she at last realizes her power of organized labor. She recognizes her own power as a worker." With mentions of Harriet Tubman and Sojourner Truth, the newspaper asserted that Black women's "examples will inspire us."[37] Though an obvious rhetorical ploy to draw upon the history of Black women's activism, the Communist newspaper nonetheless publicly committed itself to fighting for rights for Black working-class women. Even with such a commitment, specific actions to organize Black women workers in unions would not come for a few years.

Though the Communists were the first predominantly white organization to discuss the specific oppression suffered by Black women, most of the women studied here were not official members of the CPUSA. Instead, these women operated on a variety of levels in many different organizations that best represented their immediate and long-term needs and desires. One organization that specifically appealed to Black women workers was the Trade Union Unity League (TUUL), an independent radical labor organization.[38] In 1929, the Comintern announced the Communist Party's transition into the Third Period, a philosophical pivot that saw leaders stressing that workers should establish radical unions in opposition to more mainstream ones organized by the American Federation of Labor (AFL). In contrast to the AFL unions, the TUUL unions actively recruited Black men and women as Third Period ideology dictated these workers were an essential part of the working-class struggle, a notion that drew inspiration from the 1928 Resolution. The primary objective was to promote independent, radical union organizing in line with the Third Period philosophy, and while the TUUL was marginally successful in organizing unions independent of the AFL and mainstream labor unions, its most important and substantial success stories came with the organization of the Unemployed Councils (UC).[39] The TUUL's Unemployed Councils reached thousands of urban poor around the country as the councils sought to address immediate needs, providing goods and services to those hardest hit by the Depression. The work done by the Unemployed Councils and local radical activists in cities like Chicago, St. Louis, Cleveland, and Detroit brought radicalism to life and

highlighted its relevance for 1930s workers, and African American workers in particular. To attract a broader base of support, the UC never officially affiliated with the CPUSA, though Communists often led local councils. Instead, the UC leaders drew on the support of the unemployed, underemployed, homeless, and starving urban residents to supply the membership for the movement. As the Depression wore on, UC leaders drew on this discontent to organize the unemployed—regardless of their political or ideological affiliations—and stage demonstrations to attract widespread attention.[40] As Communist leader William Patterson remembered, "The Unemployed Councils were a creation of the Communists, though in the main their composition was made up of non-Communists."[41] The UC became wildly popular—a status less reflected through numbers than their significant social influence. The UC answered a desperate demand during the early Depression that charities and local governments were ill-equipped to meet. Private charities, churches, women's clubs, and fraternities lacked the administrative capabilities and funds to provide relief for those hardest stricken, while local governments found that raising taxes among an unemployed population did little to boost revenue. As well, state governments and the federal government, under Republican president Herbert Hoover, regarded relief as traditionally a local problem.[42] Federal relief would not come in substantial numbers until the Roosevelt administration, leaving workers desperate for relief for four years. The UC provided a program, a long and short-term plan, and, most importantly, tangible results that attracted thousands of workers, who were becoming increasingly disillusioned with, and radicalized by, American politics.

The success of the UC depended on the decentralized model of their operation. Because these street units responded to the specific needs of their community, the work of the UC varied from city to city. The National Unemployed Council had little oversight of the UC in cities like Detroit, Chicago, St. Louis, and Cleveland. Even if they had administrative control, action on the ground in each city necessitated different strategies. In Chicago, the radical tradition of the city, coupled with the tightly knit Black community, created an explosive situation. Cleveland, more liberal than radical, still held to traditional forms of relief, and radicals fought a constant battle against established institutions and Northern traditions. Radicals found that activism in St. Louis must address the city's prevalent Southern characteristics, and in Detroit, organization necessarily took place around the automobile industry. Some scholars have argued that this meant the only things local councils had in common "were their demands

for more relief and more public works, their emphasis on the philosophy of class struggle, and their over-all Communist sponsorship."[43] Yet, as this book demonstrates, members of the Midwestern Unemployed Councils were linked in their distinct approach to Black radicalism, employed by Black women.

Communists' ultimate goal of a working-class consciousness in the United States was not exclusive to a workplace, as the UC showed. In its recognition of Black working-class women's specially oppressed status, the Communist Party acknowledged that these women existed beyond the traditional Marxist spheres of influence. Outside the industrial factory shop floors, the party focused on problems that affected the working-class populations. For targeting African Americans, the CPUSA highly publicized their efforts to save the Scottsboro Nine, nine young African American men falsely accused of raping two white women outside of Scottsboro, Alabama, in 1931. The International Legal Defense (ILD) led the teens' defense. Though it was Communist-affiliated, it operated independently in order to gain support of those who were not willing to join the party but would agree to working under its leadership.[44] In its short lifespan, the ILD had found fame in defending the world-famous Sacco and Vanzetti and other union leaders in court. In 1932, the ILD took on the case of Angelo Herndon, an African American Communist arrested in Georgia for distributing "insurrectionary" materials.[45] In the work defending the Scottsboro Boys and Herndon, the ILD saw an opportunity to reach African American neighborhoods. The ILD's work for the Scottsboro case specifically drew the attention of Black women from around the country, as the mothers of the accused youths appealed to mothers everywhere who had suffered injustice.[46] White radicals' ability to rally around the existing working-class consciousness of Black women and encourage organizing on issues of unemployment, hunger, housing, and the Scottsboro Boys brought thousands of Black women closer to—and sometimes into—the Communist Party.

The Black women involved in Communist Party activities were not always "good communists," ardent supporters of Communist doctrine, or well versed in Marxist theory. However, this did not limit their ability to engage in party ideology and make use of party resources. Nell Irvin Painter, in her study of Hosea Hudson, a Black Communist in the Depression-era South, notes how many Blacks associated with the party "made it their own," incorporating issues of race and region into their interpretation of communism.[47] Examining Black Communists at local levels brings out the nuances of these understandings, as Robin D. G. Kelley demonstrated in his analysis of Black Communists in

Alabama and Mark Naison in his history of Black Communists in Harlem.[48] Black radicals in the Midwest were no different; they encountered specific challenges in their lived experiences that influenced their interpretation of American Communism. However, because the Midwest as a distinctive region is often overlooked, there is little examination of how these Black women and men "made the Party their own."

While local environments, politics, social relations, and economics pro-moted the distinctiveness of Midwestern Black radicalism, those involved with the Communist Party were invariably shaped by national and international forces. The year 1935 sparked a period of great transition for the American Communist Party. The Third Period, which defined itself through the inter-racial union organizing of the Trade Union Unity League, gave way to the Fourth Period and to the Popular Front era of the Communist Party. During the summer of 1934, the Comintern had decreed that Communists should unite with other leftist, radical, and moderate liberal groups in fighting fascism. The rise of Hitler in Europe specifically prompted this change, and before long, official party doctrine called for the end of radical independent unions; instead, Communists should promote cross-coalition cooperation and new tactics in the fight for the proletariat and anti-fascist cause.[49] Non-Communists, no longer deterred by Third Party rhetoric and politics, often cooperated with the Com-munists in labor organizing and protests. Midwestern cities became a model for this coalitional solidarity, as demonstrated in Cleveland's Scottsboro campaign and Detroit's United Auto Workers union.[50] Even with party changes dictated, not discussed, African American women continued to operate with a distinct understanding of how radicalism worked in the Midwest, often independent of party control.

While African American working women were drawn to the party and its operations because of its repeated denunciation of racism and workers' oppression, they did not necessarily stay because of rigid party doctrine. In-stead, realities of their own lives informed their decisions. This is the core of Midwestern Black radicalism; there is no one experience, no one interpretation. Many women never entertained the thought of joining the Communist Party, but their remarkable actions during desperate times show an understanding of Black radicalism that revolutionized their actions. Even Black women who did join the CPUSA and worked as diligent comrades in the proletariat struggle did so with an understanding of what it meant to be an African American woman living in the Midwest. *A Brick and a Bible* documents the many ways

that radical African American women—who were involved in strikes, politics, and community organizing—modified traditional Communist interpretation in favor of a theory more suited to their historical context. The 1928 and 1930 resolutions provided the theoretical impetus for Communists to address what Black women already knew: the intersection of race, class, and gender left African American working-class women in position "ready to fight."

SOURCES

Recovering the stories of Black working class women in the 1930s presents its own challenges, as often these women did not keep a daily journal, donate their papers to archives, or publish regularly. Ultimately, without the various publications of the CPUSA, we would not have records of many of these remarkable Black women. In particular, *Working Woman* was a gender-specific journal filled with letters, articles, and interviews, featuring Black working class women. Women like Carrie Smith, the Scottsboro Mothers, and "Negro Woman Worker" had the opportunity to have their words printed in a national publication. On the other hand, the party's theory-driven *Communist*, TUUL's monthly magazine, *Labor Unity*, ILD's *Labor Defender*, and CPUSA's official organ, the *Daily Worker*, reported on these women's activism, rather than letting them write for themselves. All Communist sources must be considered with a certain degree of skepticism; the CPUSA was known to exaggerate numbers, use hyperbolic rhetoric, and employ propagandistic techniques. However, by putting these Communist documents into conversations with other sources, I have crafted what I believe is the account closest to the truth. Many times, local mainstream and Black newspapers published the women's words verbatim, which offers great insight into how they approached their activism. Due to their CPUSA membership, some of the women, like Mattie Woodson and Romania Ferguson, are mentioned in FBI surveillance files. However, most of the women's voices are lost or filtered through various media. Very few women left their own account; Thyra Edwards left an incomplete, unpublished memoir; Maude White (Katz) gave a short audio oral history before she passed; Rose Billups sat in on an interview with her husband. When possible, I have let these women speak for themselves.

Midwestern Black radicalism seeks to recover, recount, and celebrate the remarkable lives of Mattie Woodson, Carrie Smith, Ida Carter, Maude White, and many others. As such, there is no single story of Midwestern Black radicalism.

The women documented here represent a variety of lived experiences, ideologies, and personalities. To claim a single experience is to do them injustice. Midwestern Black radicalism seeks to identify the myriad ways African American working-class women in the Midwest joined forces with the Communist Party to organize factories and neighborhoods and fight hunger, poverty, unemployment, and homelessness. Despite successful strikes and community organizing, these women and their activism were, for the most part, forgotten in American history. This history can be seen on the one hand as a peak and decline and, on the other hand, a prolonged and enduring struggle that outlasts the twentieth century.

INTERVENTIONS

The Midwest has not been featured prominently in Black radical studies. The one exception is Erik McDuffie's work on the "diasporic Midwest," which is helpful in conceptualizing the Midwest in relation to Black radicalism. McDuffie looks to Midwestern cities as "epicenters" of Garveyism throughout the twentieth century, where African Americans recognized their link to the larger Black diaspora and the international struggle for justice.[51] Marcus Garvey and the Universal Negro Improvement Association (UNIA) prominently factor in African Americans ability to forge a substantial and lasting legacy of Black radicalism in the Midwest. However, Garvey's deportation in 1927 and the stock market crash of 1929 shifted Black Americans' needs and expectations. Some African Americans look toward religious organizations, such as the Nation of Islam, or other Black nationalist movements, like the Peace Movement of Ethiopia.[52] While others have studied these transitions of former Garveyites during the Depression, there has yet to be a study that looks at the emergence of Black protest and Communist-affiliated organizations in the Midwest. Some Black activists looked to pan-Africanism or internationalism to inform their actions, yet others did not. A single version of a diasporic Midwest does not always apply, and Midwestern Black radicalism calls for continuing to examine the local as a complex, often contradictory, interplay of ideas about race, class, gender, and region.

Recent works on national Black radicalism have tended to focus on the CPUSA.[53] However, most African American women in the Midwest did not join the CPUSA, and therefore their stories go unheard in Communist histories. Even recent histories examining Black women's roles in radical activities

give only a cursory glance to Black women in the Midwest, instead focusing on the Northeast or South. While in conversation with these texts, *A Brick and a Bible* disputes the notion that Communist Party leadership or membership were necessary to radical activism. Midwestern Black radicalism uncenters the CPUSA and brings the women from the margins to the core of activism during the 1930s.

In addition to highlighting the Black Midwest and focusing on Black women in discussions of radicalism, *A Brick and a Bible* discusses how space and place matter in Black radicalism. Discussions of Black radicalism in public spaces are typically relegated to the civil rights era.[54] However, as this book demonstrates, Black activists carved out spaces for their radical protest much earlier than the 1950s or 1960s. Most of the activities of the Black radical women presented here occurred in public places—of no small importance in an era that did not always encourage, or even allow African American women to publicly assert their demands. Their chosen space of protest, whether in front of city hall, on a neighborhood sidewalk, or in a public park, holds significant meaning and helped shape the city. Recently, scholars have looked to how access to recreational spaces has shaped the fight for racial justice.[55] Historian Stephanie Seawell notes that the use of public recreational spaces became part of the struggle for urban Blacks to claim their "right to the city," especially in the urban North. She writes that examining these struggles for fair use and access to public places "provide[s] insight into the aims, tactics, and legacies of the Black Freedom Movement in the urban North."[56] On the ground, in these public spaces, activists contested the racism, sexism, and classism in their city. While most scholars focus on the post-World War II era, I argue that examining the claiming of space during the Great Depression, and one of the nation's greatest moments of unrest, provides insight into how African American women interpreted Midwestern Black radicalism. These public places, traditionally and socially off-limits for Black women, served as important locations for Black, leftist feminists to engage with public officials, fellow activists, sympathizers, and antagonists. In doing so, they laid the groundwork for activists in the postwar era to transform and expand social spaces, continuing their claim to their "right to the city."[57] Midwestern Black radicalism does not seek to rehash moments of Black radicalism and simply place them in the Midwest. Instead, this distinct form of Black radicalism challenges our historical understanding of Black leftist feminism and the Black Midwest, pushing us as scholars and citizens to make sense of our times.

These histories might seem repetitious: unemployment, evictions, soup kitchens, marches, riots, unarmed Blacks killed. But it is not the same story; it is thousands of individual lives affected uniquely and powerfully by personal and systemic acts of racism, classism, and sexism. These stories should not be unfamiliar to twenty-first century readers. News reports of unemployment, homelessness, hunger, and violence against Black bodies are pervasive during our times, no more apparent than in the Ferguson Uprising in 2014 and the Rebellion of 2020. In 2014, Ferguson was a city plagued by 13 percent unemployment and in the global COVID-19 pandemic of 2020, the United States reached unemployment levels not seen since the Great Depression.[58] In times of economic instability, issues of systemic racism are often laid bare and activists rise to the challenge. Black Lives Matter, a movement born to address issues of police violence, has grown to incorporate issues of employment, class, sexuality, violence against women, higher education, media, and capitalism. Co-founder Patrice Cullors stresses that "BLM . . . is not just about respectability politics . . . it is about access to shelter, food, and mobility." Addressing immediate issues of employment, housing, and food recalls the mantra of the Unemployed Councils, which also operated in times of great economic stress and social tension. But Black radicalism is reborn in these moments of tension. And it is no small matter that the founders of BLM were three African American women—Alicia Garza, Patrisse Cullors, and Opal Tometi. And it is no small matter that instances of police violence in two Midwestern cities, Ferguson, Missouri, and Minneapolis, Minnesota, sparked the country's largest protests against racism in the twenty-first century.

"No movement emerges out of thin air," writes Black Lives Matter historian Barbara Ransby. "There is always a prologue, and prologue to the prologue . . . nothing is predetermined or dictated by history. However, historical conditions both create and limit possibilities for change."[59] The Rebellion of 2020 did not spontaneously erupt any more than did the Great Depression. And just as the systemic poverty and economic frailty of the 1930s did not instantly disappear, neither will systemic racism. The struggle for racial justice requires a long-term, revolutionary vision—what Robin D. G. Kelley terms "freedom dreams"—put into action with sustained energy, strength, and power from ordinary people.[60] The radical reimagining of the future was put into place many years ago and continues to be reshaped and reformed by activists of the Black Midwest today.

CHAPTER OUTLINE

Beginning with Detroit, this book presents four case studies, detailing each city's specific geographical location and regional history, the history of race and radicalism in the city, actions of African American working-class women, and the enduring legacy of this activism. The chapters are organized thematically by city instead of chronology, and although many of these events happened in response to each other, they also unfolded simultaneously. The reader, then, is encouraged to think across chapters in terms of chronology and how one city's development compared to another's.

The stories set in each city reveal certain aspects of Midwestern Black radicalism, and while many of the themes overlap, each city does have a unique element. For instance, in chapter 1, because Detroit was a city so focused on the male-dominated automobile industry, Black women like Rose Billups often performed important activist roles on the periphery of labor organizing. This contrasts with chapter 2, where in St. Louis Carrie Smith and Cora Lewis organized and led strikes, closely engaged with community organizing, and used their roles as mothers and Christians to inform their activism. In chapter 3, the African American women on strike in Chicago, led by Ida Carter, greatly influenced by the city's radical history, rejected local institutions and politicians, and instead whole-heartedly supported the Communist Party. Lastly, the fourth chapter documents how proponents of Midwestern Black radicalism in Cleveland adapted to the challenges of a perceived liberal city and found ways to prolong their radical efforts in more mainstream activism, such as Maude White's involvement in a local civil rights organization. In all, this book documents how Midwestern Black radicalism during the 1930s necessarily involved organizing at many levels, addressing local politics, changing strategic tactics, and incorporating themes of motherhood, community, religion, Black history, and local politics.

CHAPTER 1

"Lose Your Fear":
Rallying Labor in Detroit

When police opened fire on unarmed protesters in Dearborn, Michigan, on March 7, 1932, amid the chaos and thousands of fleeing people, African American Communist Mattie Woodson stopped in the middle of the street. Seventy-five years later, fellow protester David Moore recalled the scene: Woodson stooped to tend to a white man who had been hit by a bullet and tore free a piece of her skirt to blot the blood from his neck. A photographer snapped a picture of the tragic scene, but it was only published once before being censored by the Ford Motor Company (FMC).[1] For owner Henry Ford, the image demonstrated not only the prejudice against working class protesters, but also the extent of the participation of African American women and their connections with white radicals in labor organizing. The *Chicago Defender* took a similar approach in documenting the events of what would become known as the Ford Hunger March, reporting that "there were no Colored women," even though eyewitness accounts said otherwise.[2] Presumably, the press, both mainstream and African American, wanted to de-emphasize any role Black women may have had in the radical activities of that cold March morning. However, as this chapter demonstrates, Black women in Detroit had important radical roles as agents in and outside the automobile industry and risked their lives to promote Black radicalism in their city.

The Ford Hunger March was a defining moment in many working-class Detroiters' minds. Henry Ford's merciless answer to workers' demands for food, employment, and fair wages showed workers that negotiation with capitalists was futile. This interpretation was contentious in a city like Detroit with an established Black middle class that had close economic and social ties with the automobile industry. Often, moderate Black organizations like the National Association for the Advancement of Colored People (NAACP) and Detroit's Urban

League (DUL) favored alliance with white elites over working-class activism.[3] Black churches, long allied with Henry Ford and other Detroit white business owners, shrank from workers' rights, advocated maintaining the status quo, and offered few solutions to immediate problems. When Black women such as Mattie Woodson reshaped notions of respectability by publicly marching, holding meetings in their homes, boycotting and protesting racist businesses, and demanding food and employment for Black workers, they fought to widen the scope of Midwestern Black radicalism to the auto industry and Black communities in Detroit.

Historians have largely marginalized these women's roles in developing Black radicalism in Detroit and organizing the auto industry. Some efforts to diminish Black women's contributions were deliberate, such as the Ford Motor Company's censure of photos or the *Defender*'s inaccurate reporting. Elsewhere, Black women's roles were overlooked because they happened on small, personal scales, like feeding or housing the homeless. Black women were foundational in forming Midwestern Black radicalism and developing a place for women in the auto industry. They may have not operated heavy machinery or punched in and out every day, but Black women contributed important activism that ultimately led to the United Auto Workers' (UAW) union and a lasting activist community in Black Detroit.

The history of Black working-class women in Detroit during the Great Depression, radical or not, has largely been ignored by historians, and recovering their stories presents a challenge and an opportunity. Because the automobile industry dominates the economic, social, and political landscape of the Motor City, it has also dominated historians' approaches to Detroit's Black history.[4] For these earlier historians, Black labor in Detroit began and ended on the shop floors. More recently, scholars have looked to how community building defined interwar African American activism, particularly among the working and middle classes.[5] Black women-led organizations like the Housewives' League redefined discourses of middle-class respectability as their members became involved in political organizing, economic building, and social protest. Similarly, Black men in political and economic groups like the Civic Rights Committee and the Booker T. Washington Trade Association fought against racist political and economic institutions. This scholarship of working- and middle-class Blacks, though foundational in documenting and understanding Black Detroit in the 1930s, generally ignores Black working-women's activism and their relationship with white radicals.

Recovering the history of Black working-class women in Detroit is not without complications: their stories are often lacking in historical records. However, by reconsidering social and political activists and organizations through overlapping regional, radical, racial, and gendered lenses, history can come closer to a better representation of these women. In order to do so, this chapter examines several foundational moments in Detroit's history of race and labor in the early years of the Great Depression. Many of these events, like the Ford Hunger March and the Briggs strike, center on the Ford Motor Company and the automobile industry. Other activities, such as those of the Unemployed Councils, respond indirectly to the auto industry, addressing issues of factory layoffs, racism, unemployment, and community organizing. Regardless of the degree of their activism, Black women fundamentally helped shape a Black radical, working class community that outlasted the Great Depression.

THE BLACK MOTOR CITY

African American migration to Detroit after World War I is a familiar story: drawn by promises of employment and driven from the South by Jim Crow, the city's Black population swelled from 5,589 in 1910 (1.2 percent of Detroit's population) to 40,740 in 1920 (4.1 percent), to 120,786 in 1930 (7.7 percent).[6] A 1926 study by the Mayor's Inter-racial Committee showed that the majority of Black newcomers arrived from Georgia, Alabama, and Tennessee, facilitated by the accessible railroad transportation.[7] As in other Midwestern metropolises, Black Southern migrants in Detroit found their housing options limited. Prior to 1915, there was only one majority Black district in the city, known as Saint Antoine Street District, for the street that bisected it.[8] However, with more than one hundred newcomers arriving daily, the neighborhood grew crowded and overpopulated and Black residents spilled into the bordering areas known as Black Bottom and Paradise Valley.[9] The Black neighborhoods, though suffering from substandard housing, high rents, lack of civic agencies, and high risk of disease, provided a home for the exploding Black population. Resident Helen Nuttall Brown remembered that though Black Bottom was close to downtown Detroit, it was "very far removed in terms of being isolated economically and geographically." Despite the substandard living conditions, these Black neighborhoods fostered a sense of community and security among a disenfranchised population. As Brown commented, "It was home to me; it was a safe place."[10]

While de facto segregation imposed degrading and dangerous living conditions, recent migrants made the best of their conditions and retained strong community ties that defined their Southern values.

While their stories for leaving the Southern states were not unique—poverty, environmental disasters, racial violence, discrimination—Detroit boasted a compelling "pull" factor unlike any other city during the Great Migration. Beginning in 1910, Henry Ford and the FMC had not only revolutionized the city's automobile industry, but the very ways manufacturers worldwide thought about mass production. The much-exalted assembly line offered the opportunity for workers to stand in one position and perform the same tasks repeatedly, a mindless, monotonous task that workers with little or no training could perform. In another step in his own personal industrial revolution, in 1914, Ford implemented what he called the Five Dollar Day, Ford Profit-Sharing Plan.[11] FMC offered workers an eight-hour workday with a take-home pay of five dollars and a non-discrimination policy for hiring Black workers. By offering fair wages and treatment for African American workers, Ford broke automobile industry traditions of racist wages scales, greatly appealing to Southern Blacks. Henry Ford's makeover of the city exemplified the optimism thousands of African Americans had felt as they migrated north.[12]

In order to establish strong ties with the Black community, Henry Ford had devised an ingenious system whereby African American workers need only bring in a letter of recommendation from a minister at a local church, and they could get a job.[13] The story went, according to Arthur Michael Carter III, that a reverend of a prominent Black church "could pick up the phone and was able to secure jobs for his members."[14] Ford worker Frank Marquart had the impression that Ford did this "deliberately in order to create a pattern that would pit the Black workers against the white workers in a sense that it would make the Negro workers loyal to Mr. Ford."[15] Marquart's observations largely reflected reality: churches were often the first stopping point for migrants new to the city, and the direct pipeline Ford fostered with Black clergy enabled FMC a steady stream of Black labor. For most of the 1920s, this process was successful in making African American migrants to Detroit thoroughly dependent on Ford. Reverend Charles Hill, one of the few Black clergy who was critical of this practice, noted that Ford was "almost . . . a god" to Black workers.[16] Ford's important influence and ties with the Black clergy led to the automobile industry becoming the greatest employer of Blacks in

Detroit, employing almost 45 percent of the city's male African American population by 1930.[17]

Ford's perceived equal opportunity business model only went so far. Despite Ford's policy of non-discriminatory hiring, African Americans in the automobile industry faced intense inequity in terms of job placement and expectations. Most Black workers found employment in the foundry, a job widely considered the most undesirable work for Ford employees. Subject to noise, heat, filth, low pay scales, hazardous working conditions, and back-breaking labor, Black foundry workers were known around town as "Ford Mules."[18] The treatment these Black workers received likened them to work animals and non-human, a mentality not so different from the era of slavery. Katherine E. Reid's father was one of those "mules." Her family came to Detroit in July 1923 and her father obtained work at the FMC's massive River Rouge plant, located in Dearborn, about nine miles outside of Detroit. Due to the distance and lack of personal transportation, Reid recalled her father woke at 2 a.m. "because he had to walk to Davison to get the Baker streetcar."[19] He would return many hours later, exhausted and filthy, only to repeat the cycle again in a few hours. Coleman Young, future activist and Detroit's first Black mayor remembered their pervasive presence in the Black communities, "straggling home from work all dirty and sweaty and beat."[20] The exhausted condition of the "Ford Mules" was an inescapable visual reminder of Black labor's dependence on Ford and the inevitability of worker exploitation in the Motor City. With almost half of Black men in Detroit working for FMC, the daily experiences of these Black Ford workers affected community and family members. Reid and Young's experiences as young African Americans in the city were certainly shaped by observing the persistent images of devalued Black workers. While white workers during the 1920s could often find empowerment in union organizing, the "Ford Mules" dependence on Henry Ford ultimately rendered them weak in the struggle for racial and class solidarity. The dangerous working conditions, the obvious racial divisions of labor, and a complete inability to organize began to frustrate African American Ford workers as the 1920s came to an end.

Black women's personal working experiences in Detroit were shaped less by the automobile industry and instead were found in more traditional "feminine" places. While their husbands, sons, and brothers could usually find work in the automobile factories, Black women employed in the auto factories numbered only 116, or less than 1 percent of the city's Black female workforce.[21] Slightly larger numbers of African American women were employed in the

automobile factories during World War I to replace male workers, but were laid off as soon as the war ended.[22] The Detroit Urban League cited prejudice against Black women as the reason. After World War I, as more men arrived in the city ready for factory work, the automobile industry transitioned into one not suited for any women, Black or white.[23] Only 6,702 women were employed in the automobile industry as laborers or operatives, compared to 93,159 men.[24] Work for Black women in Detroit, then, was limited due to the specialized nature of labor in the city.[25] While an educated few found work as secretaries, teachers, or social workers, giving rise to a Black middle class and "bourgeois respectability," most were employed as domestics or dressmakers and seamstresses, work that was undoubtedly low-paying, unpredictable, and demeaning. African American domestics were subject to the whims of white employers: Minnie Parish, a Southern migrant from Florida, had nine domestic service jobs between 1929 and 1930 and four periods of unemployment.[26] For white middle to upper class families, Black domestics like Parish were disposable, and whites often preferred to hire white employees, if possible. A social worker noted that she had difficulty finding work for Black domestics, as "a great many white people will not take them."[27] Ernestine Wright remembered going to the unemployment office, waiting for hours, and hoping to get called for a day's work. Often, a day's work earned as little as one dollar.[28] Even if a woman was fortunate enough to find steady employment, it did not guarantee quality employment. Wright recalled that placement agencies were reticent to send young women as they were afraid that the husband "would flirt with them," which, according to Wright they did.[29] Sexual harassment was endemic to Black domestic labor and combined with the low-paying and erratic nature of the work, made the industry undesirable.

Sexual harassment was commonplace in domestic services and mostly went unreported. One rare documented instance was when one of the largest hotels in the city employed a number of "good-looking mulatto girls" as elevator operators and maids. However, these women experienced frequent sexual harassment, and after three months, the hotel fired all light-skinned girls as they were quitting too often due to harassment. Instead, the hotel hired what they perceived as "less attractive" darker skinned Black women. It is not known how the darker-skinned women were treated, but certainly the colorist impulses of whites shaped employment practices across the city. Yet, the actions of the lighter-skinned women demonstrate an important moment in Black women's solidarity. In his description of these developments, Forrester Washington,

Detroit's first Urban League director, praised the first employed women for making "the only protest in their power against the vulgar behavior of these men—by giving up their jobs."[30]

Civic and religious organizations tried to relieve Black women from the low-paying, uncertain, and degrading circumstances of domestic labor, but had limited success. The Second Baptist Church offered a wide variety of classes aimed at educating Black women in skills beyond household work, including lessons in dress making, home nursing, millinery, music, stenography, practical electricity, and even music, theology, and Black history.[31] The Detroit Urban League reported that during the 1920s "we have made efforts to get colored girls in places where a given amount of intelligences was necessary," such as factory work or typist, "but in going in[to] any of these fields, it was found that because of their color, they were given no opportunity to work."[32] Despite efforts make by local churches and civic organizations, between 1910 and 1930, around 80 percent of African American women were employed in domestic services.[33] As scholars have noted, by 1930, African American women were "inextricably linked" with domestic service occupations in the city.[34] This work, though often undesirable and degrading, provided substantial support for Black families. African American neighborhoods and communities were built upon the backs of these women, who intimately understood the inseparability of race, gender, and work.[35]

For women who recently made the Motor City their home, Black churches and traditional civic organizations were seemingly the only options for assistance in finding jobs and housing and establishing a sustainable community. While the DUL, YMCA, and Black churches helped in these aspects, many new migrants sought an avenue to fight the racial injustice of the city. They came to Detroit to escape the rampant racism of the South, yet found their opportunities limited in the Midwestern city. While Black churches could serve, and often had, as avenues for protest, due to many Black clergy's dependence on Henry Ford, any promotion of unionizing or workers' solidarity inside the churches' walls was unlikely. Historically, Detroit's NAACP had fought to fill the role of civil rights champion. Founded in 1911, the branch fought to fight national and local racial discrimination in court.[36] Detroit's NAACP was part of what Beth Tomkins Bates has termed the "Old Guard," or organization that depended on tried and true tactics of reform via legal relief.[37] For example, the NAACP made national headlines in the mid-1920s when they employed Clarence Darrow, then the best criminal lawyer in the

nation, to defend Black Detroiter Dr. Ossian Sweet. In 1924, Sweet had moved his family into an all-white neighborhood, well aware of the potential for violence. Sweet and several family members and friends armed themselves against a large crowd of white rioters who attacked the Sweet household. Shots rang out from the house and one white man was killed, another wounded. Along with ten others, Sweet was charged with murder, but due to the NAACP's intervention and Darrow's defense, he and his co-defendants were acquitted. Though thousands of Blacks looked to the acquittal as a Northern rejection of segregation, the case did little to stem daily racism in Detroit.[38] Blacks still had to ride in freight elevators, could not eat at so called "white restaurants," and though schools were integrated, one Black Ford worker noted "the prejudice, the hate, discrimination and so forth against Blacks . . . wasn't much better in Detroit than in the South."[39] In particular, the Sweet case demonstrated the interests of the NAACP: respectable middle-class Blacks acting on their legal right to defend themselves and their property. According to Beulah Whitby, the newer working class Blacks in the city felt distance from the middle-class approach to fighting injustice and "there was a great cleavage among Negroes, between the old Detroiter and the new-comer."[40]

In the minds of many Black Detroiters, the tactics of the "Old Guard" had failed them. By pursing legal cases, the NAACP exhibited a moderate approach to fighting the racial injustice in the city. By the mid-1920s, Blacks who sought a more active and militant approach turned toward Marcus Garvey's Universal Negro Improvement Association. Garvey's teachings of nationalism, self-determination, and Black pride offered a direct attack on moderate organizations like the NAACP, the Urban League, and many other middle-class African American associations who aligned with white elites. John Charles Zampty was one of the first Blacks in Detroit to join the UNIA.[41] Like many Black Detroiters, he was unhappy with the current African American leadership in Detroit, arguing that their program advocated integration, which was impractical and impossible due to the extent of white racism in the city. Zampty directly attacked the "Old Guard," saying, "I do not see any good that the NAACP has done or is doing as far as their program is concerned." His disgust also extended to the Urban League, which, according to him, was "asking for open doors and handouts."[42] An important part of the New Negro Movement was self-determination and self-sufficiency, something Zampty perceived these older organizations devalued. Therefore, Zampty and other Black Detroiters eagerly responded to Garveyism. Founded in 1920, in only five years the Detroit

division of the UNIA boasted over 5,000 members.[43] Membership, however, only showed a portion of the influence Garvey had in the city. Marches and meetings often attracted over 10,000 men and women, a weekly newspaper, *The Detroit Contender*, preached Garvey's message to the masses, and the Detroit division owned and operated many local businesses in Black neighborhoods.[44] J. A. Craigen, Detroit division member and later president, reported to the 1924 national convention in Detroit that he "represented the second greatest division of the association, second only to New York."[45] The headquarters on Russell Street was a hub of activity; Charles Digg recalled, "I remember looking through the fence on the Russell Street side . . . I frequently saw people in uniforms, parades, and other activity around that building, as the movement was quite popular."[46] Much like the "Ford Mules," the presence of Garveyites filled Black neighborhoods. Unlike the Ford workers, however, the men and women marching in uniform claimed racial solidarity and empowerment that challenged the city's everyday racism.

Black consciousness and Black economics grounded the Garveyite ideology, which attracted both men and woman. Though Garvey's nationalist rhetoric embraced a masculine sense of militancy, it did not discourage African American women from joining the movement. Many African American women challenged contemporary notions of Black female respectability by marching alongside men in military uniforms, attending mass meetings sponsored by UNIA, and supporting Black businesses and entrepreneurship.[47] Historian Keisha Blain argues that Black women involved with the UNIA often challenged male supremacy, advocating a "proto-feminist" stance while at the same time embracing the "natural" roles of mother and wife.[48]

Black women's embrace of feminine roles was often revolutionary, however. Ruth Smith, whose family had moved to Detroit after World War I from Alabama, remembered UNIA specifically attracting her mother. Smith recalled becoming familiar with the UNIA around 1920, when her mother compelled her to attend division events every Sunday. "We had to go whether we wanted to or not. . . . Instead of going to church on Sunday, we would get up early and go to the Detroit division of the UNIA, diligently every Sunday."[49] This type of involvement is what historian Ula Taylor refers to as "community feminism," wherein Black women negotiated feminist and nationalist ideas to "carve out" their own territory, where they often challenged ideas of perceived inferiority, sexism, and racism.[50] With most Black women employed as domestics and denied the opportunity to express solidarity in the workplace, they turned to

their communities as sources of autonomy, self-determination, and race pride. The UNIA helped provide space, training, and networks for this to happen.

However, due to the deportation of Garvey and financial woes, the national UNIA collapsed by the mid-1920s. Though local divisions such as Detroit attempted to keep the organization alive, by the time the stock market crashed, working-class Black residents were seeking immediate answers to their problems. In his 1943 book *A Hand Book on the Detroit Negro,* journalist Ulysses W. Boykin noted that though the city once had a "strong unit of the Garvey society," by 1930, Blacks "needed aid and assistance to face the problems of labor, health, housing, discrimination, and citizenship."[51] Local UNIA leaders sought to keep the presence of their message alive, and as late as 1935, were still holding meetings at Liberty Hall on Russell Street.[52] Though numbers and influence of local divisions declined, scholars have long noted that the lessons the UNIA taught established a longer lasting legacy of racial pride, consciousness, and militancy in Black neighborhoods across the country.[53] The UNIA's resurgence post-Depression demonstrated the enduring spirit of Black Detroiters to fight for racial uplift and solidarity. However, as the nation faced unprecedented challenges, Black workers, and specifically Black women, sought to take the lessons learned from Garveyism and apply them to a new outlet for activism.

DETROIT'S DEPRESSION

As Detroit began to feel the full impact of the Depression, many Black women were forced into working to supplement their husbands' wages. Even workers supported by the Ford Motor Company's "Five Dollar Day" promise found themselves struggling to make ends meet. Every year between 1931 and 1933, the Ford Motor Company initiated sweeping wage cuts, despite Henry Ford's assertions in 1929 as well as 1931 that neither the company nor any of its suppliers would reduce pay.[54] When Ford workers began to experience the full impact of the Great Depression, the loyalty Henry Ford built up with his African American employees began to dissolve. The massive River Rouge complex, which employed one hundred thousand workers in 1929, reduced the workforce to fifty-six thousand in 1932 and to twenty-nine thousand in 1933.[55] With the massive layoffs in the one-industry town, unemployment rates in Detroit soared in comparison with the national and state averages. From 1930 to 1933, Michigan's average rate was 34 percent, compared to the national average of 26 percent.[56] The *Chicago Defender,* once the nation's largest proponent of Black

northern migration, started to discourage Southern African Americans from seeking work in Detroit. In 1932, the *Defender* observed that instead of finding employment in the automobile factories, the city's newest migrants became "wards of the city and are just increasing the burdens of the welfare department." Thousands were unemployed, even more on the welfare list. "Stay away from Detroit if you are looking for work!" the paper warned.[57] The ties between Ford and the Black community faded as thousands were laid off and unable to provide even the basic necessities for their families. Instead of symbolizing employment and equal treatment, Ford became the embodiment of whites' treatment of Black workers during the Great Depression.

While Black men struggled to find factory work, Black women faced equal challenges in securing employment. The DUL, where unemployed women had usually looked for work, found itself overwhelmed with requests. People from around the country wrote John C. Dancy, the director of the DUL, for advice about job placement. Dancy, however, could not help them, telling one man that "the City's Relief Agencies are up to their necks in trying to devise ways and means for taking care of those who have become dependent."[58] African American women often took it upon themselves to seek employment for themselves and their families. Eleanor Shamwell wrote from Alexandria, Virginia, that she was "depending" on Dancy to help her family, following up eight days later with another letter.[59] It is unlikely she procured employment, as Dancy wrote to another woman not long after, "I would advise you not to come to this city in search of work at this time."[60] Dancy's words, though discouraging, reflected the harsh reality of the city's dearth of employment opportunities; in 1930, the DUL was only able to fill 1513 job requests out of 8499.[61] Major budget cuts in 1932 stripped the DUL of 40 percent of the organization's funds and the trend of less than 15 percent placement rate continued through the mid-1930s.[62] Similarly, private charities such as the Associated Charities and public agencies like the Department of Public Welfare were underfunded, understaffed, and faced constant budget reductions.[63] Organizations in Detroit traditionally tasked with aiding the needy, like others in many cities, were simply not equipped to take on the Great Depression.

While Black Detroiters struggled with unemployment and feeding their families, they looked to traditional African American organizations like the NAACP and DUL to alleviate some of their woes. Instead of immediate aid or long-term solutions, they were met with inadequate short-term relief and lack of long-term plans. Many middle and upper-class Blacks shared the opinion of the

Reverend Robert Bradby, who urged Black workers to "be "steady workers" so as to improve the worthiness of colored industrial workers."[64] Despite high rates of poverty, unemployment, homelessness, and hunger in Black working-class neighborhoods, Black elites reasoned the proper recourse was to stay the path. This approach likely rang hollow on the ears of families starving and facing eviction. The Black middle and upper class elites simply did not understand the desperation of the working class, reflected in those organizations' declining membership. Though the Ossian Sweet case drew more than two thousand members to the Detroit chapter of the NAACP, by the early 1930s, the branch had done little to retain these members or attract new ones. In 1933, Detroit's NAACP chapter had only 550 members.[65] When Detroit's elites offered no solutions to the problems of poverty, unemployment, and racism, a new group of unemployed Black workers began to challenge "the Old Guard."[66]

For the most part, local churches advocated traditional approaches to fighting racism and supported the local NAACP and DUL. Black churches' connections with Ford prevented church leaders from supporting unemployed workers' rights in the early 1930s. One exception was Reverend Horace White, minister of Plymouth Congregation Church as well as a National Negro Congress member and union supporter.[67] In 1938, he wrote "Who Owns the Negro Churches?" for the *Christian Century* journal, reflecting on the relationship between Black churches and white industry in Detroit. White saw how the churches had mostly been inactive in supporting Detroit workers and reticent to support unions. Yet, he noticed that "in spite of the fact that the Negro church has so far failed him, the Negro worker still looks to it for help." Black clergy, though, were more likely to respond to the needs of Ford and other white industrialists, as often labor organizers and liberal organizations were prevented from speaking at church functions, under the supposition that employers would fire congregation members. The churches, then, were "actually the property of the big white industrialists."[68] White's observations were not far from the truth. Reverend Robert Bradby of Second Baptist had retained close ties with Ford Motor Company general manager Charles Sorenson, providing the company with hundreds of quality workers. In response, when the Depression hit, the company returned the kindness by shipping fifty tons of coal to the church.[69] Such incidents were not rare, as White pointed out, and gave credence to the notion that men like Bradby were "leading for the industrialists rather than for the welfare of the Negro."[70] At the time, though there were a few ministers like White who were advocating for Black workers, they were "too few to be

heard." When Charles Hill, the pastor of Harford Baptist Church since 1920, came out as against Ford's practices, he lost one hundred members of his congregation who said he had no business taking a pro-union stance. According to Hill, though, "The church ought to be interested in all areas here on earth, as well as talking about going to heaven."[71] Church leaders like White and Hill were few and far between, though. As the NAACP, the DUL, and most Black church leaders shied away from issues plaguing the Black working class, the unemployed, hungry, and homeless began questioning the old ways.

Drawing on the lasting ideas of Black self-determination, racial solidarity, and Black Nationalism from the UNIA, a growing number of working-class Blacks sought religious fulfillment from the recently established Nation of Islam (NOI). Though the NOI drew from the established popular teachings of the Moorish Science Temple of America (MSTA) and the UNIA of the 1920s, the onslaught of unemployment and degradation wrought by the Great Depression brought renewal and relevancy to the teachings of Black Nationalism. The NOI's attractiveness for Black Detroiters also stemmed from the city as the first appearance of W. Fard Mohammed, who established Temple Number One in the city in 1930. Fard repeated Garvey's message of Black pride, revisiting the rise of race consciousness in the 1920s, and the MSTA's doctrine of strict adherence to a certain interpretation of the Quran.[72] Clara Poole was initially attracted to the meetings Fard held around Black neighborhoods. As a Black domestic worker who supported her often unemployed, alcoholic husband, Elijah, Clara sought support and direction on how to lead her family in trying times.[73] She was not alone; much like they led their families to UNIA meetings, Black women again became a force for rallying the Black community. With Clara's support, Elijah would rise to be Fard's right hand man, and when Fard disappeared in 1934, Elijah Poole, who had become Elijah Muhammad, assumed leadership of the NOI.

As in the UNIA, Black women found the teachings of the NOI appealing and quickly established a place for them to assert themselves in the Black community. Clara welcomed an environment where she could express herself as a former Black domestic, familiar with being exploited by white supremacy.[74] The NOI offered a religious organization that rejected Black churches' dependency on white charity. While many viewed women involved in the NOI as powerless, recent scholars have revealed the more "subtle stories" of these women who held great power in shaping their communities.[75] Clara, a woman who never graduated from the eighth grade, established a school to teach neighborhood

children reading and writing. These schools grew to have enormous significance in the NOI, and in 1934, the NOI established the University of Islam, arguing that a specialized education was vital to Black Muslims.[76] NOI teachers maintained that public schools had consistently failed Black children, and in 1930, Detroit NOI members withdrew their children from these schools to attend Nation-led classes. This led to violent encounters with Detroit law enforcement, who claimed the NOI aided in the delinquency of children. In one incident, NOI teachers and mothers of the children resisted and barred the police's entry into their schools.[77] While the women continued to teach, they moved their operations underground to avoid further public encounters. However, media coverage of the riot showed the militancy and dedication of Black women in Detroit to fight for their communities in the face of white authority.[78]

For the most part, white Detroiters viewed the NOI with unease and skepticism, while the Black press was somewhat more accepting. A 1934 editorial in the *Detroit Tribune Independent* noted the appeal of the NOI's emphasis on Black pride and self-determination, as well as alliance with other people of color. It is understandable, the paper reasoned, considering "the new era of world readjustment in which we live."[79] By the article's publication, approximately eight thousand Blacks had joined the Nation of Islam, many Southern migrants.[80] Elijah Muhammad moved NOI headquarters to Chicago soon after, citing increasing harassment in Detroit. While this move did not completely devastate the movement in Detroit, the rapid growth the city saw initially was not repeated. By 1943, Ulysses Boykin reported that the "[Black Muslim movement] has not grown to any considerable extent in the recent years."[81] Much like the UNIA, however, the NOI would grow significantly after World War II, expanding the roles and influence of women in the movement.

The influence of the NOI, like the UNIA, is difficult to fully measure. While the NOI preached strict adherence to its religious teaching, the organization was less inclined to call for political or direct action. The riot regarding Black Muslim children's education was an outlier; for the most part, the NOI steered away from politics and public protest. This approach limited its appeal to many Black residents. Black worker Shelton Tappes observed that "the Muslim movement didn't seem to call for any activity. And the people in those days seemed to want to be actively involved or engaged in something."[82] Dissatisfied with lack of help from local political institutions and Black elites, many working-class African Americans began to envision themselves as agents of change. This brought the community together along with fostering a sense of Black radicalism. Coleman

Young observed that "the Depression also gave life to Black Bottom" as residents were brought together by brutal social and economic conditions. The neighborhood was energized on issues such as labor organizing, automobile plant layoffs, housing, and more. "It was a climate very conducive to the nurturing of young radicals."[83] The lingering ideologies of Black self-determination and nationalism, promoted and popularized by the UNIA and the NOI also promoted a certain sense of rebelling against the "Old Guard" and potential of building a working-class community. African American women's roles in "community feminism" and building as seen through Clara Poole, though often overlooked, contributed to enlivening the working-class population. As essential family providers, financially and emotionally, Black women helped lay the foundation for a new breed of activism.

It was not just Black communities that felt invigorated by the challenges of the Depression. Working-class whites, too, suffered massive unemployment and working-class communities across the city suffered. Yet in suffering, there was potential for solidarity between the races. David Moore commented that there "was more unity among the Black and white people here in Detroit at that time of the Depression, the whites and the Blacks was [sic] closely knitted."[84] One organization that sought to unite these individuals and groups was the Unemployed Councils, whose members had been working for unemployed community members and fighting evictions since 1929. When he was unable to find work, Moore became involved in anti-eviction protests, and soon he found himself "deep involved in the unemployment councils."[85] White Communists had established a radical presence in the city prior to the Depression. The Communists had been active in Detroit since 1922, their work primarily centered on organizing the automobile industry, publishing a shop newspaper, recruiting workers, leading strikes, and building the TUUL's Auto Workers Union (AWU).[86] Activists frequently organized meetings at Grand Circus Park, attracting thousands of sympathizers and curious on-lookers. Though often broken up by law enforcement, the consistent presence of Communists in working-class neighborhoods drew people's attention to the efforts of the activists.[87] Considering their relatively small numbers, the Communists established a significant presence in the automobile industry in Detroit, an influence that would prevail through the Depression and the 1935 founding of the United Automobile Workers (UAW) of the Congress of Industrial Organizations (CIO). In March 1928, 43 percent of Detroit Communists belonged to auto shop nuclei of the AWU and controlled the highly circulated shop paper *Auto Workers*

News.[88] Keeping with the Communist Party's Third Period ideology of inclusion of Black workers, the AWU began promoting interracial organizing as early as 1929.[89] The *Daily Worker* noted that organizing the "Motor City" would necessarily mean "winning the support of the most exploited section of this working-class": African Americans living and working in the most dismal conditions.[90]

While the majority of AWU members were Black and white men, women were encouraged to join the union, as wives and daughters were eligible to join for only twenty-five cents a month.[91] As well, when the TUUL held its first national conference in Cleveland, Ohio, in 1929, Black women were encouraged to attend. Louise, one of the few Black women working in the Detroit automobile factories, attended the conference and even spoke. Described as a "little firebrand," she reported to the national TUUL executives on her struggles in factory work and especially highlighted the conditions of women. Her fellow workers chose her to represent them because she came "right from the job and class struggle." The Communist publication, *Working Woman*, documented other Black women present. One Black woman attended the convention and listened diligently to the speeches. Unable to procure childcare, she brought her young child, who, fidgeting in her lap, "gurgle[ed] at the ceiling," clutched the mother's breast, and pulled her hair. The mother, undeterred, nursed her child as she sat in the convention hall, taking notes.[92] Louise and the unnamed mother offered a Black working-class perspective, firmly linked to their experiences as Black women. Their presence, and the media coverage that followed, emphasized the importance of Black women's lived experience as mothers and workers in the radical union struggle.

Radical women's publications and advertisements continually urged women regardless of race to join the AWU. The *Working Woman* journal specifically linked problems women faced in providing for their husbands and children. One article proclaimed, "The only way we can better our conditions is by organization . . . JOIN THE AUTO WORKERS UNION."[93] A flyer advertising International Women's Day additionally appealed to what were perceived as women's issues. "We mothers, mothers of Dearborn, when we go to demonstrate on March 4, we will demand work for our husbands and against child labor, for free food, transportation and hospital care for our children." Furthermore, the advertisement stressed that this applied to all women, "Negro and white."[94] Most Black women did not join the AWU; however, that did not indicate a lack of interest in radical labor and social change.

With a strong worker presence and a huge proportion of them without jobs, Communists in Detroit had little trouble finding support in the Black communities. Shelton Tappes remembered that the average Black worker, employed or unemployed, usually responded well to radical propaganda, socialist, Communist, or otherwise. "It was . . . a matter of individual choice . . . The response of the Negro was usually the most vocal to that group who was the most vocal in expressing the hopes and aspirations of the Negro for equality, and those who spoke out for Negro rights, and tried to announce a program calling for the acceptance of the Negro generally."[95] The TUUL had the best success in recruiting Black workers, and had almost as many Black members as white members. The TUUL's Detroit chapter actively engaged in the community as well as the workplace; every meeting ended with a social event, such as a dance, and in the summer, thousands of people would attend the TUUL-sponsored picnics.[96] Some of the most common TUUL-affiliated activities were those of the Unemployed Councils. The city had about a dozen local councils, located in the large metropolitan area of Detroit, the Black suburbs like Inkster, and the industrial areas of River Rouge.[97] Black auto worker Joseph Billups recalled that they hosted meetings on the steps of City Hall "practically every night." Another popular gathering place for the unemployed was Grand Circus Park where, according to Billups, "All day and all night long . . . the unemployed would group, would come together." Billups claimed that it was at one of the park meetings where the idea of unemployment insurance began. His wife, Rose, often joined her husband in these mass meetings, listening to the speakers. She too observed the radical changes happening with the working class in Detroit as well as around the country. The community rallied around ideas of solidarity and notions of unemployment relief. The unemployment insurance movement, she argued, "really started in Detroit."[98] Whether she was correct in her assessment is impossible to know; however, as a working-class Black woman, Rose could understand and appreciate being at the center of the spirit and innovativeness of the movement.

Like those in Chicago, Cleveland, and St. Louis, the UC in Detroit were particularly active in anti-eviction measures. Evictions were a common occurrence throughout the nation, wherein local authorities would forcibly remove residents and their belongings from their homes due to lack of payment. Joseph Billups often helped lead the crowds to replace the family's furniture in the house and leave men to guard the house in case the sheriff arrived. Even if law enforcement came, which, according to Billups, they only did if the

landlord paid them, the UC crowds would simply repeat their actions when the sheriff left. Very few landlords would pay it again because the same thing would happen over and over again.[99] The anti-eviction actions were a visual and pervasive reminder of the daily injustices suffered by Detroit's unemployed. While the protesters actively fought against evictions, they also sought to forge working class solidarity in the streets, claiming those public spaces as their own. David Moore remembered that "one time it was snowing hard, and an evicted woman was actually having a baby on the sidewalk with other women around her, wondering if they had enough blankets to cover up the woman having a baby!"[100] These efforts, among many others, demonstrate the Black working class's ability to seek and build community during chaos. One particular anti-eviction demonstration led to a violent encounter at a police station. In August 1931, only weeks after a deadly anti-eviction riot in Chicago, protesters attempted to carry furniture back into the home of Viola Turner, a single mother of three. Local police prevented them and ended up arresting half a dozen agitators and bringing them to the Hunt Street police station. A mob of more than 2,500 marched to the station where they demanded the release of the agitators; police met the protesters with clubs, and the protesters responded with bricks and stones. After a half-an-hour battle, the crowd dispersed with six injured, but no fatalities.[101] The evictee, Turner, was not a Communist, and though her involvement in radical activities in the city is unknown, the consistent efforts of the UC to help Black women in their most desperate times only furthered the organization's appeal.

Black women involved in the Unemployed Councils, in addition to fighting evictions, worked to ameliorate other immediate woes, such as hunger. Rose Billups collected meat and bones from sympathetic storeowners and beans from farmers, which she cooked in a huge pot for the masses of unemployed workers. During that time, Jewish storekeepers were known to save meat and bones and farmers would give surplus crops. Once, Rose remembered, a generous farmer donated six sacks of beans, and, although, according to Joseph, Rose did not know much about cooking, her huge pots of beans would draw hundreds of hungry unemployed workers.[102] Rose's efforts show that although she may have been limited culinarily, her commitment to the working-class cause could not be deterred. Together, the Billupses also established welfare offices around the city, where unemployed workers could get a meal and clothing.[103] Providing for the down-and-out required a strong relationship with local vendors and the community, as all handouts were donated. As the go-to cook, Rose

was essential in building those relationships for the UC, and her community-organizing skills would later transfer to her success in union making in the automobile industry.

African Americans who wished to get involved with the workers' movement were most likely to join in Communist activities, as they were the most prominent radical group among the Black working-class communities that promoted immediate relief. Marquart remembered, "Every time a Negro would pick up a piece of CP literature, he would always find something that pertained to the problems of Negroes."[104] Besides the literature, public activities made African Americans aware of the Communists. For Coleman Young, the Communists "were the only ones who gave a damn about the concerns of us pickaninnies." Communists were frequently storming welfare offices, moving people back into their homes, advocating equality, and seemed genuinely interested in fighting for improvement.[105] This was especially impressive for men like Marquart and Young, who had previously heard only from traditional "Old Guard" organizations on how to live. When religious leaders like the Reverend Bradby insisted that Black workers should continue working in awful conditions for low wages for white businessmen, Communist literature that promised an improved economic future and racial equality through neighborhood and workplace organizing, found receptive audiences.

However, not all African Americans in Detroit were swept up by the promises of the party. Many Blacks shared the views of Shelton Tappes, who was involved in many of the demonstrations and party activities, but "never had any desire to join the Party."[106] He felt that the party was only interested in Blacks to "exploit the feelings of the Negro worker, take advantage of them, by seizing a situation that maybe they felt pretty strongly about, and setting themselves up as champions of the cause."[107] Even Coleman Young, who praised the activities of the Unemployed Councils and worked for Ford Motor Company, never joined the party. He knew the party line "backwards and forward" from soapbox speakers and barbershop talk, but because he did not agree with all the party's teachings, he never joined. Though Young teamed up with the party in labor organizing and the work of the UC, Young remarked, "I would have teamed up with Satan if he could assure me that I'd have all the working privileges of a white man."[108] Though not the first choice of many African Americans in Detroit, the Communist Party and the Unemployed Councils were the only organizations aggressively promoting racial equality alongside tangible answers to the woes of the Great Depression. Radicals' longstanding

presence in the automobile factories as well as the activities of the UC inspired many Blacks to participate in party activities to various degrees.

Having a husband in the automobile industry influenced Rose Billups's involvement in the UC and organizing Black women. The Billupses married in 1932, and Rose was well aware of her husband's radical activity. In 1930, Joseph ran for governor of Michigan on the Workers' Party ticket, receiving almost 4,000 votes.[109] He was also a mainstay at Communist rallies and protests in the city. His radical activity, however, did not prevent him from approaching established politicians to negotiate; in 1930, he met with Detroit mayor Frank Murphy and successfully negotiated more relief funds.[110] For the most part working-class Black Detroiters acknowledged and appreciated his work, regardless of his politics. According to fellow workers, at the time Joseph was considered "the outstanding Negro in the community."[111] This notoriety, though, came with consequences. While he was an experienced auto worker, employers fired him once they discovered his radical activity. Joseph would find employment in another factory under a different name, only to be fired again.[112] Rose, like many Black women in Detroit, was the primary breadwinner for the couple. She worked at a local shop, where she designed and sold hats. Her meager income was never enough, and though Joseph would sometimes receive small sums from the CPUSA, the Billupses were certainly living the working-class struggle.[113] Rose herself was not a member of the CPUSA or UC, however as her experience as cook showed, she frequently worked with them to help those in immediate need. Because these organizations "appealed to Negroes," African American Detroiters, like Rose, regardless of political affiliation were compelled to contribute to the radical cause. Rose was very aware of the radicals' appeal, specifically when it came to issues of housing. "When they had no place to stay, they saw that they got back to their homes, if they were evicted. And they got the electric lights [turned back on]."[114] The work of the UC and the CPUSA impressed Rose so much, she helped organize a subscription rally for the *Working Woman*, raising $25.00 for the Communist publication. The journal published her name and praised her efforts, recognizing her as an important player in the working-class struggle.[115] This sort of publicity could backfire on the Billups family; however, Rose continued her work with an understanding that her radical activism did not necessarily mean she was a Communist. Black women like Rose Billups operated as essential figures in organizing relief, even as non-members of the CPUSA. This sort of activism helped define African American women's style of Midwestern Black

radicalism—the CPUSA may have informed and inspired their actions, but certainly did not set the terms.

Detroit's radical community offered many levels for engagement, and while Rose did not align with the CPUSA, some African American women wholeheartedly embraced party practices and principles. Mattie Lee Woodson, a CPUSA member who devoted years to the cause, interpreted her radicalism through a party lens. Woodson came to Detroit from New York, but both her parents were born in South Carolina. In 1930, at age twenty, she was a homemaker, and her husband worked as a wageworker in a bell shop in Detroit.[116] Likely, the Depression took its toll on the young family, and Woodson became involved in the Unemployed Councils and joined the Communist Party. This chapter's beginning anecdote, in which Woodson stopped during the chaos of the Ford Hunger March to tear her dress to tend to a wounded protester, demonstrated how she was willing to defy standard notions of respectability and took public stances in confrontations. She worked closely with Ford workers like Shelton Tappes, and hosted meetings in her own home. At the meetings, Communists and non-Communists would discuss "Negro matters" as they pertained to union organizing.[117] Later, after the founding of the UAW, the union members discussed and planned strikes and work stoppages to protest racism in the automobile industry. Woodson continued to serve as an employee of the party's District 7 throughout the 1940s and 1950s. Her public activism and association with the party did not falter; in 1945, she attended the Michigan Communist Party State Convention in Detroit, where she gave a speech and was nominated secretary, but declined for unknown reasons.[118] Her involvement, though, came at a dangerous price. During the Red Scare of the 1950s, Richard Franklin O'Hair, a former auto worker and FBI informant, named her, among dozens of others, a Communist agitator before the House Committee on Un-American Activities. Woodson appeared to have escaped the worst of the Red Scare prosecution, as she was never called to testify before the House and the FBI never opened a case file on her.[119] Interestingly, accounts of Woodson are only secondhand; even though she was a leading Communist figure in Detroit and Michigan, she never published any speeches or articles. The photo of her tending to a white comrade during the Ford Hunger March was destroyed, and her life remains a mystery.

Though publicly allying themselves with the Communist Party had consequences, Black women who represented Detroit continued to do so with militancy, force, and remarkable courage. The 1932 Communist National Nominating

Convention took place in Chicago and featured 18-year-old Renelda Gumbs as a speaker. Gumbs, described as a "mere slip of a nice, brown-skinned girl," graduated high school with honors in New Jersey, but, as the *Pittsburgh Courier* declared, "American colored prejudice offered her a mop instead of an opportunity to study at Columbia, and she chose Communism."[120] With higher education off the table, Gumbs moved to Detroit to direct the Youth Communist League (YCL) and readily adapted to the radicalism of the city. During her speech in Chicago, she raised her fist into the air and declared into the microphone that leaders of the NAACP were "the worst enemies" of Black youth. She went on to disagree with the CPUSA's official platform and insisted the term "equal rights" be revised. "Equal rights is not enough . . . The old parties have sugared us along with equal rights promises. They meant equal rights to the kitchen, equal rights to the worst jobs, and least opportunities." Gumbs insisted the platform include "full and unconditional equal rights" for African Americans. The reporter for the *Courier* stated she made one of the most impressive addresses. Swayed by her passionate plea, the platform committee included "full and unconditional" in the final draft.[121] Gumbs's direct challenge to party leadership was a remarkable victory for a young, Black woman. Certainly, her educated background helped propel her to higher levels of the CP hierarchy, but her keen awareness and interpretation of Communist doctrine and race established her as an essential voice in the 1930s. Renelda Gumbs was one of the many Black women who appear once in Communist or Black press articles, only to disappear when their moment in the spotlight is over. The lack of knowledge of the rest of their lives does not indicate fleeting influence. As Gumbs showed, her ability to confront and challenge the CPUSA had lasting repercussions in party literature.

Beyond public speeches, African American women from Detroit continued their bold approach to understanding and advocating for radical principles regarding race, class, and gender. Twenty-one-year-old Dorothy Ida Kunca had worked her way through school as a waitress and domestic worker only to finally get a job at the General Motors factory. She performed jobs traditionally assigned to men, but as a Black woman, she was paid less for the same work. She soon joined the AWU to help fight this injustice. From a working-class family and with firsthand experience of the toils of a Black laborer, Kunca was chosen to be the Detroit representative to the 1934 World Committee of Women conference in Paris. The conference's expressed purpose was to "work out a common program of action against war and fascism." Kunca, a

young Black woman from Detroit, was an unlikely candidate to an international conference on women, however, the CPUSA provided her, as well as other women, the unique opportunity to learn and assert themselves as Black working-class women.[122]

African American Detroit women did not have to leave the country to represent their interests on grand scales. Mary Sidney attended the National Congress for Unemployment and Social Insurance in Washington, D.C., in January 1935. A special subsession focused on women's issues. The members drafted H.R. 2827, a bill that demanded maternity insurance, a "Mother's Bill of Rights," which highlighted free day care, birth control clinics, and free lunches, as well as free transportation for school children. Sidney represented working-class Black women as she stood before the sub-session and spoke. There, she was warmly received as she advocated for unity between Black and white women. She was critical, though, of the ways race had driven a wedge between working-class women. She called for "white women to love their Negro sisters!"[123] Like generations of Black working-class women before her, Sidney was acutely aware of the difference race played in gender roles. Instead of ignoring or discounting the racial divide, she confronted it and challenged white women to help bridge the gap. Much like her counterparts, Rose Billups, Mattie Woodson, Renelda Gumbs, and Dorothy Ida Kunca, Mary Sidney was not content to let the problems affecting Black working-class women go unheard. Although they all approached their radical activism in distinct ways, no one could doubt their commitment to the Black working class.

Race continued to play an important role in radical organizing in Detroit. A defining moment in many Detroit radicals' lives came in March 1932, when Blacks and whites marched together in the Ford Hunger March. The massive layoffs at Ford Motor Company made Ford a natural target of the Detroit Unemployed Councils.[124] March 7 was blisteringly cold, with temperatures well below freezing. Despite the weather, a crowd of 3,000 gathered in Detroit, one block from the Dearborn town line.[125] They carried banners and signs that contained familiar UC slogans: "We Want Bread, Not Crumbs"; "Open Rooms of the Y's For Homeless Youths"; "Fight against Dumping of Milk While Babies Starve"; "All War Funds for Unemployed Relief."[126] While the march on FMC was directly in response to worker layoffs, women involved in the radical movement saw the link between labor and domesticity, as shown through their emphasis on "feminine" issues, such as milk for babies, food, and homeless youth. This was not the first time protesters had brought "women's issues"

to the fore of their activism. AWU pamphlets and *Working Woman* articles consistently appealed to women as mothers and caregivers. These issues were essential to understanding Midwestern Black radicalism due to their centrality in Black women's lived experiences. By equating the problems mothers faced with those workers faced, these actors of Midwestern Black radicalism fundamentally reshaped activism in the city.

The march began down Miller Road, with protesters singing and in good humor. A pamphlet later issued by the Youth Communist League reported on the procession: "Negro, white, foreign born, girls, women, and young workers with a song on their lips, defying the bitter cold wind, marched unarmed until they reached the Dearborn line."[127] The thirty to forty Dearborn officers then showered the crowd of three to four thousand with tear gas, but the wind blew most of it away from the protesters. Though mostly unaffected by the gas, the crowd was disorganized yet continued forward another half a mile until they reached the entrance gate and bridge of the factory. Dearborn police as well as Ford Motor Company private police met the protesters with more tear gas as well as icy water from fire hoses. The marchers responded with a hailstorm of missiles. It was then that the Dearborn police and hired private security officers opened fire. Amid the tear gas, icy water, and barrage of bullets, the crowd scattered. Further action was futile, and would only result in further bloodshed.[128] Among the dead were Joe Bussell, sixteen, a newsboy, and Joe York, nineteen, an organizer for the Young Communist League in Detroit, both shot by police bullets. As well, Coleman J. Lenny, twenty-seven, a former Ford employee, and Joe DeBlasio, an unemployed worker active in the UC, had both been fatally shot.[129]

At some point in the days following the riot, a fifth victim of the march died. Curtis Williams, a Black worker, had been shot during the march, but reportedly did not seek treatment out of fear, and died a week later.[130] Joseph Billups took charge of planning William's funeral, but could not find a cemetery that would accept the body, which Billups attributed to Ford's influence. Finally, after two weeks, as a large sympathetic crowd made its way with picks and shovels to a local cemetery to forcibly bury the body, Billups was told they could take the deceased to get cremated. At the time, officials would not allow anyone to witness the cremation, saying they would shoot anyone who entered the building. However, Rose Billups entered with three other men to witness the cremation, and made arrangements to have the ashes sprinkled over the River Rouge Plant.[131] Years later, Rose acknowledged that her reckless actions

could easily have resulted in her death, but she attributed her bravery to her youth and commitment to the Black working class. Her heart broke seeing the injustice of a murdered young man who had no place to be buried.[132]

The Billupses' involvement in William's funeral indicated a strong interracial presence and cooperation during and after the march. The drama and the fatal consequences of the march were enough to impress many Black workers to join the radicals' cause. David Moore declared that the Ford Hunger March was "a turning point in my life, the day I was no longer a boy but a man." Black socialist Christopher Alston skipped school and saw his friend George Bussell fall to bullets, leading Alston to become "a confirmed radical."[133] Shelton Tappes slept in too late to attend the march, but noted several Black workers—Paul Kirk, James Anderson, William Nowell, and Veal Clough—soon got involved in the workers' rights movement.[134]

Though the *Chicago Defender* reported no African American women were present at the Ford Hunger March, Mattie Woodson's presence blatantly corrects that statement. Furthermore, Rose Billups's efforts to secure proper arrangements for Curtis Williams after his death demonstrate the levels of Black women's activism. As the Black activists continued pressing for change in Detroit, African American women would find additional ways to contribute and shape their city's future.

BLACK WOMEN ORGANIZE THE AUTOMOBILE INDUSTRY

The Ford Hunger March and the violent response marked a turning point in the automobile industry. While Black Detroiters had long considered Ford a benevolent, paternal, fair employer of thousands of working-class Blacks, the march exposed him as a brutal industrialist who would stop at nothing to shut down radical organizing. With this notion, union activists realized organizing the automobile industry would take more than a handful of workers joining the AWU after a bloody march. Sustained pressure, willingness to compromise, and mass turnout for demonstrations and strikes would soon prove to be necessary, something the AWU and Communist Party alone could not provide. Both the Communist Party and the automobile industry turned away from independent radical union organizing, making an important transition and evolution of organizing in Detroit. As the party entered the Popular Front era and the Congress of Industrial Organizations gained momentum, the foundation that Black women in the UC and the AWU had built became essential.

More than anything, the Briggs Plant strike represented the coming together of the TUUL and mainstream unions in the automobile industry. In January 1933, the Auto Workers Union, the ILD, and the Unemployed Councils joined mainstream labor organizers like the Detroit Federation of Labor as well as radical groups like the Industrial Workers of the World and the Socialist Party to organize a strike at the Briggs Plant. As one worker recalled, "Every shade of radical of every possible opinion was there."[135] Women responded in good numbers, often leading demonstrations and the picket lines.[136] Pamphlets and leaflets distributed to advertise the strike consistently mentioned issues regarding children, hunger, evictions, and others that would appeal to women.[137] Ultimately, the strikers won most of their demands, and the AWU claimed a great victory.[138]

Like the Briggs strike, other strikes in the early 1930s prompted actors besides radicals to step forward and develop more mainstream unions.[139] As these more moderate leaders took control of the union movement in the automobile industry, the Communists and the leftist AWU were pushed aside. Mainstream labor organizations that supported African American workers influenced workers, both Black and white, to leave the radical AWU. In 1934, there were only 274 AWU members in Detroit, down from three thousand in 1926.[140] In 1935, the United Automobile Workers Union formed under the Congress of Industrial Organizations, later the Committee of Industrial Organizations, effectively ending the AWU's reign.[141] Yet the AWU's influence endured, as the UAW, like the AWU, welcomed African American workers and women, albeit with varying levels of enthusiasm.[142] The fledgling union placed Blacks in leadership roles: for example, Christopher Alston and Joseph Billups went on to be UAW organizers, and in 1941 Shelton Tappes was voted recording secretary of Local 600, the UAW's largest local.[143] These men were all involved in the Unemployed Council's neighborhood organizing, and with that radical influence, sought to turn the UAW into an organization by and for African American workers.

Though the AWU's waning influence marked a change in labor organizing in the auto industry, it did not signal an end to Black women's activism. Rose Billups played a key role in supporting the activities of the fledgling UAW. She organized and headed the Women's Auxiliary of Local 600, but in the beginning faced the daunting task of convincing African Americans the union was in their best interests. Many Black women were afraid their husbands would lose their jobs for joining a union, a justified fear considering the automobile industry's efforts to resist labor organizing throughout the 1920s and early

1930s. Rose would have to go and speak individually to the women, explaining that the women should "lose their fear." She explained to them that the union provided for the families of the unemployed workers. This idea of unemployment assistance harkened back to radicals' conversations in Grand Circus Park regarding unemployment insurance. Rose's experiences with the UC trained her in how to connect community members with labor organizers, advancing from bean soup to workers' rights. The success of Auxiliary 600 depended on her boldness and bravery stemming from her earlier years of community organizing. Unions were still held as suspect and organizers often faced dangers. As a result, Rose would meet Black women and men in saloons and back alleys to avoid drawing attention. Her efforts with the women's auxiliary paid off; she brought in many Black women, who, in turn, recruited their friends. Union management often laughed in disbelief and admiration that she could bring in so many new members. After one strike, she received a big button reading "Volunteer Organizer." And though her work existed outside the factories, she still considered herself a Ford worker.[144] The role she performed as a recruiter and supporter ensured the legacy of the UC and the AWU would live on in the UAW.[145]

The extent to which the AWU and the UC established a foundation for the rise of the UAW can never be fully measured. The influence the radicals had in the early 1930s outlasted the union. As Black autoworker Frank Marquart argued, "The radical movement helped prepare the minds of people for the industrial unionism because they constantly hammered on that theme for years. I would say that the radicals did more than any other group to put forth the idea of equality between the races in the union.[146] The hearts and minds of Black workers could only be won after significant work performed by individuals, something David Moore recognized in 2007: "Bill McKie, Nelson Davis, Veal Clough . . . Mattie Woodson, all those men and women, Black and white. Not only were they among those who took part in the Unemployed Councils and the march on Ford, but they were instrumental in starting the trade union movement here in Detroit . . . "[147]

In 1941, the Ford Motor Company recognized the United Automobile Workers union, representing a huge victory for working-class Detroiters. By then, most Black churches in Detroit supported unionization, and as the war demanded more workers, African Americans began to enter the automobile industry with significant, yet also limited, gains. The role Black women such as Rose Billups played has often been marginalized; yet it was Rose's years of work

as a community organizer and ally with UC that helped pave the way for the Black community's acceptance of the UAW. For Rose, "the union gave human dignity," something she had been fighting for since rallies in Grand Circus Park. For Rose, allying with the CPUSA or the UC or the UAW did not define her actions, but informed her understanding of Midwestern Black radicalism.

Though 1930s "Black Detroit" is often synonymous with Black men and the automobile industry, the women documented here challenge that popular understanding. Rose Billups, Mattie Woodson, Mary Sidney, Renelda Gumbs, and the woman identified only as "Louise" showed remarkable strength in reshaping the traditional norms of Black women's respectability. The waning popularity of the UNIA and the NOI in the Motor City in the 1930s helped these women and their Black male counterparts transition into a period where they could assert their rights as working-class African Americans. Though the Communist Party provided publications and meetings for these women's voices to be heard, women like Rose Billups shouldered their way through the racism and sexism of the time to pursue higher standards for themselves and their families. As a "one industry town" controlled largely by Henry Ford, Rose and her associates confronted challenges no other organizers in the Midwest faced. Ford, however, was no match for the diligent work of Black women involved in party activities, the AWU, and the Unemployed Councils.

CHAPTER 2

"Why Can't We Get a Living Wage": Community and Labor Organizing in St. Louis

I n many ways, Carrie Smith was a typical middle-aged Black woman living in a Midwestern city. Every Sunday, she walked the several blocks from the home she rented close to Downtown St. Louis to Central Baptist Church to hear Rev. George E. Stevens lead services. She had moved to St. Louis in the early years of the Great Migration and was devoted to her St. Louis community and neighborhood, active in her church, and was a member of a local fraternal organization. At age forty-two, she had worked for the same company for eighteen years and considered herself a highly skilled worker.[1] It may have come as a surprise to her friends and family, then, when Smith joined forces with local white Communists to plan and execute a strike in the Funsten Nut Factories. She negotiated with the mayor, organized picket lines, published journal articles, and lead protest rallies, activities that had mostly been off-limits for African American working-class women like Carrie Smith. However, building upon radical traditions in her community and Black women's activism, her lived experiences, and her faith, Smith established a place for a religious, middle-aged woman in the working-class struggle. Together with hundreds of other Black women in her company, Smith successfully conducted one of St. Louis's greatest labor strikes. Though Communists helped organize the strike and ultimately claimed credit for the victory, the Funsten Nut Pickers' Strike was not a strictly Communist Party affair. The striking women made this clear as they brought Bibles to the picket lines and said a prayer before meetings. In bringing their children and families to protests, involving the community, and taking a militant pro-union stance, women like Carrie Smith showed how intersecting identities informed their activism. This key moment of Black unrest shaped a legacy of Midwestern Black activism in St. Louis, creating a tradition that would long outlast the Great Depression.

While Carrie Smith shared many characteristics with thousands of other African American women in the Gateway City, her commitment to her fellow strikers in the summer of 1933 distinguished her; she was visible, militant—a unique leader in her community. Many women joined in her struggle, with less visibility, but with no less dedication to the struggle. These experiences, often untold and undocumented, mirror those of women in other Midwestern cities. The Midwestern Black radicalism St. Louis saw during the 1930s, then, represents the full spectrum of Black women's involvement. Labor, community, and neighborhood organizing and engagement with civic and religious leaders all contributed to a lasting sense of Black radicalism and Black women's empowerment specifically in what some called the "Gateway City."

Until only recently, St. Louis had mostly been ignored in racial histories.[2] As a border city, St. Louis did not seem to fit into studies of either Southern or Northern racial struggles. The city is referred to as the "Northernmost Southern City" or a "Northern city with southern exposure." Labor, Communist, and African American historians tend to overlook the struggles that took place in the Gateway City, instead focusing on more labor-heavy cities such as Detroit and Chicago. Historian Walter Johnson, in his recent *Broken Heart of America*, writes that "historians have traditionally treated St. Louis as a representative city, a city that is, at once, east and west, north and south." However, St. Louis is not an outlier in Midwestern Black history, but indication of the power of the radicalism in the heartland. Johnson claims St. Louis has been the "crucible of American history," a notion that played out with the Black radical activism of the 1930s.[3] St. Louis was a hotbed for labor and community organizing, and though the city's organizers started late compared to others, Black women in the Gateway City quickly became Midwestern Black radicalism's most ardent supporters. The legacy of Carrie Smith and her colleagues is part of a longer story that is only just now being told.

BLACK ST. LOUIS

Geography and social history placed St. Louis squarely in the middle of the Yankee North and the Jim Crow South. The 1820 Missouri Compromise legalized slavery in the state; however, the traditions and plantation-style living of the antebellum South never quite developed in St. Louis, which, with a large German population, tended to be abolitionist. Because of its mixed racial history, the city entered the twentieth century similar to other border

city communities, with unequal application of racial segregation. The city was the last stop on the railroad before entering the South, and in St. Louis conductors changed signs on the train cars to designate "Colored" and "White" sections.[4] The nonsegregated streetcars, though, were the only element that separated St. Louis from a typical Southern town, and while there were no official segregation laws, St. Louis hospitals, theaters, restaurants, hotels, public swimming pools, sports venues, hotels, theaters, churches, restaurants, and hospitals practiced de facto segregation. Further complicating the city's racial makeup, the Missouri constitution prohibited interracial marriage. At their best, race relations in the Gateway City were complicated and confusing; at worst, they were explosive and deadly.

Black St. Louisans of all classes, ages, and gender endured the convoluted de facto and de jure segregation. Reba Mosby was a young girl in 1919, but her age did not exclude her from the city's rampant racism. In riding one of the city's first buses, she had taken the front seat, knowing that she was legally allowed to sit anywhere. When the bus driver asked her to sit in the back, she refused, and he grew "livid." However, the ten-year-old remained seated, and "rode all the way from downtown to 5800 West" without changing seats.[5] Her defiance angered the white driver; however, her age prevented her from any further trouble. Mosby's resistance predated Rosa Parks's by thirty-five years, and showed how segregated public transportation was not limited to the Jim Crow South. Even though she escaped any negative physical consequences, Mosby remembered that incident for her entire life. It was no wonder, then, that some leaders in the African American community called St. Louis "a big southern town.[6]

Though there was no denying the city's racist characteristics, St. Louis still drew Southern Blacks with promises of improved race relations. Sidney Redmond, after receiving his law degree from Harvard College and practicing for a few years in Mississippi, made the conscious decision to move north to St. Louis. According to Redmond, "The opportunities in St. Louis were greater than they were [in Mississippi] . . . It was unheard of to have a Negro on any jury in Mississippi in that day." Redmond acknowledged the racial discrimination even he, as a professional, experienced in the Midwestern city, but for him and thousands of other African Americans, St. Louis was "a tremendous improvement" over Mississippi.[7]

Redmond was not the only Black Southerner who sought sanctuary in St. Louis prior to the Great Depression. Professional jobs, though, were rare, and

the majority of Southern migrants moved to the city for work in light and heavy industry. Situated at the confluence of the Missouri and Mississippi Rivers, St. Louis had been an important trade center in the nineteenth century and became a bustling commercial economy during the turn of the century. By the 1920s, the city offered employment opportunities for African Americans in food processing plants, clothing and textile manufacturing, iron and steel production, and electrical work. Tales of economic prosperity and a flourishing Black community continued to draw migrants from the South. From 1910 to 1920, the percentage of African Americans in St. Louis had doubled, and by 1930, Blacks outnumbered foreign-born whites in the Gateway City, at 11.5 percent and 9.8 percent of the total respectively.[8] By 1940, roughly thirty-eight thousand African Americans had moved to St. Louis during the Great Migration.[9] While not as numerous as other Midwestern cities, the influx of African Americans during this period significantly shaped the Gateway City and surrounding areas.

Black women in St. Louis—like hundreds of thousands of other African American women during this period—were mostly limited to domestic and personal service. By 1930, nearly 80 percent of Black women in the labor force were employed in domestic work. The work was mostly steady and available, as a woman's marital status did not restrict her from working in others' homes. In addition, working-class women, single or family providers, often needed work. Ira Reid from the National Urban league reported, "Neither maidenhood, wifehood, nor the widow's weed tend to eliminate for her the necessity of work."[10] Though domestic service made up the majority of Black women in the labor force, St. Louis's reliance on light industry—such as food processing—attracted a large female workforce. Charleszetta Waddles was born in the city in 1912, and, at age thirteen, went to work at a rag factory on Twenty-Second Street. The work was not easy; Waddles joined the ranks of young and old African American women working long hours to sort, process, and organize fabric scraps on an industrial scale. The factories also employed white women, mostly immigrants, but the Black women habitually worked longer hours for meager pay in the most undesirable jobs. Due to the necessity of her working, Waddles "didn't get a chance . . . to be a little girl too much."[11] Her story was not unique; thousands of children, unable to afford the privilege of education, found themselves growing up rather quickly. St. Louis, whether through light industry or domestic work, offered hope for many Black migrants, albeit in limited ways.

As in other Midwestern cities, recent migrants found their housing options limited, and 90 percent of African Americans settled in the Black-dominated neighborhoods of Beaumont, Garfield, Mill Creek Valley, as well as in the downtown area and across the Mississippi River in East St. Louis.[12] In the early stages of the Great Migration, when social custom was not enough to enforce racial segregation, white St. Louisans sought to legalize housing segregation in a 1916 special election. Passing three to one, the racial segregation ordinance made it illegal for Blacks to move into a majority white residential area, in the "best interest of both races." The local branch of the NAACP, Black ministers, and the Black newspaper the *St. Louis Argus* rallied the Black community to oppose it. Rev. George E. Stevens had led the opposition, even hosting several public meetings at Central Baptist Church. Stevens and other leaders of the Black community were vindicated when, in 1917, the United States Supreme Court deemed racial segregation ordinances unconstitutional in *Charles Buchanan v. William Warley*.[13] However, the racial animosity that led to the ordinance's passage endured and St. Louis remained one of the most racially segregated cities in the United States.[14]

Blacks and whites in St. Louis experienced social and racial strain, regardless of physical segregation. Across the Mississippi River was the historically Black community of East St. Louis, Illinois, where racial tensions erupted in July 1917. The 1917 race riot in East St. Louis exposed the area's race relations for what they really were: Jim Crow hostility in a Midwestern city. The two days of anti-Black violence, perpetrated by white men and women, left dozens of African Americans dead, hundreds injured, and three million dollars of property damage. Called everything from "civil unrest" to "a massacre" and even "ethnic cleansing," the riot was the culmination of decades of racial animosity that could not be easily erased.[15] Though the rioting had taken place in Illinois (just east of the Missouri state line), the aftershocks quickly reverberated west across the Mississippi River. As thousands of Blacks fled East St. Louis, they took up residence on the Missouri side of the river and only returned east for work.[16] Ironically, segregated St. Louis, Missouri, became a sort of asylum for those made homeless by the riot. Mayor Henry Kiel rented all available public places and set up beds for the dislocated African Americans.[17] While the city continued to be a "northern city with southern exposure," Black residents continued to make the city their home in hopes of a better future.[18]

The 1917 East St. Louis riot and the "Red Summer" of 1919 marked a crisis and opportunity as the "New Negro Movement" emerged. Urban Blacks

flocked to the Universal Negro Improvement Association, attracted by Garvey's speeches on Black self-determination, racial unity, and pan-Africanism. In December 1916, in his first tour of the United States, Garvey visited St. Louis for about a week. He spoke at St. Paul's AME Church and Central Baptist Church, churches with a history of challenging racism and white supremacy. His addresses were deemed "most interesting," however St. Louisans did not immediately flock to the UNIA.[19] It was not until 1921, when, J. D. Brooks, secretary general of the UNIA, spoke to a large crowd at the Pythian Hall to explain the global Garvey movement that the organization gained momentum in St. Louis. Brooks appealed to the crowd, explaining the benefits of the UNIA and that it was not just a "West Indies Movement."[20] He stressed that the UNIA had significance for Blacks at home, even in the Midwest. At first hesitant, Black St. Louisans responded slowly to the movement, but participation grew steadily during the spring of 1921.[21] An April meeting brought in eighteen hundred people, and, according to the city's leading Black newspaper the *St. Louis Argus*, the "spirit of the Negroes in St. Louis [is] turned towards the Universal Negro Improvement Association."[22] With weekly meetings held in Pythian Hall, Douglas Hall, and the First Free Baptist Church, the St. Louis division of the UNIA began to establish itself as an important force in the city's Black neighborhoods.

UNIA members in St. Louis, however, faced intense discrimination and violence. The *St. Louis Argus* announced in May 1921 that "certain secret forces and organizations are making attempt to destroy or disrupt the Universal Negro Improvement Association in St. Louis" and warned members against outside agitators.[23] After this warning was issued, the *St. Louis Argus* ceased to announce Garveyite meetings in the city, however the movement continued to grow. Garvey returned in March 1922 and October 1924 to large crowds, and the presence of Garveyites in the city remained, though the exact number of members was disputed. Local division president W. R. Wheat claimed membership exceeded 2000, yet federal surveillance agents thought that was a "gross exaggeration" and estimated no more than 400 UNIA members in St. Louis in 1922.[24] Four years later, in campaigning for the longevity of the movement, William Sherrill, vice president of the national UNIA, drew over 800 people in total for two mass meetings, and the *St. Louis Post-Dispatch* claimed the St. Louis division's membership was 3500.[25] Meetings continued for the next few years, and in 1927 the city hosted a regional UNIA convention. At the meeting, local Garveyites committed themselves to a "Negro Bill of

Rights," which included anti-lynching measures and the promotion of Black self-determination and an end to segregation.[26] The convention marked a high point for UNIA members in St. Louis, though it was marred by Garvey's deportation only a few months later.

The Garveyite movement was well-known for its inclusion of and opportunities for Black women, and the St. Louis division was no different. While national female leader Henrietta Vinton Davis made frequent trips to the Gateway City, local Black women also served in leadership capacities, albeit secondary to men. Early female presidents Mrs. B. Venerage and Mrs. Harding often conducted meetings and addressed large crowds highlighting the roles of women in the UNIA. The nurses of the Black Cross in the city were particularly effective, as they had joined forces with the East St. Louis division.[27] The women trained in first aid and taught basic emergency medical treatment, including wrapping sprained wrists and ankles, applying bandages to wounds, and treating other minor injuries. As well, the women provided health education to Black communities and were instrumental in raising donations from social activities.[28] Their actions, like those of other African American women involved in the UNIA around the world, both accepted and challenged traditionally feminine roles. One St. Louis woman recommended that there should be more female leadership and autonomy in the organization. Victoria Wallace Turner was a leading figure in the area, serving as representative at the 1922 national convention in Harlem and then as spokesperson for the female delegates. In her role as spokesperson, she submitted a five-point resolution to be adopted by the UNIA, which demanded women be able to play important roles to "help refine and mold public sentiment." She emphasized that a woman should lead the Black Cross Nurses and have "absolute control over the women" and that more women should be on organizational committees. Her resolutions were met with resounding agreement among the other women in the room. While Marcus Garvey did not see any need for all the resolutions, he did accept a modified version of two of them. Ultimately, no immediate organizational changes came from Turner's 1922 resolution, and men and women continued to have "separate tasks and unequal power" in the organization.[29] However, Turner returned to St. Louis energized, eager to rally men and women, saying: "Although we are small in number we are growing and hope soon to have reached the heart of every man and woman in our city. All of our meetings are wonderful demonstrations of the unity of spirit."[30]

One particular meeting in 1931 drew members from Kansas City and East St. Louis to welcome Madam Maymie De Mena—reportedly a "re union of one happy family of Garveyites." Lillie Waterford said that it was "indeed like the old days" and that Madam De Mena "has made St. Louis become awakened." This meeting, though, proved to be the last hurrah of a dying organization in the Gateway City, as it was apparent that the efforts of the St. Louis Garveyites to bring in official members were failing. Monthly reports showed only single-digit recruitment, and reports in the UNIA's national newspaper the *Negro World* from the city's divisions were rare after 1932. The city's divisions' decline reflected a national trend, as Garvey's deportation and the Great Depression caused Garveyites to resort to other organizations to channel their racial pride and struggle against white supremacy.[31]

One movement that could potentially fill the void left by the UNIA was the American Negro Labor Congress (ANLC). Formed in 1925, the ANLC was decidedly Communist, though it was advertised as a broad-based coalition committed to addressing lynching, segregation, police brutality, and issues pertaining to the Black working class.[32] For the most part, the national UNIA leadership did not support the ANLC, specifically its Communist ties. A *Negro World* editorial commented, "Far be it from us to decry or underrate any movement which promises to benefit the American Negro . . . but we do not believe we have any such promise in the Russian Soviet Communistic movement."[33] For the most part, the UNIA and *Negro World* leadership was correct; the strict adherence to Communist doctrine severely limited the ANLC's appeal. By 1929, the ANLC was struggling and had only limited success in rallying workers from the rural South. The congress met in St. Louis for the 1930 national convention, attracting a few former Garveyites in the area looking to fight against racial injustice. Likely, the organization met in St. Louis as a middle ground, geographically and politically, for the purpose of establishing renewed regional activism. To show commitment to the Black working class, the meeting took place in November at the United Brothers of Friendship Hall in Mill Creek Valley, a Black neighborhood.[34] In alignment with Third Period politics, and in an effort to appeal to a wider base, the organization changed its name during the 1930 convention to the League of Struggle for Negro Rights (LSNR).[35] The revamped organization's platform included additional efforts to fight lynching, support Black self-determination in the South, and promote white and Black solidarity. In many ways, the platform mirrored the rhetoric of the city's UNIA

convention from 1927: a proposed Negro Bill of Rights, self-determination, and an end to segregation and racial violence. The ideological overlap with the UNIA demonstrated Communists' desire to become "heir to the UNIA," as Robin D. G. Kelley writes.[36] Though national Garveyite leadership was still very skeptical of any Communist interventions, local former UNIA members accepted this ideological olive branch. Prior to any Communist actions, they had discussed a proposed Negro Bill of Rights and UNIA officials even urged the creation of an interracial committee in the city, sparked by the violence of the Tulsa Race Riot.[37] As the UNIA faded in organizational influence during the Depression, Garveyite values remained alive in the ideological practices of the LSNR.

Women found a home in the new LSNR. While Black women were only eight out of the 120 delegates at the 1930 convention, they made their presence known. One reporter noted, "What they lacked in numbers was more than made up by the militant and fighting spirit which they displayed."[38] The LSNR itself provided ample opportunities for Black women to become involved and lead radical activities. As they traveled across the country, the Scottsboro Mothers addressed issues that had deeply affected them as working-class Black women. In Midwestern cities like St. Louis, the LSNR continuously promoted Black radical ideology with their presence at mass meetings and rallies. The neighborhood networks established by the UNIA movement had readied Black populations to turn toward nontraditional community leaders to address immediate woes and establish a longer vision of working class justice. As a new organization with new vigor and life, the LSNR was poised to confront whatever challenges the new decade presented.

The Great Depression in the Gateway City

When the stock market crashed, Black St. Louisans were hit hard. The Depression disproportionately affected working-class African Americans, which left local relief organizations strapped. Quality employment was difficult to find and secure. In 1930, 9.8 percent of the St. Louis workforce was unemployed: 8.4 percent of white workers and 13.2 percent of Black workers. One year later, the rate rose to 21.5 percent for whites and 42.8 percent for Blacks. St. Louis's relief system was one of the worst in the country, spending less per capita, assisting fewer people, and operating with 38 percent less relief money than any other city of similar size.[39] Privately run and organized, St. Louis's relief system simply could not keep up with the demand the Depression had created.

African Americans were hardest hit, with 75 percent of those seeking work identified as unemployed or underemployed.[40] Black families found ways to cope, either living three to five families per house or splitting up the family while the breadwinner pursued any employment opportunity. Lack of food, clothing, and medical care defined the lives of many working-class Blacks in St. Louis. In cramped houses and neighborhoods with minimal modern facilities, diseases ran rampant. Forty-one percent of people who died from tuberculosis in St. Louis in 1931 were Black, with young Black women the most vulnerable.[41] Due to the white middle and upper class's economic woes, Black domestic workers often found themselves completely out of work, or only employed part-time. The once consistent work of domestic service in the city deteriorated into exploited labor, poor working conditions, and starvation wages. Those women who worked in industry found their situation no better. The thousands of African American workers employed in light industry saw their employment rates, wages, and working conditions plummet. Even if there was a call for female workers, Black women were hesitant to apply, as industries such as the nut, rag, and paper factories were known for unsanitary conditions and prevalent sickness. In 1929, a nut-picking facility called for twenty to thirty new workers several times, however, not one woman responded.[42] This action, or inaction, demonstrated that even without any sort of Black labor organizing power, African American women found ways to defend their human rights.

St. Louis's Urban League workers did not seek to harness this courage in the face of workers' exploitation and continued to attempt to place women in the factories when able. Since 1918, the St. Louis Urban League had been assisting urban African Americans in finding employment. When the Depression hit, the league found itself swamped with requests for job placements. Migrants from Mississippi, Tennessee, Arkansas, Illinois, and other parts of Missouri all sought aid in the form of employment. Requests for jobs unsurprisingly outnumbered available positions. In November 1931, the industrial secretary reported that the league was only able to place one out of every eight male applicants in jobs, and one out of every three female applicants.[43] This trend continued, and in April 1933 alone, 905 applicants requested work; a total of 155, the highest in months, found jobs.[44] Even if applicants were lucky enough to find work, they still endured low wages, between one and five dollars for a week's work. Despite its best efforts, the Urban League in St. Louis was simply not equipped to deal with the massive numbers of unemployed African Americans.

Despite their struggles, working-class African Americans in St. Louis did not immediately turn to more radical avenues. Though UNIA meetings of the 1920s had once attracted thousands of audience members, movements for racial solidarity had largely declined without sustained organizational presence. The LSNR, while still active nationally, had mostly left St. Louis behind after the 1930 convention. While Communists in other Midwestern cities had previously made inroads with the Black community through TUUL unions prior to the Great Depression, most Blacks in St. Louis had never heard of the Communist Party in 1930. Although the working class in St. Louis had experienced widespread suffering analogous to Chicago, Detroit, and Cleveland, the Communists, by their own admittance, had long ignored the city. Bill Gebert, district organizer in Illinois and Missouri admitted the party "looked upon St. Louis as if nothing happened there, despite the misery and starvation of 100,000 Negro population, Jim Crow-ism, and segregation." The lack of a strong party presence was due to the misperception that "you can have struggles in Chicago, but not in St. Louis."[45] The perceived antiradicalism and Southern social characteristics of St. Louis were enough of an excuse for Communist leaders to ignore the city, even though there was the "burning issue" of race.[46] Unlike Chicago or Detroit, St. Louis industries held no tradition of radical history or progressive union activism, and the local American Federation of Labor (AFL) excluded Blacks.[47] Race relations were tense and complicated, as the 1917 East St. Louis riots showed. White St. Louis Communists had their own racial prejudices. Even though St. Louis party headquarters was located at 1243 Garrison, in the heart of a Black neighborhood, it had not been used as a rallying center for Blacks. On the contrary, certain members were worried that hosting meetings for Black workers would decrease the value of their property.[48] The racial prejudices of the "Northernmost Southern city" took precedence over interracial solidarity in the early days of the Depression. By late 1929, there were still no African Americans in the party in St. Louis.[49] Any radical interracial organizing would require fundamental changes in thinking about race, class, and gender in the city.

The Gateway City offered many inescapable examples of the specific issues African Americans faced. As the Depression worsened and more workers lost jobs, evictions in Black communities were common. In less than two years, there were six publicized anti-eviction protests in the city, all beginning in the fall of 1930 when a landlord attempted to evict a Black resident for not paying rent. The mostly white Unemployed Council members sensed the opportunity

to help these families as well as attract more Black St. Louisans to the unemployed movement. The majority of the tenants who faced eviction were Black women, single providers who could not afford rent. In November 1930, tenant Asia Simon, a migrant from Arkansas and $25 overdue on her rent, was "submitting quietly" to local law enforcement until around twenty men and women, Black and white, "swooped down upon the movers, grabbing the furniture from them."[50] Their efforts paid off, and Simon and her family returned to their home. Records do not indicate whether Simon was impressed enough to join her local UC, but after this anti-eviction protest, Black involvement in the UC began to increase. Another anti-eviction protest less than a month later involved several African Americans, and resulted in ten arrests.[51] Six Black men were arrested, but their charges were later dropped by the judge who advised the men to "keep away from the other members of the UCs" and "keep out of trouble."[52] Many in these Black communities saw the UC's efforts and, even if they did not officially join, began to ally themselves with the unemployed activists.

Once concerted efforts were under way to address the needs of Black communities, interracial solidarity, a defining characteristic of the UC across the country, began to thrive in St. Louis. However, African American and white workers did not always share the same experiences in the struggle. In the middle of the winter of 1931, twenty-four-year-old Florida Williams, an African American woman, joined nineteen-year-old white activist Sonia Mason in preventing an eviction. While Mason was an avowed Communist, young, and unmarried, Williams, a homemaker and politically unaffiliated, was married to a laborer at an electric company and had a nine-year-old child at home.[53] Williams's involvement in the incident threated her husband's employment, a factor Mason did not need to consider. Both young women were charged with "disturbing the peace," charges that were later dropped.[54] Overall, the St. Louis judicial system showed greater leniency toward Black men and women arrested in these protests. Even repeat offenders were dismissed with warnings to stay away from trouble. The presumption, for most white elites in the city, was that African Americans were being misled by the Communists and were therefore victims themselves. White men and women were considered the instigators and those who had the most interest in protesting. White protesters usually faced conviction, and paid fines or served time in the workhouses if they could not afford the twenty-five-dollar or fifty-dollar fine. Among recurring white protesters were local Communist leader John Peer and a group of young white women who repeatedly challenged authority. Ethel Barron, Yetta Becker, and

Ethel Stevens were labeled "girl agitators" by the *Post-Dispatch*. "We are just like the other workers, white and Negro," they said. "[We're] fighting to put the Government in the hands of the workers instead of the capitalists."[55] Absent from the news coverage of the anti-eviction protests are the roles and agency of Black women. Florida Williams risked her livelihood and her family's reputation by participating in an anti-eviction protest; yet her courage and sacrifices went unnoticed.

African American women, however, were not invisible, nor always "submitting quietly" in the struggles against evictions, unemployment, and hunger in the early years of the Great Depression in St. Louis. Lizzie Jones, a forty-four-year old African American housewife, physically fought police officers who arrested her in a 1931 protest march on city hall. A crowd of around a thousand marchers, mostly African Americans, had descended on city hall with signs bearing slogans such as "The Unemployed Demand Free Rent-Stop Evictions" and "Give Charity Garbage to Pigs—We Want Food." A small portion of the crowd, Jones included, made its way into city hall, where they encountered a wall of police who told them to immediately disperse. Jones turned to leave, but two officers grabbed her. "I thought they were going to throw me over the railing," she said. "So I fought." She beat the police officers with her fists and kicked to free herself, to no avail. Her actions of self-defense landed her in a police car, but, like the many other Black women protesters in St. Louis, she was not charged.[56] Jones had not entered the protest as a member of the Communist Party or Unemployed Councils. She went to city hall because she had heard there was going to be someone "speaking about a job."[57] She had traditionally been a homemaker as her husband brought home wages as a worker for a railroad company. However, the woes of the Great Depression had driven Jones out of her home and comfort zone to seek work, and ultimately landed her in jail.[58] Her experience was transformative, and Jones continued to be active in various unemployed and labor movements. In direct contrast to mainstream media's portrayal of these protests, Jones was a Black woman who took on an active role, though not affiliated with a radical group at the time. The brutality she experienced ultimately provoked her to pursue a successful radical organizing career.

After the 1931 march, the popularity of the UC in St. Louis began to grow. Hershel Walker, a Black migrant from Arkansas, was in the city only two months before he joined his local council. He commented that, during this time. because unemployment was consistently rising, the movement "was building

itself pretty strong."[59] One year later, Blacks and whites united again in a 1932 protest-turned-riot at city hall. A crowd made up of an estimated 1500 to 3000 equal parts Black and white participants, marched to city hall to address the Board of Alderman. After being rejected and hearing some three hours' worth of speeches, some of the more radical agitators in the crowd began to organize the protesters in a more militant fashion. An unidentified white man ordered women to create the front lines of the group that would now rush the city hall entrance, arguing that the police are less likely to attack women. After some encouragement, around fifty women, mostly Black, made their way to the front. Like African American women involved in anti-eviction protests, their militancy and commitment to the cause carried great risk, and as the crowd began to push, the police released a volley of tear gas bombs. As hundreds of demonstrators fled, some stopped and turned back, throwing whatever bricks, debris, or missiles they could find at the police, who in turned opened fire.[60] Four men were shot and over twenty others injured. Among the wounded was Benjamin Powell, a Black unemployed worker who had attended other Communist meetings. Though he was standing peacefully across the street, he was shot in the abdomen and later died in the hospital.[61] Members of the St. Louis Unemployed Councils also claimed another victim from police violence: forty-eight-year-old Magnolia Boyington, an unemployed Black worker, who attended the rally-turned-riot, was beaten by the police, and passed away almost a month later from injuries related to the attack. UC members publicly condemned St. Louis law enforcement for dealing injuries that ultimately led to her death and organized a mass funeral march to city hall.[62] Boyington, Black and white radicals argued, paid the ultimate price for standing up to capitalist oppression, and for many, she served as a martyr. The publicity of her death marked a turning point for Black women in the movement; they began to be more visible members of radical activities, paving the way for not only participating, but leading, future organizing efforts. Black women's invisibility in St. Louis radical activism began to subside, though the cost of this new attention was high.

The violence did not deter Black St. Louisans, and they began to join the party and radical organizing in larger numbers. By 1934, St. Louis Communists claimed 700 to 850 members, of whom about 150 were African American.[63] The persistent interracial organizing by the UC prompted St. Louisans to consider— if not embrace—radical organizing. The strength behind the UC organizing was emphasizing that community activism was linked with workplace battles.[64]

There were six Unemployed Councils in St. Louis in 1932, including several in African American neighborhoods, active in rallying working-class men and women around issues of unemployment and hunger. Organizer Hershel Walker remembered that everything the UC did, both Blacks and whites attended. He witnessed "Blacks and whites demonstrating together before city hall, going to jail together, and getting food to eat together" in the segregated city.[65] Beyond marches and protests, the UC in St. Louis organized workers' meetings, of which Walker attended a few. According to him, it "wasn't just Marx" they discussed, but any Socialist theoreticians and writers. They were encouraged to express their own opinions and thinking "behind the writings of Marx and others." Both Blacks and whites attended these meetings, and Walker was so impressed, he joined the UC and the Young Communist League.[66]

Walker's account, however, is only one side of the story. Communist agitation among the Black communities could be anything from a minor nuisance or a physical threat to traditional organizations like the Urban League and social welfare offices. During the early 1930s, the St. Louis Urban League's (STUL) opinion of labor organizing was mixed. Though more encouraging of Black unionization efforts than other cities' Urban Leagues and active in demanding Black jobs in public construction projects, secretary John Clark and other leaders were worried that an association with radical labor unions or the Unemployed Councils could indicate an alliance with the Communists.[67] Any seeming connection between the STUL and the Communist Party would threaten the league's ability to appeal to the Black middle and upper class for donations or seek cooperation with white businessowners. When the Urban League sent speakers to various white churches, Lions Clubs, and Rotary Clubs as part of the "Negro Question Hour" in May 1933, Clark made sure to instruct his speakers on the issue of increasing radicalization. Unemployed or underemployed Black workers are especially vulnerable to "radical propaganda" and "unchristian practices," so STUL members must be sympathetic to their "frame[s] of mind." League member Ulysses Donaldson went to Kingshighway Presbyterian Church and reported to Clark that he stressed "some of the potential outcomes of an alliance of discounted Negroes with Communists and other groups of Radicals and so-called Reds." Donaldson took Clark's instructions one step further. "I asserted that this alliance constitutes one of the present perils of the American nation."[68] STUL's anti-Communist attitude meant they mostly avoided participating in unemployment, anti-eviction, or

radical relief activities, thereby limiting their community involvement and causing tension between city relief efforts and the working class.

Inabel Burns Lindsay, an African American social worker, experienced the other side of the Communist-led protests. During the thick of radical agitation, social and welfare workers were routinely harassed and threatened with physical assault by members of the Unemployed Councils. "They marched on welfare offices; they beat up welfare workers; they did everything except tear or burn the buildings down," she remembered in an interview later in her life. Protesters would often fill her office, preventing her from doing any work or even going to the bathroom. One of her workers would announce their presence, "Mrs. Lindsay, the Communists are here! The Communists are here!" Despite their harassment, Lindsay always treated them with respect because she personally witnessed their terrible living conditions and the troubles unemployed workers experienced. Because she was sympathetic, the radicals often invited her to meetings. She remembered one such meeting "down in a slum area in the weirdest kind of barn" where the Communist speakers railed against the relief system. The radicals did not advocate violence or revolution, but simply wanted "to vent their hostility and anger, which they did." Lindsay acknowledged their pain; as a superintendent with very limited funds, she sometimes had to eliminate categories of people who were eligible for relief. "Able-bodied young married people with no children, for example, was the first group we cut off," she recalled. "It was a very painful thing to undergo. Very."[69] Lindsay represented a middle-class level of Black female respectability who worked within the relief and social welfare system to assist needy families while also acknowledging and respecting more radical ways. In attending Communist and UC meetings, where Black and white workers denounced the government and shouted for racial solidarity, Lindsay demonstrated the range of ways Black women responded to the Great Depression. She was not alone; in many Midwestern cities, African American women employed as social workers or relief officers sought ways to meet radicals halfway and form coalitions rather than rifts. These women were not immune to many of the issues Black and white radicals criticized, such as segregation. After her involvement in the welfare office, Lindsay decided to pursue a master's degree in social work. However, at the time, no universities in Missouri would accept African American students.[70] Even Lindsay's adherence to the politics of respectability and working within government systems did not shield her from pervasive racism.

The Funsten Case

Categorically "last hired, first fired," African American women had traditionally sought jobs as domestic workers since factory work could not be relied on. The St. Louis Urban League reported in 1931 that the "bulk of jobs for women and girls calls for domestics." Like other cities, African American women were relegated to household labor. As in other cities, these women began to seek industrial employment opportunities in order to escape the drudgery and exploitation of domestic work. St. Louis's Urban League noted "a gradual increase in types of work for women and girls in other occupations and commercial concerns . . . It is discouraging to note [that] the still larger number of small paying orders calling for women and girls are offering them from $2.00 to $3.00 per week."[71] African American women who sought work in light industry typically pursued employment at downtown's nut, rag, and textile shops. Many of the calls for factory work came from the nut factories, a popular industry in the city. By 1932, St. Louis was recognized as "one of the greatest pecan centers in the world," hosting several large-scale nut shelling facilities, such as the Funsten Nut Company, Liberty Nut Company, American Nut Manufacturing Co., and Central Pecan and Mercantile Company. St. Louis was not the source of the pecans, as the nuts were native to states along the Mississippi River Valley and in the Southwest. Every week, a freight train would arrive in St. Louis, delivering thousands of pounds of pecans still in their shells from Georgia, Texas, Oklahoma, and Louisiana. Once in the St. Louis factories, the majority of the nuts were shelled and sold through retail and commercial outlets.[72] The Funsten Nut Factory was one of the largest commercial outlets in the city, owned and operated by Eugene Funsten, a native of St. Louis. Eugene Funsten came into the nut business through his father, who founded the R. E. Funsten Dried Fruit and Nut Company in 1902.[73] For the first half of the twentieth century, the Funsten Company, along with the San Antonio-based Duerler Nut Company, dominated the pecan-selling industry in the United States.[74] It was also known as a questionable place to work. The company would hire large numbers of untrained Black women workers, in unsanitary factories, where, according to the 1929 STUL report, "the temperatures are such that a large percentage of sickness is present in all."[75] R. E. Funsten had made it clear back in 1916 before the Missouri Senate Commission for Women and Children that he was not concerned for the well-being of his employees. "It is their labor we are after. We have no time to inquire into their mode of living . . . We look only after their

efficiency in the work we want them to do." Although Funsten reiterated the average pay per week was $8.80, a "good many" workers reported earning no more than four dollars a week. These wage rates would plummet after 1929.[76] During a regular season in the 1930s, there were sixteen nut factories active in the St. Louis area. Funsten owned seven of the factories, employing close to three thousand workers.[77] The main plant and office were located on Sixteenth Street and Delmar, where mostly white women worked. Across the river, the East St. Louis plant employed nine hundred female workers, mostly Black. The remaining five factories were scattered in Downtown St. Louis.[78]

Nut picking was a multistep process, where tasks were divided by race and gender. First, the nuts were soaked in water to prevent fracturing and shattering during the unshelling process. The plants employed a small number of African American and white men to weigh and dry the nuts, and then bring twenty-five-pound bags to the women. Sitting at long tables in low lighting, the Black women separated the nut meat from the shells with small knives, placing nut halves in one pile and broken pieces in another. They also saved the shells, so that once they were finished, everything would be weighed again to ensure it added up to twenty-five pounds, proving to the owners that they had not stolen any product. No men were employed as nut pickers, as women were supposedly better suited to the delicate task with their small hands and high dexterity.[79] The work was tedious, and the poor lighting contributed to eyestrain and injuries. On-the-job injuries were common, and the *Post-Dispatch* commented that the Black women's fingers were "scarred by their work."[80] Henrietta Chatman, who was the sole breadwinner for her young grandson, worked at a nut factory on Chouteau Avenue. In her late sixties, she was losing her eyesight and constantly cutting her fingers with the small knife used to pry the nutmeat from the shell. Henrietta had to quit for her own health, and her grandson took over as wage earner. (Chatman's grandson was Henry Jackson, later known as Henry Armstrong, a well-known boxer from St. Louis, whose income source was outside the reach of most Black families.[81])

Working conditions at the factory contributed to long-term respiratory illness due to poor ventilation. Lillian Moisee reported that the nut shells emitted dust in the air and the women were constantly coughing. To ease the cough, the women took to drinking sweetened milk. Josie Moore, who worked in the East St. Louis shop, recalled the poor working conditions and health standards. With no windows, little ventilation, and minimal heat in the winter, Moore remembered how illness was treated. "Oh, it was terrible. I remember a couple

of women taking sick and they told the man, the boss, that they would have to go home. He said, 'Well if you start that going home, you just stay there.'"[82] Due to lack of other employment opportunities, the women were forced to endure the dismal working conditions to provide for their families.

Working conditions for white women at the main plant on Delmar were considerably better. Jennie Buckner, the placement secretary for the St. Louis Urban League noted, "There was a shadow of racism in it too. All the girls in the factory who did the sorting and the weighing at the Delmar plant were white girls and the salesmen and the supervisors were all white while the dirty work was parceled out in the Negro community."[83] Oral histories and newspaper accounts show there was more than just a "shadow" of racial discrimination in Funsten's factories: Funsten employed white women for less hours and more pay and physically separated the white women and Black women. The African American nut pickers worked more than nine hours a day, starting at 6:45AM and ending at 4:45PM, with a forty-five minute lunch break.[84] The white women who worked in the factories, mostly of Polish descent, came in at seven in the morning and left at 4:30PM, and received an hour lunch break.[85] White women performed lighter tasks than the African American women, like sorting and weighing, and worked on different floors. In general, Funsten employers paid white women considerably more than Black women. According to the *Post-Dispatch*, in 1933, African American nut pickers brought home $1.80 a week while white workers received $2.75.[86] Black women received two to three cents per pound of nuts while white women earned four to six cents.[87] Funsten attributed the pay difference to the different grade of nuts, as African American women worked with lower quality nuts and therefore their output was not worth as much. Funsten did not address the dismal working conditions, the racial separation, or why only white women worked with the higher-grade nuts.

For Funsten, the physical separation between the white and Black workers served as a necessary buffer between the two groups. According to African American worker Evelina Ford, "At that time colored folks and white folks didn't agree very much."[88] Ford, like many of her Black co-workers, was a recent migrant from the South.[89] Coming from Mississippi, she likely embodied many of the hopes and dreams of other Black migrants, only to witness St. Louis's racial divide in her workplace. Conflict between Black and white workers was common during this time, as Depression-struck laborers vied for jobs and the ability to feed their families, and Funsten's solution to potential problems was

to prevent workers from mingling. While most of the white women worked in the main plant on Sixteenth and Delmar, some neighborhood factories still employed a small number of white women. In factories where both Black and white women worked, white women usually operated upstairs whereas Black women were designated to the basement with minimal, if any, contact between the groups. Alice Love, a white woman who worked in the factory on Chouteau, did not even realize that African American women worked in the same factory. She only realized she had Black coworkers one day when the plant manager turned on the lights. Through the cracks in the floor, Love could see African American women working in the basement below.[90] The racial tensions St. Louisans experienced outside the nut factory were also present within, fostered by unequal pay and treatment.

The issues festering in the nut factories were not new; the nut companies and other St. Louis industries that employed mostly African American women had practiced racist work and wage policies and poor working conditions for years leading up to the Funsten strike. Before 1930, the nut, rag, and paper factories could not fulfill their needed unskilled labor; due to low wages, unsanitary working conditions, and rampant sickness among workers, "not a single woman would respond to repeated urgent requests to take work there."[91] After the severities of the economic depression set in, women were more likely to seek previously considered undesirable work. The factories, though, could be more selective in their hiring, and Black women were always "last hired, first fired." The November 1932 Urban League report documented that "two nut factories, a leather goods factory will hire no more colored women. Many other such conditions are coming to our attention . . . Reasons given for cutting off Negro help are as follows: too great a turnover, not dependable, inefficient, not intelligent enough, etc."[92] Though the turnover rate seems innocuous enough, the accusations of unreliability, inefficiency, and unintelligence reflected racist stereotypes reminiscent of slavery. Despite these obvious racist tones, the UL continued to exercise caution when it came to Black nut pickers.

The Funsten Nut Company issued five wage cuts from 1931 to 1933.[93] Carrie Smith, a veteran nut picker of eighteen years, had seen her weekly wage plummet. The largest sum she earned for one week's work was eighteen dollars in 1918. By 1933, however, she never made more than four dollars a week.[94] Eugene Funsten argued that such cuts were necessary, and that the company had failed to turn a profit in two years. Nut companies in Texas and other central Southern states were challenging St. Louis's position as the pecan capital of

the country. In less-regulated factories of the South, owners could pay Mexican immigrants and African American workers much less, thereby turning profits that surpassed those accumulated by the Funsten Nut Company's. As a result, Funsten had repeatedly cut wages. "When times were good," he told the *Post-Dispatch*, "we passed a larger share of the earnings along to the workers; now that they are not, we have had to reduce their pay."[95]

The long hours and low pay took a toll on the families of the workers. The women often suffered a double burden as family caretakers as well as providers. Though many of the Funsten workers were young women, a good amount were mothers and sole providers. Cora Lewis, a 43-year-old widow, was the breadwinner for her six children. However, the long hours often left her little time to care for her children. Lewis told the mayor she worked five and a half days a week with low wages and she was unable to support her son. Because the family was desperate, Lewis's son went to find work himself and was subsequently arrested for truancy and sent to the Bell Fountain Reform School.[96] The low wages at Funsten Nut Company prevented Lewis from being at home and being able to provide for her son, and eventually led to the institutionalization of her eleven-year-old son. Though Lewis first identified as a mother, her status at the Funsten factory prevented her from fulfilling this essential role for her son. However, it was not her employment alone that doomed her son to a detention center. Often, advocates of respectability politics blamed the working mother for her child's truancy or misbehavior. The sentiment goes, if the mother was at home giving proper care and attention to her family, the son would not have misbehaved. Yet Lewis rejects that notion; instead, it was Funsten's low, starvation wages that forced her son to find employment. The brutal exploitation of workers in the name of profit created a system in which a young African American boy could not succeed. Historian Keona Ervin argues that Lewis, along with her fellow nut pickers, challenged conventional notions of women's work and responsibility.[97] Their intersecting social identities as workers and mothers complicated the middle-class expectations of a stay-at-home mother. Lewis saw that her roles were intimately intertwined; one influenced the other. In doing so, Lewis and the other Funsten nut pickers crafted a working-class movement that linked fair wages and motherhood, expanding their notion of how Black radicalism could work on this local level.

When conditions for the nut pickers seemed at their nadir, the African American workers received aid from a conspicuous, but unsurprising, source: the local Communist Party. An African American member of the Unemployed

Council, identified in documents only as "C. L.," was aware of the conditions at the Funsten plants, as he had several family members who were employed there.[98] He, along with William Sentner, met with three Black women from the plant in early March 1933 to discuss the possibility of a strike. The women were hesitant; a previously attempted strike in 1927 ended in embarrassment when the striking workers failed to obtain support from fellow workers. The second time, in order to gain the Black women's trust and support, Sentner and C. L. "explained the necessity of unity of Negro and white," Communist leader Ralph Shaw wrote.[99] In addition, Sentner described the ILD's role in the defense of the Scottsboro Boys, a case African Americans in St. Louis were well aware of. Shaw stressed how "the fight was carried for them [the women]," and that with the party's support—in particular the Trade Union Unity League, which specialized in organizing industrial workers—the nut pickers would be able to engage in a successful strike with significant gains.[100] By relating the Communists' involvement in the Scottsboro Boys' defense and TUUL's successes, organizers successfully convinced the first few women to align with the party. After a few home meetings, the number of women interested in striking grew from three to around twenty. When the group reached that size, Shaw and Sentner encouraged the women to discuss demands to bring to Eugene Funsten, organize an executive committee, and recruit women from other nut factories. By the last week of April, the group was so large that they could no longer meet in homes but had to rent a hall.[101]

After the initial meetings, the African American workers assumed leadership from the white Communist leaders. Carrie Smith was a natural leader, with age, experience, and passion on her side. Under her leadership, the group of workers agreed to approach Funsten with a demand to increase wages to ten cents per pound for nut halves and four cents per pound for pieces. Smith coined the phrase "We Demand Ten and Four," which soon became the accepted slogan for the strike. On April 24, 1933, an elected committee of twelve Black spokesmen entered management's office and delivered their demands. The leadership committee informed other workers to stop working, gather around the office to hear the response. Even though Funsten turned the women away and did not answer their demands for weeks, experienced organizer Ralph Shaw declared "everything worked perfectly."[102] Almost one hundred workers stopped their work and supported the committee's action. The initial stages of the strike had been successful and the women successfully demonstrated their abilities to lead and organize.

Carrie Smith took the lead in organizing the Funsten workers under the TUUL's Food Workers' Industrial Union (FWIU). One of the smaller unions of the TUUL, the FWIU nationally had thirty-two hundred members in 1930. Prior to 1933, though, there were no TUUL unions in St. Louis, so the establishment of the FWIU and similar unions in St. Louis faced an uphill battle.[103] Smith's leadership was fundamental to the FWIU's success in the Funsten Factories, as she was an essential connection between the white radicals and the Black working-class neighborhoods. The party in St. Louis had marginalized African Americans, and the Funsten strike was an opportunity to rectify that. For Carrie Smith, allying with the Communist Party was as much a practical move as it was a message to the moderate African American organizations. When the mayor asked her, "Why didn't you get in touch with the Urban League to represent you instead of the Communists?," Smith responded, "The Urban League and all the rest of them knew we were sitting in that sweat shop for nothing. None came to our rescue but the Communist Party and I think that I have just as much right to choose who I want in my council as you have in yours. As for the Communist Party, I was with them."[104] There was certainly some truth in Smith's statement. As early as 1929, the Urban League's Jennie Buckner, reported on the conditions in the nut, rag, and paper factories downtown: "The wages are low, the factories unsanitary as well as the workers and the temperatures are such that a large percentage of sickness is present in all."[105] When Buckner urged the league to help organize rag workers in November 1933, John T. Clark, the executive secretary of the St. Louis Urban League, refused. He wanted the workers to organize independently from any group "so that many of their problems might be settled through their own representatives with their employers."[106] Rather than utilize the league's already scant resources, the executive secretary preferred that industrial workers negotiate workplace issues among themselves. While this would relieve the league from the burden of industrial organizing in the city, it would also exempt the league from any labor agitation mishaps or accusations of turning "red." Though the Urban League hosted meetings in the community about the Funsten strike, the organization was primarily responsible for replacing the strikers, essentially working to undermine the women's efforts.[107] In 1933, the annual report read differently, declaring that the league had an active role in the labor disturbances that year, "especially in the cases of the strikes of the workers in the pecan shelling and waste products industries."[108] The UL did, however, give credit where credit was due: "The series of strikes . . . was traced to radical leadership.

We thank them for this service because they brought forcibly to the public attention the worst type of industrial exploitation."[109]

Smith's experience with the failures of the STUL and other mainstream race organizations mirrored many other Black women's pasts. The *Communist* quoted an unidentified striker who, in answering why she sided with the Communist Party, said, "The Urban League never sticked [sic] with us, nor the Universal Negro Improvement Association nor any other Negro organization or church. The Communist Party is the only one that gave us guidance and leadership. That's why we sticked by the Communist Party."[110] The Urban League's reticence to help organize industrial labors during the early Great Depression significantly hampered their influence on Black working-class women like Smith. And the absence of the UNIA and local church support left the women only one other option: the Communist Party.

In choosing the TUUL, largely controlled by Communists, the St. Louis nut pickers solidified their ties with the Communist Party. In turn, the women received aid from the Communists, such as publicity, funds for flyers and pamphlets, and spaces for meetings. As well, the Communists directly trained many of the women, including Smith and Lewis, to lead the strike. Part of the Communists' strategy of recruiting African Americans to the party included small workshops and classes where party members would educate new recruits on party doctrine, Marxist theory, and how to properly organize and execute a strike. Smith was an excellent organizer, however white party leaders had their doubts about her longevity as a Communist. The party reported many of her fellow strikers believed her to be a part of the Eastern Pacific Movement, a pro-Japanese radical group. "Carry [sic] denies it, but many girls are embittered against her." In addition, Smith had also "raised issues against domination" by the white men in the union. It seemed her leadership was welcomed in the party; her challenge to the hierarchy was not.[111]

Cora Lewis received training from local party leaders as well, and reportedly came through "with flying colors." However, one report lamented "it is too bad that she is old and weak in body." Lewis was forty-three, one year older than Smith. Presumably, the years of industrial labor had taken a toll on the women, making them "old and weak" in the CPUSA's eyes. When Carrie Smith fainted during one meeting with the mayor, the local party leaders' fears were confirmed.[112] Both Smith and Lewis's potential as union organizers and Communists were limited, due to perceived disadvantages of age and health. In making these observations about the Black women leaders, the organizers

revealed that they were searching for a leader for the future. Smith and Lewis, however, were probably doubtful.[113] Smith and Lewis were likely not aware of the party leaders' concerns; even if they were, they intended to prove the white male leadership wrong.

By May 13, Carrie Smith, Cora Lewis, and the rest of the strike committee, made up of mostly African American women organized under the FWIU, were anxious and tired of waiting to hear from Eugene Funsten. They called an open mass meeting and voted that on the following Monday, the original committee would approach Funsten again for an answer, and if their original demands of "ten and four" were not met, they would walk out. In their final meeting before the strike, Smith took a position on the steps in front of city hall, hefted a Bible in one hand and a brick in the other, and forcefully declared, if the workers stick together, "girls, we can't lose!"[114] Her enthusiasm was contagious, and when Funsten refused the nut pickers' demands, on May 15, at 7:30AM, about five hundred women walked out of the Funsten nut factories.[115] Smith entered the shop and shouted the signal, "The heavy stuff's here! Get your hats and coats and let's go!" From there, the workers marched to the Fifteenth Street park, where each factory elected strike representatives, and from there, a General Strike Committee was elected. Under the guidance of the General Strike Committee and Smith as leader, the strike spread to other Funsten factories.[116] The Funsten workers and their allies spread the strike carefully and systematically, just as the party leaders had taught them. Around closing time, a group of fifteen to twenty strikers would appear outside a factory with signs and leaflets and encourage factory workers to join the strike. They recited their demands of "ten and four," recognition of the union, equal wages for African American and white women, and sanitary working conditions. At night, the committees would meet again, this time with the recently recruited workers, and plan factory walkouts and pickets for the next day. When planned correctly, the walkouts attracted 100 percent of the workers, and in the course of eight days, over eighteen hundred workers struck, representing twelve different shops. According to reports, 85 percent were African American women. The involvement of the white workers was mixed. The first day, the white women stayed inside, as they were told the Black women who were leaving were "going on a picnic." It soon became clear to the white women what was going on, and the next morning, many of them joined the strikers, joining hands and marching together.[117] Not all white workers sympathized with the strikers, though. Nora Diamond, a white worker, did not participate because it did not

affect her and was "led by the wrong kind of people, Russians, foreigners."[118] Diamond echoed the sentiments of Funsten and other white elites in the city; despite the evidence that over one thousand Black women marched in picket lines, attended rallies, and demanded a labor union, the presence of white Communists undermined the struggle, and much like early Black radical activities in the city, the roles of Black women went underestimated and minimized.

Though the workers led the walkout, the strike soon became a community affair. Picketing began every morning at five, organized centrally around the main plant on Sixteenth Street and Delmar Blvd, as well as the smaller factories in neighborhoods near the women's homes. The smaller factories were situated at 4241 Easton Avenue, 3404 Walnut Street, 2233 Chouteau Avenue, and 1517 Morgan Avenue., all in the heart of Black neighborhoods.[119] Because the factory locations were close to neighborhoods, husbands, children, neighbors, siblings, and friends often joined the striking women. Cora Lewis reported that "brothers, sisters, daughters, mothers, children, and all went on the picket line." Lewis's children did not even have to be told to join their mother; they assumed it was their duty to support her in the struggle to provide for the family. Lewis proudly declared, "My daughter pickets all the shops in the city."[120] Previously, Lewis's employment at Funsten prevented her from accomplishing her motherly duties of providing for her children. Once she went on strike, her family could join her, and her role as mother and family leader had been reasserted with the additional function of union organizer. Asserting her role as both a worker and a mother, with neither identity having precedence, Lewis reformed expectations of Black women during the era.

That women were the leaders of the movement did not prevent men from accompanying and supporting the women workers on the picket lines. Operating much like the city hall protests in July 1932, women and men walked side by side, asserting and chanting their demands in unison. Often, the working women were joined by their husbands, sometimes as supporters, sometimes as protectors, as there was some inherent danger in protesting. Lewis related the story of how one man said "his wife was earning the living and that she went on strike in order to get higher wages, and that if anyone lays a hand on her, they would never live to see the day thru."[121] Though the men often followed the lead of the working women, they still adhered to traditional gender roles as family protectors.

With the help of the UC and the TUUL, the strike brought together Blacks and whites, men and women, in a solidarity effort never seen before in St. Louis.

The nut pickers' strike attracted considerable attention from the community. Sympathetic Black businesses owners provided food for the strikers, and even the Workers International Relief in Chicago provided relief. Bakers would send second-day bread to the picket lines, and the strikers enjoyed support from the clothing workers and the meat cutters in the city.[122] The General Strike Committee understood that this coalition building was essential to the strike's success, and organized visits to trade unions, fraternal organizations, and churches. Though the Communist Party in the past had condemned middle-class organizations, even they had to praise these efforts. The *Communist* reported, "In short, the strikers surrounded themselves with thousands of workers, employed and unemployed, Negro and white, who supported them; as a result, it was impossible for the city government to defeat the strike."[123] Their efforts were rewarded as a few days after the initial walk-out, workers from another nut company joined in. The majority Black women workers at the Central Pecan and Mercantile Company joined in labor solidarity, soon joined by other food processing plants.[124] By the next day, May 21, only six days after the strike's beginning, the workers at the American Nut Manufacturing Company had joined, and there were eleven factories and almost 2,000 employees involved in the strike.[125]

When hundreds of Black women walked out of the Funsten Nut factories, they left hundreds of jobs open, enticing the city's thousands of unemployed workers. The strikers were ready to discourage strikebreakers, from the very beginning carrying signs reading "We employees of the Funsten nut factories are on strike—please do not take our jobs."[126] The women showed remarkable militancy, preventing law enforcement from breaking the picket line by smashing police cars and attacking taxis carrying strike breakers.[127] After an altercation where strikers threw bricks, bats, and other missiles at police cars carrying the nonunion workers, one hundred women were reportedly arrested. "The women learned quickly how to carry brick sandwiches," commented local Communist leader Ralph Shaw in the national Communist publication *Labor Unity*.[128] Unlike the early years in the Great Depression, the St. Louis Police Department no longer had hesitations about arresting Black women and charging them with criminal behavior. The second day of the strike, eight Black women along with one white man were arrested and charged with inciting a riot.[129] Clearly, African American women involved in radical struggles were beginning to be recognized. Even if this recognition was accompanied by criminal charges, St. Louis African American women found themselves

as active, public agents of Midwestern Black radicalism whereas before they "submitted quietly."

Despite the negative press deriding the violence on the picket lines, Eugene Funsten was stubborn in his negotiations. He closed the nut factories where the majority of the workers had struck, and, as late as May 19, told the African American newspaper, *St. Louis Argus*, that he would only consider raising the wages to five cents per pound for whole nuts. If that was not adequate, he said, "the plants would remain closed."[130] A few days later, with four factories shut down, Funsten changed his tone and agreed to let the mayor of St. Louis, Bernard Dickmann, and his appointed committee handle negotiations of the strike. According to Mayor Dickmann, the city government had a stake in settling the strike, as the picket lines had brought violence to the streets and had begun to attract national attention. As well, the mayor considered the Funsten workers dependents of the state, since "some of the workers employed by the plant were on the charity relief rolls."[131] In actuality, it was far more than "some of the workers": prior to the strike, between 40 and 60 percent of the Funsten employees were on relief.[132] Dickmann's charitable intentions were made public, but his political aspirations were certainly clear. Recently elected mayor—the first democratic mayor in 24 years—Dickmann received formidable support from African American voters. His interest, then, in the Funsten Nut Pickers' strike, served as a savvy political move to endear himself to the African American community.

To influence the mayor's commission, Carrie Smith and Cora Lewis organized a march from Communist headquarters to city hall. The demonstrators marched two miles, carrying signs that read "Animals in the Zoo Are Well Fed While We Starve" and "Fight for the Freedom of Labor- Demand Unemployment Insurance."[133] Mayor Dickmann left his office to address the 450 mostly African American women, who cheered after he declared he wanted to see the workers get just pay. While he made no promises, he assured the women he was on their side. The front page of the *St. Louis Post-Dispatch* featured a photo of the encounter: Mayor Dickmann stands among a sea of Black faces, almost hidden, so editors added a white arrow to point out the politician.[134] After he returned to his office, the demonstration continued, with speeches from workers. Smith was the first, her sentences punctuated with a chorus of "Amens!" from the crowd.[135]

On May 24, Smith, Lewis, and the strikers' committee, with help from the mayor's commission, reached an agreement with the Funsten Nut Company.

Funsten agreed to double the workers' wages, pay African American women and white women equally, and improve overall working conditions. Though Funsten would not officially recognize the FWIU, he would receive complaints from shop committees, thereby allowing unions. In a meeting with strike leaders Smith and Lewis, Mayor Dickmann complimented their "victory without blemish." Smith and Lewis were unconvinced of the mayor's role; Lewis later commented the strikers won not because he inserted himself in negotiations, but because "all of the girls white and colored stuck together and [were] determined to win this strike."[136]

Immediately, the Communist Party touted the strike as a resounding victory, emphasizing the extraordinary dedication of the African American women while at the same time attributing the organizational success to the party. The story the Communists told framed the Nut Pickers' Strike as one that could only be possible with the combined forces of the Communist Party and local African Americans. The strike was mutually beneficial; the Communists hoped to further attract African Americans to the party, thereby building party membership as well as worker solidarity. For their part, certain members of the African American community understood and supported the alliance between the city's "reds" and the Black working class. After all, radicals were the only ones who recognized the city's pervasive racial inequality as related to unemployment and worker exploitation. An editorial in the *Argus* the day after the strike's conclusion praised the work of the Communist Party and their affiliated legal division, the International Labor Defense: "Their insistence on the same pay for the same class of work among the workers, both white and Black, can't but strike a popular chord in the minds of the colored people."[137] The *Argus* did not necessarily support the Communist Party's lofty ideology of working-class solidarity or the proletariat revolution, but the editors could recognize how the Communists' emphasis on equal wages could be immediately beneficial for African American workers.

Yet, the *Argus* and the CPUSA did not agree on everything. During the strike, the party continually disparaged the "demagogy" of Mayor Dickmann and the "reformist Negro politicians."[138] According to the Communist Party, "reformist," or liberal organizations, necessarily sided with Funsten as they both advocated capitalism and an enforced class hierarchy (two ideas vehemently denounced by Communist doctrine). The *Argus* saw the local leadership differently, praising Mayor Dickmann's actions as giving St. Louis African Americans a "new deal." In addition, Dickmann personally spoke to the

strikers, speaking to them in "a humanitarian language." The editorial concluded, "Honestly fellows, this does look like a new deal for the people."[139] By using the term "new deal," the *Argus* editorial staff made the connection between racial reform and democratic leadership, specifically that of the national New Deal programs advanced by President Franklin Roosevelt. Dickmann, a Roosevelt supporter, received the majority of the Black vote in his 1932 election, reflecting the national trend of African Americans moving away from the Republican Party. Through his role as arbiter of the strike and using "humanitarian language," Mayor Dickmann earned the respect of the African American community. Dickmann's re-election a few years later was solidified by the African American vote for the Democratic Party.[140]

The women also complicated the interpretation of the perfect Communist proletariat in their support, reliance, and trust of local government. Carrie Smith emphasized how she and her fellow workers not only needed but deserved living wages. When she addressed the mayor, she "told him that we were working people and couldn't have a decent living out of our work . . . we obeyed the laws of the city and [were] loyal citizens. Why can't we get a living wage?"[141] Smith, a law-abiding, working citizen had paid her dues to the city, and now it was time for the city to reciprocate. For Smith, though the democratic process had failed her in the past, she still identified as an American citizen and demanded a response from her local government. Her interpretation of Midwestern Black radicalism complicated the party's all-out critique of mainstream political parties. The CPUSA saw the African American community's faith in local government as potentially troubling, and even as the strike ended and the workers went back to the factories, the party advocated paying the nut pickers continued attention. The *Communist* urged, "Under no circumstances must we already feel that all the workers in the nut factories have been won ideologically to the extent that no further work is necessary. On the contrary. It is necessary to carry on systematic political work among the workers in the nut factories bringing in all other problems confronting the working-class."[142] Though the nut pickers' demands had been met, they had not yet completely accepted Communist ideology. During strike meetings, the Communists pressed issues relevant to the women, such as Scottsboro and unemployment. At the same time, party leaders discussed the Soviet Union, and compared their policies toward race and class to that of the United States, "showing the revolutionary way out of the economic crisis of capitalism."[143] Though the women had readily accepted the Communists' help in organizing

the nut factories, they were reticent to carry on party politics after the strike. The nut pickers' victory, then, was not complete for the Communist Party. As shown in the national publications, the party considered the Funsten nut pickers' victory only one step in the larger struggle for workers' rights.

Whereas the party emphasized oppression along the lines of class, the nut pickers entered the strike with ideas of how race, gender, and region operated in St. Louis that complicated the monolithic working-class solidarity movement presented by the CPUSA. That she was a mother of six and unable to provide for her family directly influenced Cora Lewis to strike. Communist leaders did not always adequately and appropriately address these issues of motherhood and its role in Black working-class activism. During the 1930s, Communist leaders were inclined to use symbols and rhetoric that romanticized violence and masculinized militancy.[144] Women who participated in the movement were either masculine—such as the nut pickers, celebrated for carrying "brick sandwiches"—or extremely feminine, as seen in the sympathetic, weary strike leaders Smith and Lewis. Their photographs that accompanied their article in *Working Woman* show two African American women, unsmiling, tiredly looking at the camera. Yet Smith and Lewis were not defined by this image of fatigue. Nor were they purely physical fighters. At the time the nut pickers physically and militantly confronted Funsten and his unjust practices, they were still mothers. They brought their children to the picket lines, demanded free food and childcare, and, like Lewis, related stories about their family obligations. These women presented a model of Black radicalism that necessarily incorporated motherhood and womanhood.

At the same time that they were mothers, providers, and citizens, the Funsten Nut Pickers held other personal identities that informed their radicalism and participation in the strike. Both Smith and Lewis identified as religious women, which placed them among the majority of African American women in St. Louis at the time. Smith attended Central Baptist Church weekly, embracing longstanding ideas of Black women's respectable involvement in the Black church. This observance of middle-class respectability politics was troubling for whites in the Communist Party. District Organizer Bill Gebert thought it was "very important to note" that the women were religious and without experience in the working-class movement. Gebert was concerned that the women's religion and lack of organizing experience were linked, and that religion inhibited their pursuit of workers' rights. But instead of religion limiting their experiences in the strike mobilization, the nut pickers embraced elements of

Christianity to inspire them. When the workers initially voted for the strike, Smith led the women in prayer, saying "Oh Lord, give us strength to win our demands. Boss Funsten does not treat us Negro women right. We made the first step, oh Lord, you should make the second step and help us win the strike," to which the crowd responded "amen."[145] Smith encouraged protesters to bring their Bibles to the picket lines, and they often sang hymns while they marched. The nut pickers blended working-class militancy with Christianity in a way that made sense to them as working women in St. Louis. The imagery of Smith carrying a Bible and a brick in her hands illustrated how the strikers utilized their religiosity, militancy, and commitment to workers' rights to gain victory, fashioning an image of respectability all their own.

For Smith, and many other African Americans around the country, her church served as a community center that also provided an activist education. The church she attended weekly, Central Baptist Church, had hosted Marcus Garvey in one of his tours of the city. The church and its pastor, Reverend George Stevens, were known for the activist stance concerning African American workers, despite not affiliating with specific unionization efforts. For Smith and for thousands of other Black women in the city, the church served as a source of political, cultural, and social knowledge. The themes of self-determination and racial solidarity she heard weekly likely inspired her as she led the nut pickers. The Baptist churches in the city that once held Garveyite meetings now served as a fertile ground for educating the next generation of Black radicals—middle-aged, working-class Black women. While it is not known how Smith and her fellow strikers personally felt about Garvey, Smith herself was able to find a middling ground for her lived experience as a Black woman and radical union organizer.

Religion has been described as "the central guiding force in the lives of most African Americans."[146] African American religion fostered a culture of opposition, and offered a community space to fight the many systems of oppression. Historians have long noted how a radical, prophetic interpretation of Christianity rose during times of slavery, as enslaved Blacks latched onto Biblical themes of oppression and exploitation.[147] The Black church's influence shaped a radical tradition of resistance and opposition for over four hundred years that played out in different civic and political organizations, social movements, and public culture. Gayraud Wilmore, however, notes that the 1920s saw a "deradicalization" of the Black church. Black clergy in cities like Detroit and St. Louis turned away from issues of working-class oppression and racism.

As such, African Americans began to look outside organized religion, in a moment that coincided with the rise of the Communist Party's recruitment of Blacks.[148] This transition to a secular radicalism informed by prophetic Christianity played out in the streets of St. Louis during the nut pickers' strike. Carrie Smith did not abandon her faith, but instead wove it into her daily experience as a working-class Black woman.[149] In 1933, that meant her Bible had a place on the picket line.

The American Communist Party had a complicated relationship with religion; while national party leaders denounced religion as the "opiate of the masses," local Communists often utilized themes of Christianity to relate to workers. For example, Robin D. G. Kelley shows how Alabama Communists blended religious imagery and language with the party's principles, such as depicting capitalist owners as devils or speaking about a "conversion" to Communism. The Bible was often used as a guide to working class struggles as much as the *Communist Manifesto*. Communists in the North, however, avoided connecting the potentially revolutionary aspects of Christianity to Marxist ideology.[150] Not only did St. Louis Communists avoid this sort of meshing of cultural values, they actively derided religion. The *Communist* related a story of one African American woman whose pastor refused to let her take a collection for the strikers. She turned around and left, declaring she was now a Communist and the union was her church.[151] In this case, local Communists considered religion an obstacle to overcome in the pursuit of a working-class consciousness. Only when the woman left her church and wholeheartedly embraced the Communist Party could she fully participate in the party and the strike. Though she showed signs of a "conversion" to Communism, the woman is portrayed as misguided because she initially sought help from her local church.

Though this "conversion" story is characteristic of Communist-exaggerated propaganda, the Black clergy's refusal to take sides in the strike did reflect reality. During the strike, Black churches in St. Louis were conspicuously silent on issues of workers' rights and unemployment. According to Hershel Walker, "You couldn't get ministers in St. Louis to support the unemployed movement, not until they had to."[152] Since the Communists avoided and even disparaged religion and their own churches had abandoned them, the Funsten workers often sought assistance from other faith-based organizations. Shortly after the strike began, a committee of two white women and two Black women visited the Social Justice Commission (SJC), an organization formed in 1931 for the purpose of "championing social and economic justice." The commission

consisted of fifteen clergymen and ten professors from both Washington University and Saint Louis University and was headed by Rabbi Ferdinand Isserman of Temple Israel.[153] In dramatic fashion, the women opened pay envelopes in front of the commission to show their weekly wages, ranging from $1.50 to $2.00. The SJC agreed to help the striking women in any way they could. Rabbi Isserman was particularly vocal in his support for the Funsten workers, and though he was neither a Communist nor a Communist sympathizer, he joined them in critiquing local moderate organizations. In an editorial in *Modern View*, a local Jewish publication, Rabbi Isserman wrote that "if it had not been for Communist leaders this tragic condition would not have been brought to light. The Urban League and other organizations interested in colored people were familiar with this situation. They lacked, however, the vigorous leadership to bring this condition to light." The rabbi's support of the Communists' intervention, however, ended there. "It is indeed a pity that in our city the only group prepared to speak for eight hundred exploited negro workers were members of the Communist party."[154] Rabbi Isserman could understand why the women turned toward the Communists, but lamented that other leaders and organizations were absent. He encouraged those moderate leaders to step up and take over where the Communists left off. By doing so, Rabbi Isserman and the SJC provided the strikers with a religious leader with whom to ally when their own churches had abandoned them.

By all appearances, the strike seemed entirely successful: the women gained all their demands and union representation within the Funsten factories. Carrie Smith articulated the sentiment surrounding the formation of the FWIU union in the Funsten factories: "The girls are loyal to the union. 'You better not say anything against the union or they will fight you.'"[155] The nut pickers' strike was initially electrifying, inspiring organization among workers in various industries across St. Louis. Workers at a bag company, another nut factory, a local rag company, steel plant, and river docks all struck the same year with positive results. For most of the strikes, the TUUL helped organize the laborers, and from 1933 to 1935, the TUUL and local unions led thousands of St. Louis African American workers to short-lived victories.[156] Even John Clark of the St. Louis Urban League had to admit the Communist Party and TUUL had certainly gained traction. "The Communists came out of these strikes with a prestige tremendously increased among the workers."[157] Indeed, according to assistant director Ira Reid, Communists had been "the only ground-gainers for Negro workers in St. Louis." It seemed the party had so endeared itself in

the African American community that white party members started selling cracklings on the streets.[158] Only six years prior, white St. Louis Communists had been worried that inviting Blacks to their meetings would devalue their property. As women like Carrie Smith and Cora Lewis proved, African American workers were not a risk to the working-class struggle, but an essential part of it.

However, each union, for different reasons, ultimately failed to stay organized past 1935. The nut pickers and the Food Workers Industrial Union found Funsten less willing to cooperate than previously hoped. In October 1933, the Funsten Nut Company laid off 191 workers, and while it agreed to pay ninety cents for picking a box of nuts, the size of the boxes increased from twenty-five to thirty-five pounds, in essence the same pay for more work.[159] To answer, seven hundred nut pickers again protested the Funsten Nut factories. They staged a mock public trial, and a jury composed of workers from many industries found Funsten guilty of violating the terms of the strike settlement.[160] The second attempt at a strike brought out new picketers, like Rosebell Kelsey, a thirty-two-year-old Black worker. She stopped to speak with the striking nut pickers and refused police orders to "move along." As a result, she was struck on the head and had to receive seven stiches.[161] Her charges were later dropped and the protest petered out as the off-season for nuts approached and the demand for workers decreased. The struggle, though, was not over. In 1934, two hundred nut pickers, members of the TUUL, struck over the issue of open shop versus union shop, and won their demands.[162] An open shop guaranteed workers the right to choose their own union, a considerable victory in labor organizing. Meanwhile, Funsten had already begun to close plants in St. Louis and move the nut operations south, where he could find unorganized and cheaper labor. As well, reports came of Funsten firing key activists, leveraging plants against each other, and utilizing anti-Communist tactics to damage the organizing base of the TUUL.[163] The plants started to employ greater mechanization, which required skilled workers, who were mostly white. When the Comintern officially disbanded the TUUL in 1935, almost all of the Funsten Nut operations had moved to the South.[164]

However, as historian Keona Ervin writes, the struggles of Smith, Lewis, and hundreds of other Black working-class women deeply influenced radical labor and community organizing in St. Louis. Their leadership, intersectional approach, and lived experiences helped "forge a fresh energy between the labor and freedom movements."[165] Ervin notes how Black women continued to agitate for

justice in the Gateway City throughout the twentieth century, establishing the Funsten strike not as an outlier, but as an early indication of their potential. As trained labor activists, Carrie Smith and Cora Lewis continued fighting for Black women workers in St. Louis and around the country. In July 1933, only a month and a half after the strike, Lewis spoke before fifteen hundred people crowded into the Washington Tabernacle Baptist Church. They had come to see Janie Patterson, the mother of one of the Scottsboro Boys. Patterson was on a three-month tour, along with Richard Moore of the International Labor Defense, the legal affiliate of the CP arguing the Scottsboro case. Lewis helped introduce Patterson, reminding the audience of the nut pickers' strike and the relatedness of the two.[166] While her words of the evening were not recorded, it is likely she spoke of her experiences as a mother and a labor organizer, showing her overlapping identities not as binaries, but as complements.

Carrie Smith continued her activism as well, as a labor leader in the FWIU. As part of her role, she signed a "Unity in Action" statement after the strike that declared solidarity between the FWIU, the Communist Party, the Tom Mooney Council of Action, and the League of Struggle for Negro Rights. Smith was the only woman to sign the document, and her experience in the Funsten Nut Pickers' strike no doubt influenced her decision to do so. One of the articles in the "Unity in Action" urged "unity for Negro people everywhere." It elaborated: "These efforts must be directed toward organising the workers in the factories, the unemployed in the neighbourhoods . . . for the purpose of preparing and carrying out militant struggles, strike actions, protest meetings, demonstrations, struggles at the relief bureaus, etc." Along with the four other signers, Smith represented thirty-nine labor organizations and 11,500 members.[167] The radical forces in St. Louis continued to mobilize, sponsoring a demonstration in November to "celebrate the 16th anniversary of the victorious Russian Revolution."[168] The flyer for the event emphasized that organizing through the TUUL was the best way to defeat the evils of capitalism. However, it seems unlikely (given the waning influence of the CP in St. Louis) that a celebration of the Russian Revolution attracted a mass of Black workers.

Union organizing, especially when it is based in the community and neighborhoods, can have lasting effects that are not always manifested in workplace gains. The FWIU represented the best of the Communists' efforts in community involvement, even if their official records did not reflect that success. The year following the 1933 strike saw the united efforts of Blacks and whites fighting for adequate relief, employment, antisegregation laws, and labor discrimination. In

coordination with the neighborhood UC and the League of Struggle for Negro Rights (LSNR), the union's campaign for racial equality expanded beyond the Funsten factories and workplace rights.[169] Taking inspiration from the 1932 city hall protest and the Funsten strike itself, community members staged lively protests and marches to demand rights. In February 1934, a protester attached a red flag bearing the phrases "The Scottsboro Boys Shall Not Die," "Down with the NRA and Fascism," and "Death to the Lynchers" atop St. Louis city hall. The flag "fluttered defiantly" for an hour and a half before firemen and policemen could get it down.[170]

A major campaign of 1934 was the "Bill of Rights for Negroes," a proposed city ordinance that prohibited workplace discrimination, segregation in public places, and racist housing policies. Any violator of the ordinance would receive a minimum penalty of six months in jail.[171] Though the ordinance never passed, significant numbers of non-Communist Blacks organized around the proposal, which, in keeping with themes of the nut pickers' strike, criticized more moderate Black organizations like the UL. The activism attracted the attention of the national LSNR and Black Communist Harry Haywood, coauthor of the "Black Belt Thesis," who visited St. Louis and spoke at a city-wide conference, furthering a militant perspective regarding race.[172] In June 1934, two hundred demonstrators met at Carr Park and under the banners of the FWIU and the LSNR protested segregated public facilities. Though the movement for antisegregation laws seemed to fade quickly, radical groups organizing around issues not related to the workplace signaled a significant shift in St. Louis racial activism.[173]

African American women's radical activism after Funsten continued internationally as well as locally. Myrtle Jones, a fifty-year-old homemaker, participated in a demonstration denouncing war and fascism in front of the Italian consulate. With members of the CP, ILD, various unions, and the Young Communist League, Jones identified the growing threat of fascism as an immediate concern to African American women. She was charged with disturbing the peace, and after a night in a jail cell was released.[174] She was joined by other Black women in the city who continued to take public stances on international issues: a 1936 May Day parade featured three African American women riding in an open car carrying signs reading "Down with Dollar Diplomacy" and singing the "Internationale." The rise of fascism in Europe was a special threat to the Communist movement, and the Popular Front era saw massive organizing to confront the growing danger. St. Louis radicals were advocating an

alliance with the Soviet Union, "peace without pacifism," and "scholarships, not battleships." The protesters even carried a sign with an image of Hitler, accompanied by the text "It CAN happen here." May Day, a holiday associated with the leftist working-class movement, offered a public place for these women to denounce fascism and the country's abuse of economic power worldwide. [175] While international issues of fascism and foreign policy might not directly affect these women, the influences of Midwestern Black radicalism in St. Louis empowered women to find connections and forge alliances with struggling people worldwide.

The 1936 May Day parade explicitly addressed the Black working-class struggle, continuing themes from the early 1930s. The protesters chanted "Make St. Louis a Union Town," "Equal Rights for Negro People," and "We Fight against Eviction—We Shall Not Be Moved." The parade also featured a familiar face; Lizzie Jones, who first became involved in the radical movement in the 1931 city hall protests, had continued to be active in the fight. She joined speakers on a truck at Thirteenth and Market Streets. Described as a "plump Negro in a blue-striped house dress," Jones gave a fiery speech about her involvement in labor activism in the city, rallying the 350 marchers.[176] This thrilling moment of leftist solidarity, while characteristic of the Popular Front era, demonstrated how the activism of the Unemployed Councils and the Funsten nut pickers of the early Depression may have faded away, but their radical influence endured. Like Smith and Lewis, Jones re-envisioned the expectations of Black women during the era, showing how her home life and activist spirit were linked. Though unassuming and wearing a house dress, she profoundly shaped Midwestern Black radicalism in the city.

Direct engagement in the community and neighborhoods, cooperation with local businesses, communication with local religious groups such as the Social Justice Commission, and other tactics helped Carrie Smith, Cora Lewis, and their fellow Funsten workers reach across ideological lines.[177] By working with local businesses and religious organizations, Smith and Lewis challenged the traditional Communist way of organizing. Working-class consciousness and the proletariat revolution were not at the forefront of the strikers' minds as they instead concentrated on their identities as working-class mothers and wives with religious backgrounds in St. Louis. They advocated for human decency. Smith told one newspaper, "We think we are entitled to live as well as other folks live, and should be entitled to a wage that will provide us with ample food and clothing."[178] Their militancy and their adherence to the Communist

Party's emphasis on racial equality, though touted as Third Period Communist victories, spoke to an ideological Midwestern Black radicalism that addressed local and immediate needs and embraced these women's intersectionality.

In the midst of the strike, the *Argus* commented that "regardless of the fact that Communist propaganda instigated this strike . . . these Negro women should be revered for their loyalty to a just cause."[179] Their "just cause" was a centuries-old pursuit of justice for Black working-class women, influenced by overlapping social identities. Personified in Smith and Lewis, the Funsten nut pickers showed how their positions as mothers, caregivers, providers, citizens, and workers, their experiences as African American women and churchgoers, and their commitment to fighting injustice informed their activism. That the Funsten union did not continue after 1934 does not reflect a lack of effort or care on the part of the workers; it only speaks to the changing nature of the Communist Party and the challenges of radical organizing in the Midwest. The nut pickers, by organizing in both neighborhoods and factories, ensured their legacy would long outlast the union.

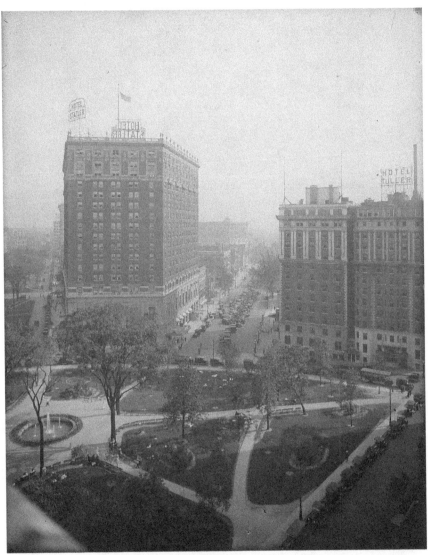

Grand Circus Park, looking toward Washington Blvd. and Hotel Statler, a common gathering place for the Detroit UCs during the Great Depression. Detroit Publishing Co., publisher. Ca. 1900. *Photo courtesy of Library of Congress, Prints & Photographs Division, Detroit Publishing Company Collection.*

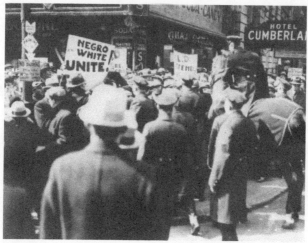

Mourners confront Detroit Police officers during the demonstration and funeral procession for four of the men killed during the Ford Hunger March. Several people hold signs aloft, the most prominent proclaims "Negro and White Unite!" February 12, 1932. *Photo courtesy of Walter P. Reuther Library, Archives of Labor and Urban Affairs, Wayne State University.*

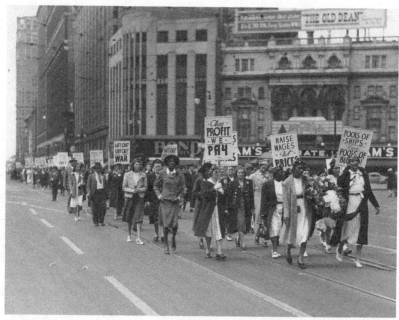

Members of the UAW Women's Auxiliary march down Woodward Ave. led by African American women. Detroit, Michigan. Circa 1940s. African American women lead the procession, their involvement due to the organizing work of Rose Billups. United Auto Workers Union Collection. *Photo courtesy of Walter P. Reuther Library, Archives of Labor and Urban Affairs, Wayne State University.*

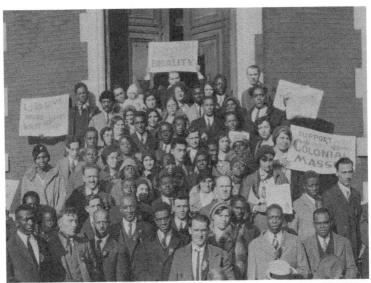

Portion of panorama photograph taken at the St. Louis 1930 meeting that would convert the American Negro Labor Congress (ANLC) into the League of Struggle for Negro Rights (LSNR). *Photo courtesy of Missouri History Society, St. Louis.*

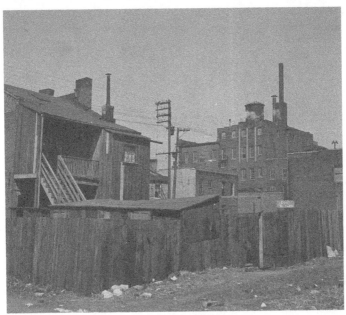

Black neighborhood in St. Louis, 1936. Living conditions such as this were common in St. Louis Black neighborhoods. *Farm Security Administration Photographs, Rothstein, Arthur, The Miriam and Ira D. Wallach Division of Art, Prints and Photographs: Photography Collection, New York Public Library Digital Collection. Public domain.*

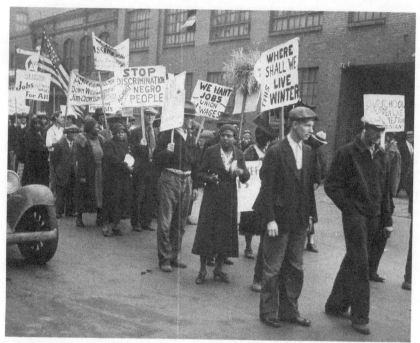

March of unemployed workers down Pine St., St. Louis, MO, ca. 1930s. African American women protesters are highly visible in the demonstration, a sight uncommon prior to the Great Depression. *Courtesy of Missouri Historical Society, St. Louis.*

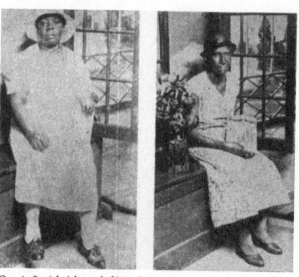

Carrie Smith (above left) and Cora Lewis (above right) pose for photos to accompany their article in the Communist Party journal *Working Woman*. August 1933. *From the photo collection held at the Tamiment Library, New York University by permission of the Communist Party USA.*

J. C. Austin's Pilgrim Baptist Church in 1922, where he held meetings extolling the virtues of the UNIA and then, in the 1930s, the Communist Party. *Schomburg Center for Research in Black Culture, Jean Blackwell Hutson Research and Reference Division, New York Public Library. New York Public Library Digital Collections. Public domain.*

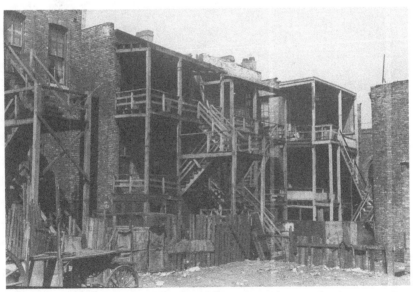

Back steps of apartments in Black neighborhoods in Chicago, sharing many similarities with the residences in St. Louis. *Schomburg Center for Research in Black Culture, Photographs and Prints Division, New York Public Library. New York Public Library Digital Collections. Public domain.*

Chicago South Side apron-making factory, similar to the Sopkin Apron Factories, which employed mostly African American women, early 1920s. *Schomburg Center for Research in Black Culture, Jean Blackwell Hutson Research and Reference Division, New York Public Library. New York Public Library Digital Collections. Public domain.*

Thyra Edwards, Chicago-based journalist, activist, social worker, labor organizer, and National Negro Congress member. Associated Negro Press. *Photo courtesy of Chicago History Museum.*

Cleveland's Public Square, where the UCs would often gather in the shadow of the Sailors and Soldiers Monument, which features relief panels of Lincoln and the Emancipation Proclamation, 1929. *Photo courtesy of Cleveland Public Library.*

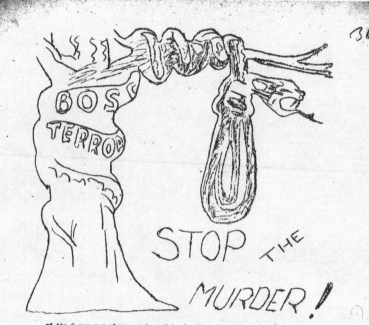

Poster from Cleveland's branch of the CPUSA and LSNR to advertise a protest in support of the Scottsboro Boys. Ca. 1931. CPUSA Files, Fond 515, Reel 160, 2100, Frame 36. *From the photo collection held at the Tamiment Library, New York University by permission of the Communist Party USA.*

CHAPTER 3

"Put Up a Fight":
Evictions, Elections, and
Strikes in Chicago

B lack women working in Chicago's industrial factories was a relatively new
phenomenon, something that worker Romania Ferguson pointed out to
the *Daily Worker* in mid-1928. Like many other Black women in the Midwest,
Ferguson came from a history of domestic service and sensed the appeal of
escaping that tradition. Specifically, in her adopted city of Chicago, she noticed
how Black women working in industry have increasingly "put up a fight" to
assert their rights but have largely done so without any union backing. "If
the organized labor movement would turn its attention to the Negro working
women," she informed *Daily Worker* readers, "there is no question but that it
would find eager and valuable allies."[1] Ferguson was a trailblazer in promot-
ing the potential alliance between the CPUSA and Black women in industry,
recognizing what Black women had been asserting for years: working-class
Black women intuitively understood class oppression. Their reticence to or-
ganize into unions or united fronts stemmed not from lack of interest, but
inexperience. Proper education and guidance, argued Ferguson, would help
foster an important and fruitful partnership. As the Depression worsened and
working-class Black women found themselves further exploited, Ferguson's
predictions of Black women's eagerness to organize proved accurate. Across
Chicago South Side neighborhoods, a remarkable coalition between Black
working-class women and radical organizations blossomed. Black women like
Ferguson ran for local political office as Communists, staged anti-eviction pro-
tests, and won remarkable victories for exploited workers, proving Ferguson's
assertions beyond a doubt.

Chicago activists experienced Midwestern Black radicalism differently from
Detroit, St. Louis, or Cleveland. The city's radical labor history empowered

African American women to access different platforms of neighborhood and labor organizing. Romania Ferguson visited the Soviet Union and attended a workers' school that educated her on Marxist teachings.[2] Wella Clinton, a hotel washerwoman ran as a Communist in the local aldermanic race.[3] Steel industry organizer Eleanor Rye literally climbed a fence to reach striking workers inside a factory.[4] And African American women associated with the CPUSA were not the only ones exercising their interpretation of Midwestern Black radicalism. Chicago's activism offered middle class reformers an opportunity to challenge notions of what was acceptable for Black women in their time. Social workers Thelma McWorter (Wheaton) and Thyra Edwards radically reinterpreted their roles as activists, extending their aid and experience to industrial union organizing. Midwestern Black radicalism in Chicago did not face the challenges of a one-industry town like Detroit, or a border city such as St. Louis. With a city primed for radical activism, Black women took the lead in labor and neighborhood organizing. Though often overlooked in the city's rich labor history, women like Ferguson, Clinton, Rye, McWorter, Edwards, and many others pushed the limits of what was truly "radical."

African American women who sought to be involved in radical activities in Chicago encountered a city that was no stranger to radical organizing. Home of the Haymarket martyrs, May Day labor celebrations, the movement for the eight-hour workday, and the birthplace of the CPUSA, the Windy City was often described as the capital of American radicalism.[5] It was here Socialist Eugene Debs initiated the Pullman Strike in 1894 that spread nationwide. Debs's ability to rally workers from diverse ethnicities and backgrounds signaled a new era in labor organizing, and highlighted Chicago as the destination for that work. The city's growing working class continued the organizing efforts, making Chicago the center of radical organizing in the beginning of the twentieth century.[6] The radical efforts had mostly centered on white male workers, something not unique in Midwestern cities at the time. However, the makeup of the working class shifted dramatically during the Great Migration, as Chicago was a mecca for many Southern migrants, prompting dramatic changes in how Chicagoans thoughts about labor. In 1910, African Americans were 2 percent of the population in the city; by 1930, the percentage had increased to 6.9.[7] Hopeful Southerners looked to Chicago as the promised land, as it already boasted several Black communities transplanted from the South. Historians have long noted the convenience of the Illinois Central Railroad, which offered Blacks in rural Tennessee, Louisiana, and Mississippi easy access to the Windy

City. Though there were stops along the way, notably St. Louis, for most Black migrants, Chicago was often the ultimate destination.[8] In addition to employment, an established Black population, and relief from de jure segregation, the city also offered one of the nation's leading African American newspapers, the *Chicago Defender*. Founded in 1905 by Robert Abbott, in only one decade the paper had become the largest selling Black newspaper in the country. The daily paper was decidedly racially conscious and left leaning in its articles and editorials; it routinely published accounts and statistics of violence against Blacks in Southern states, updates on civil rights court battles, and local Black politics.[9] In 1916, editors began to urge Southern Blacks to act and escape the "racist and corrupt South," mounting the Chicago leg of the Great Migration. Between the articles recording racial violence were sections highlighting Chicago's superior public schools, cultural activities, political freedom, and economic opportunities. By the fall of 1916, the *Defender* estimated that some 250,000 people had left the South.[10]

The realities of a Northern city, though, often fell short of migrants' expectations. Like many other Midwestern cities, racially restrictive covenants and a strong social color line boxed new migrants and native Black Chicagoans into specific areas. Nine out of ten Blacks in Chicago lived in Black-dominated neighborhoods, especially in a growing urban area known as the Black Belt.[11] With the influx of new residents, however, these areas on Chicago's South Side and West Side soon grew overcrowded, resulting in living conditions suitable for no human beings. In 1920, Olivet Baptist Church's Rev. Lacy Kirk Williams commented on the "dangerous housing experiment of placing 125,000 Negroes in the quarters [that] formerly provided for 50,000."[12] The buildings were old, exacerbating the terrible living conditions; in the Douglas neighborhood, two thirds of the buildings were built in 1899 or earlier. It was common for working-class Black families' residences to lack central heating, running water, and private toilets.[13] Disease, illegal activity, and sex work were not uncommon and certain neighborhoods often became synonymous with vice and danger. Because of the associated negative images of the area, the Black Belt's rapid expansion was not always welcome for the existing middle-class white communities. The pastor of Chicago's oldest white Baptist church described how new migrants "swarmed to the blocks surrounding the church building," lamenting how church membership declined from 403 to 10. The church was eventually sold to an African American Baptist church, confirming the neighborhood's transition. Racial hostility extended beyond white flight; from July 1917 to

March 1, 1921, fifty-eight bombs were thrown at Black residences or real-estate agents who sold to them.[14] Seeking a refuge away from racial violence, Southern migrants found their promised land steeped in racial hatred and segregation.

Despite the violence, Black migrants created a community in Chicago that flourished during and immediately after World War I. Chicago boasted one of the strongest Black cultural communities outside Harlem: creators of visual art, literature, blues music, and more migrated to the Midwestern city in the early 1930s and spurred what would become known as the "Chicago Black Renaissance."[15] This cultural explosion of music, art, and literature was an affirmation of Black expression and identity, rooted in the everyday reality many African Americans faced. As well, Black businesses and entrepreneurship thrived: Black Chicago boasted five banks, the largest Protestant church in the country, and a great civic pride. The community proudly celebrated the Black soldiers returning from WWI; at the war's conclusion, the Eighth Regiment paraded from Michigan Avenue to Grand Central Station while Black and white audiences alike waved American flags and cheered.[16] The interracial solidarity, however, was short-lived. On July 28, 1919, the city saw what veteran soldier and Chicago resident Harry Haywood described as a "holocaust."[17] A seemingly innocuous altercation between Black and white swimmers on a beach erupted into a five-day riot that claimed at least thirty-eight lives. The riot engulfed the city, but the Black Belt saw the worst of the violence. Gangs of whites roamed the streets in Black neighborhoods, randomly attacking and shooting anyone who dared stray from home. African Americans were not passive victims; arson ravaged white neighborhoods.[18] However, nearly two thirds of those injured and killed were African American citizens. As Black veteran Harry Haywood began to realize, he had been "fighting the wrong war . . . The Germans weren't the enemy, the enemy was right here at home."[19]

After the riot, white and Black Chicagoans approached rebuilding from various directions. The Chicago Commission on Race Relations, organized after the riot to analyze its origins and recommend future action, noted that the city's races needed "mutual understanding" and "sympathy between the races."[20] For African Americans, specifically, the commission warned against "thinking and talking too much in terms of race alone," which can "promote separation of race interests and thereby . . . interfere with racial adjustment."[21] For many African Americans, racial solidarity and pride was not the problem, but the answer to Chicago's racism. The riot and violence perpetuated by whites helped spur the burgeoning UNIA movement in the city. On September 28, 1919, Garvey

visited the Eighth Illinois Regiment, once a symbol of interracial celebration for WWI veterans, to address and empower Blacks on the South Side.[22] A few years later he confidently claimed to have "captured" the city, making it into "another stronghold of the Universal Negro Improvement Association." In a city full of "domiciled corrupt Negro politicians," Garvey's message of "race first" took firm root.[23] Establishing the UNIA in Chicago was an uphill battle, though; the *Defender's* Robert Abbott had a public feud resulting in Garvey suing the editor for libel.[24] The *Defender's* coverage of the UNIA was minimal, if at all. Garvey was arrested in Chicago after his 1919 address, but being released on bail, he left Chicago, never to return.[25] Garvey's influence in Chicago, however, remained, as the city's residents were primed for his teaching. The movement seemed to "spring up overnight," even in his absence, and by 1921, the local division reported forty-eight hundred members.[26] Orators regularly occupied street corners speaking from soapboxes, extolling the principles of Garveyism, racial pride, and Black nationalism. Parades led by the Black, red, and green flag bearers marched through the streets of the South Side, followed by proud members of the African Legion and Universal Black Cross Nurses.[27] By UNIA's heyday in the mid-1920s, the South Side's Division 23 declared a membership of more than 20,000, though conservative estimates approached only 9,000.[28] Certainly, membership did not alone denote Garvey's influence in the Windy City; tens of thousands of African Americans witnessed the spectacular display of African unity and Black pride, acknowledging and even accepting these themes into their understanding of race. As well, Black Chicagoans did not just encounter Garveyism on the streets, but in mainstream churches. In his 1940 study of Black churches and organizations in the city, St. Clair Drake astutely commented that Garvey had an indirect influence for "stimulating 'race consciousness' and 'race pride' among the Negroes."[29] Reverend J. C. Austin was the most well-known example of a traditional Baptist preacher who subscribed strongly to Garveyite principles and extolled them weekly from his pulpit at Pilgrim Baptist Church.[30]

Black women played important roles as leaders and organizers in the Garvey movement. The local Black Cross Nurses wore spotless white tunics, displaying their virtue and countering the stereotype of the Black "jezebel."[31] While Garvey avoided Chicago after 1919, national female leaders such as Amy Jacques Garvey and Henrietta Vinton regularly visited and spoke to crowded audiences. Lucy Lastrappe, a migrant from Georgia, sang lead in a quartet in Chicago, called the Universal Four. An active member in the UNIA for eight years, Lastrappe relished her ability to celebrate and embrace Garvey's Pan-Africanism.

Gender politics of the 1920s usually relegated women like Lastrappe to the domestic sphere; however, the UNIA enabled Black women to challenge those boundaries through the women's page of the *Negro World*, organizing meetings and tours, and public speaking.[32] Mittie Maud Lena Gordon began attending meetings in 1923 with her husband at a hall not too far from her home. Gordon, a recent migrant, was looking for any organization that "claimed to better [the] race's condition." She, as well as thousands of other Black Chicagoans, placed great hope in Garvey.[33] Membership dwindled after Garvey's deportation, likely leading St. Clair Drake and Horace Cayton to write in 1945, "Garveyism was never very popular in Chicago."[34] Historian Erik McDuffie disputes this "declension narrative," and shows, despite Garvey's deportation and early death, that Garveyites continued to shape Black activism in the city.[35]

The Nation of Islam readily attracted Garveyites who sought an organization based on race pride and self-help. Once Elijah Muhammad moved the Nation's headquarters to Chicago in the early 1930s, the city became a hub for Black Muslim activity. In 1930, eight hundred new members called Temple No. 2 in Chicago their place of worship and established a thriving community of Black Muslim businesses and neighborhoods.[36] Though the Nation embraced themes from Islam, Christianity, and Masonry, it claimed Garvey as spiritual predecessor, showing how influential Garvey's ideas of racial pride, Black nationalism, and self-determination had become.[37] Unlike their experience in Detroit, NOI members in Chicago went relatively unperturbed and the city quickly claimed the movement as their own. However, the Nation struggled with its internal battles after moving to Chicago; a series of schisms threatened the very survival of the organization.[38] And, in keeping with tradition, NOI members avoided active public engagement with politics. While the NOI had established its presence in Chicago by the Great Depression, preserving and building on notions of Garveyism, it ultimately was a background player in developing strong Black political activism in the Great Depression.

While the UNIA and the NOI spread ideas of racial pride to a broad coalition of Black Chicagoans, another organization in the city had been fighting for respect and recognition for Black workers for years. Under the leadership of Asa Philip Randolph, Pullman car porters had been working fiercely for recognition of their union, the Brotherhood of Sleeping Car Porters (BSCP), since 1925. Much like Black women's domestic work, Black porters' jobs were tainted by memories of slavery. Often called by their incorrect name or even "boy," African American men were expected to be subservient to white patrons. Unlike Black

women, however, the Pullman Company porters were able to collectively assert their rights as citizens and workers starting in the mid-1920s. The Pullman porters successfully forged a new network of protest politics that challenged labor exploitation, discrimination, and white paternalism while also opening many Blacks' eyes to the power of unions. Most Black leaders at the time did not see unions as a vehicle for procuring democratic rights; however, the continued activism by the BSCP challenged this idea. By the time the Pullman Company officially recognized the BSCP in 1937, a significant change had occurred regarding unions. Efforts from radical activists such as Randolph encouraged the Black working class to embrace unions as an avenue for change.[39] The recognition of the brotherhood showed how far the city had come since Eugene Debs's failed Pullman strike in 1894. By incorporating familiar themes of work solidarity with Garveyite principles of racial pride and dignity, Randolph and the brotherhood reformed what labor activism looked like in the Windy City.

The brotherhood, as its name implies, focused largely on obtaining citizenship rights for Black men. Part of this battle included constructing ideals of respectable Black manhood, usually related to ideas of middle-class respectability. The Pullman porters, as historian Melinda Chateauvert explains, were seen as the "aristocrats" of Black labor.[40] In their crisp, clean uniforms and respectable demeanor, they challenged racist stereotypes of the Black working class similar to the efforts of the UNIA. This desire for respect and awakening race and class consciousness was not limited to the porters. Women drew inspiration from their husbands, brothers, and fathers, seeking ways to become involved in every present struggle. As Chateauvert demonstrates, African American women devoted themselves to the ladies auxiliaries—hosting events, organizing drives and educational opportunities, and exercising their activist impulses through the BSCP.[41] Like the UNIA, NOI, the BSCP effectively fashioned a space for Black women to educate, empower, and assert themselves. Under Randolph's leadership, the BSCP continued to play a large role in providing African American women with resources to pursue education and organizing in Chicago and beyond.

Black organizations in Chicago experienced a renewed sense of hope during the era of the "New Negro." Bolstered by postwar prosperity, energetic new migrants, and Garvey's messages of Black pride and self-reliance Black Chicagoans transformed their lives and the city. Nineteen twenty-four to 1929 were the most prosperous years, as Black businessmen, athletes, writers, artists, professionals, and activists offered significant social, political, and cultural contributions that helped to define the Jazz Age in the city. Though New York claimed

the Harlem Renaissance, Chicago's own Black Renaissance made the city its own cultural and social destination, leading Black sociologist Charles Johnson to write, "Chicago is in more than one sense the Colored capital."[42] A thriving cultural community indicated a strong network of social support. Blacks new to the city could look to local institutions, such as churches, newspapers, and the YMCA, to help them settle and adapt. The Chicago Urban League (CUL), founded in 1917, was created to specifically address the immediate needs of the Southern migrants. The league's first president, Robert E. Park, felt that the most pressing issues were "work and wages, health and housing, the difficulties of adjustment of an essentially rural population to the conditions of a city environment, and to modern life."[43] While Chicago's Urban League sought to accommodate African American's needs, the local chapter of the NAACP actively fought the status quo. Similar to chapters in other Midwestern cities, Chicago's NAACP pursued legal and civic action to procure racial progress, stating their work was "to secure full civic, political and legal rights to Colored citizens and others."[44] Despite the thriving Black Chicago community, NAACP leaders had difficulty organizing a united front. As historian Christopher Reed notes, the ideological arguments between caution and assertiveness, negotiation and militancy only further divided the organization, leading it to "move listlessly" through its early years.[45] The legal battles did little to fight the daily racism and challenges of the working class.

Chicago's radical labor history and established Black culture and community provided fertile ground for Black women's activism in the 1920s. The organization of the UNIA and NOI included opportunities for women to empower and assert themselves in a city that accepted them. The BSCP, steeped in middle class respectability, additionally promoted women's organizing efforts, establishing networks of activism that would expand beyond the union. Yet, opportunities in these organizations were limited, and as Chicago entered the Great Depression, Black women began to push the boundaries of what the city offered.

THE DEPRESSION HITS THE BLACK BELT

The local chapters of the Urban League and the NAACP, Black churches, and charitable institutions in the Black Belt found themselves shocked and immediately overwhelmed by the Great Depression. The 1929 stock market collapse struck Chicago's African American community swiftly and disastrously. Black

banks, such as Binga Bank at Thirty-Fifth and State Streets, failed earlier than others in the city, causing Black Chicagoans to lose millions of dollars.[46] The many Black businesses that thrived during the 1920s closed their doors.[47] Unemployment was rampant, and the Urban League was overcome with employment requests they could not fill. Once an organization that boasted numerous job opportunities for Blacks, Chicago's UL simply could not find any work. From 1930 to 1931, over 5,800 men and women applied for jobs; only 823 were placed.[48] With such a scarcity of jobs, the *Defender* warned against any new job seekers heading North. "Those who are contemplating moving from one city to another—coming from small towns into the cities of the North—are advised that it is a poor time to make a change."[49] The editors did not exaggerate; sociologists Cayton and Drake estimated that nine thousand Blacks were displaced from clerical and semiskilled work, seven thousand in unskilled work, and twelve thousand in service work, levels that were two to three times as much as whites.[50] Once the destination for thousands of migrants, the city could no longer support its own.

As in Detroit, St. Louis, and Cleveland, African American workers suffered disproportionately after the stock market crash. Though less than 10 percent of the population, Blacks made up 40 percent of those on relief, and half of African American families were on some sort of government aid.[51] Every step along the way to procure government relief, Blacks were met with racist resistance. Delegations from the South Side frequented city council meetings, asking for better relief treatment. The council was "grudging and niggardly in its response," with one white council member blaming unemployment on the Black workers. According to him, they were lazy and "that's why so many of them are on relief."[52] Sociologist Martin Bickham found the opposite, as his observations showed all men wanted work and never accepted relief as a way of life.[53] For them, government welfare was a temporary fix for their problems. Thyra Edwards, a social worker, journalist, and activist on the South Side, agreed, accusing white politicians of "blaming the victim." In her 1935 article, "Attitudes of Negro Families on Relief—Another Opinion," Edwards cited the prevailing practice of hiring white workers over Black workers, wage inequality, and the disappearance of Black-owned businesses as factors in the disproportion of African Americans on relief. Blaming the victim only misdirects the attention from the actual problems. "Instead of the too ready indictment of the unemployed, condemnation should . . . be directed against the political economy that creates these conditions of mass unemployment."[54] A somewhat

radical approach, Edwards advocated increased efforts in fighting institutional racism and classism, an attitude that would grow in popularity as the Great Depression endured. Yet, without sustained organizational pressure, this push for radical change was limited.

While the UNIA and NOI had declined in popularity and membership, the principles of self-help, Black agency, and militancy were absorbed into various forms of activism during the early days of the Depression. The *Chicago Whip*'s "Don't Buy Where You Can't Work" campaign directed anger and frustration brought upon by the economic crash and unemployment to white business owners in the Black Belt. Activism in the fall of 1929 "signaled the beginning of a movement" that invigorated Black communities.[55] With support from Black leaders, churches, and social organizations, masses of African Americans boycotted and picketed business that would not employ Black workers. Though often met with resistance and even violence on the picket lines, protesters achieved victories against stores such as Woolworth's, which eventually hired twenty-one Black women workers.[56] Iterations of the "Don't Buy" movement lasted until 1931, and in its course, had familiarized thousands of African Americans with public protesting techniques; picket lines, sandwich board signs, loud speakers during business hours, soapbox speakers, and an abundance of literature all categorized the new protest methods on the South Side.[57] Local churches and community organizations, including the local branch of the NAACP, helped fund the protest, from paying picketers, hiring loudspeakers, and providing bail for arrested protesters.[58] Noticeably, the Urban League remained on the sidelines, plagued by financial difficulties but also a reticence to engage in more "radical" organizing techniques. In terms of collective public protest, the ideology behind the "Don't Buy" campaign was relatively moderate. Movements that focus on Black purchasing power and consumerism embrace and accept capitalism as a legitimate channel for racial progress. Even during the nation's worst economic depression, activists behind the "Don't Buy" campaign placed their trust in a capitalist system. For Black workers who began to lose faith in the capitalist system, opportunities for more radical protest were right around the corner.

"Don't Buy Where You Can't Work" opened up several hundred white-collar jobs for African Americans but did little to address the thousands of other unemployed Black workers. Local Communists called the campaign trivial and asked, "What has this to do with hundreds of thousands of Negro workers in the coal, iron, steel, oil, automobile, and packing industries?"[59] The

Communists had been sporadically active in the Black communities of Chicago up until the Great Depression. During the 1920s, white Communists had distributed copies of the *Daily Worker*, which included special articles about Black workers in Chicago. In 1924, one open-air mass meeting included a critical lecture on Garveyism and the Back-to-Africa movement by national Communist leader Bob Minor, who was white. Pointing to a large map of Africa on the wall, Minor argued that Africa could only be saved from imperialism through the united efforts of workers worldwide, led by the Communist International. Hundreds of African Americans, likely familiar with Garveyite teachings, listened as Minor declared, "Negroes must look for happiness neither in Liberia nor heaven, but right in America." The audience did not rush to join the party; however, Minor's efforts exposed Black workers to Communist doctrine before the Great Depression. The Communists continued to hold workers' meetings on the South Side and invited all to attend.[60] They also sponsored interracial dances, fundraising events, picnics, and other social events. However, their influence was limited among the Black neighborhoods during the 1920s for a variety of reasons.[61] African Americans either were "too busy enjoying the lush Twenties to pay much attention" or held tightly to the jobs and reputations they had. Additionally, white Communist leaders were unable to use language that directly addressed the specific problems of the Black worker.[62] As Bob Minor's presentation in 1924 demonstrated, the Communist Party was not intellectually prepared to discuss global conditions that affected all people of African descent and instead actively derided notions of pan-Africanism. Compared to Garveyite teachings, in the early 1920s, the CPUSA was severely disconnected from the evolving ideologies of many African Americans. The 1928 and 1930s resolutions helped revise the CPUSA's ideological commitment to Black workers. As well, the dire conditions of the Great Depression created an environment ripe with organizing potential. With nothing less to lose, large numbers of Black Chicagoans began to listen and sympathize with the radicals. Black political scientist Harold Gosnell famously noted, "When a man is unemployed, he can risk listening to a Communist agitator."[63]

Most African American residents became familiar with radical doctrine through the work of the Unemployed Councils on Chicago's South Side. Within a few years, Chicago had twelve councils in Chicago neighborhoods with over a thousand members. Only New York City, the headquarters of the CPUSA, could claim more.[64] Located within Black neighborhoods, UC workers were able to directly observe and address issues important to the people. Slogans

such as "For full economic, political, and social equality for Negro workers!" and "Self-determination for Negroes" during mass demonstrations showed radical efforts to speak directly to racial issues.[65] Less than a decade before, Black Chicagoans had witnessed Garveyites parading down the same streets, spreading messages not so different from the UC. While the Chicago UNIA still claimed six divisions and seventy-five hundred members in 1930, they were unequipped to organize massive numbers of unemployed workers.[66] In the void of a UNIA strategy, mainstream Black organizations unable to meet employment needs, and Black politicians failing to tackle large issues, many people familiar with Garvey's Black pride and attacks on accommodationist approaches gravitated to the UC. The UC emulated one Garveyite theme in particular; Garvey had often ridiculed "domiciled corrupt Negro politicians."[67] African Americans who turned to the UC continued this grievance, focusing on Black politician Oscar DePriest, a Republican U.S. congressman representing Illinois's first congressional district from 1929 to 1935. DePriest was an impressive activist politician supporting Black causes, with an enthusiastic and bombastic speaking style. As the leading Black politician in Chicago, DePriest found his constituents looking to him for immediate solutions during the Great Depression.[68] As a Black man in the U.S. House of Representatives, however, his power and authority were limited, and he became a convenient scapegoat on the South Side. For years, DePriest was the target of UC-organized demonstrations, which including storming his office and interrupting his public speeches.[69] DePriest was never the villain radicals made him out to be, but he fit neatly into Garveyite and Communist rhetoric regarding ineffective Black politicians.

The Garvey influence continued in the UC and Communist Party in Chicago. Former Garveyite Claude Lightfoot became a leader of the South Side Council and eventually joined the Communist Party.[70] Rev. J. C. Austin, who used to preach "Back-to-Africa" sermons at Pilgrim Baptist Church now extolled the efforts of the Communists' activity.[71] Chicago Garveyites Anna Schultz and Marie Houston left the UNIA for the CP, but retained a positive attitude toward Garvey, the man who had "awakened their political consciousness."[72] Another Garveyite-turned-Communist noted that, "Whatever the crimes and mistakes of this misleader Garvey, I learned a lot about organization from him."[73] Though the UNIA was ill-equipped to answer the calls for employment, food, clothing, and housing, the generation of activists trained in Garveyism firmly established their Black radical presence in Chicago.

Without steady employment, hundreds of Black families were evicted from their homes in the early years of the Depression for nonpayment of rent. From August to October of 1931, the Renter's Court, the body that ruled on evictions, saw 2,185 cases. Of those, 38 percent were for African American families.[74] They were African American women like Katie Williams, an unemployed widow with two small children who was five months behind in rent. When the bailiff, by request of the landlord, removed her furniture and locked the front door of her house, a member of the local UC appeared, broke the lock, and began returning furniture to the house.[75] Such occurrences were common, and as word spread about council members working directly to address needs of housing, Chicagoans, Black and white, flocked to support their efforts. Reportedly, within half an hour, organizers could rally five thousand people to stop an eviction. Council members passed hats to collect spare change to help the occupant pay rent, turned on utilities in apartments where they had been shut off, and quite forcefully returned families to their homes. Subtlety was not a part of their modus operandi: members often left signs reading "Restored by the Unemployed Councils" to spread awareness about their successful actions and proudly sang "We shall not, we shall not be moved."[76] Displaced, suffering families were grateful for the councils' efforts and began to call the members a "bunch of Robin Hoods."[77] According to sociologists St. Clair Drake and Horace Cayton, if a mother found an eviction notice on her door, she would shout to the children, "Run quick and find the Reds!"[78] The councils' efforts were not always successful, however. In one instance, two African American Communists, unable to return furniture to the home of evictee Cary Brown, doused the house with gasoline and lit it on fire. While a brick struck one police officer, the violence was limited and damage to the house was minimal.[79] No doubt working from frustration and a profound sense of helplessness, these men's actions were condemned by mainstream media, though more radical Blacks understood and could appreciate their militancy.

While Black men's militancy often dominated the headlines, Black women on the South Side were often at the center of such anti-eviction protests, as the evictees, leaders, or speakers. Horace Cayton observed a demonstration where "a frail, old Black woman" encouraged the crowd to "stand tight" in the face of law enforcement.[80] In the course of one struggle, the woman defended her home against the bailiff and "socked him across the wrist," forcing him to drop his firearm.[81] In another protest, Mrs. Willye Jefferies helped organize a committee that, when the evictee's furniture was placed on the sidewalk, arranged the

furniture and set up a makeshift living environment under tarpaulins outside. When confronted by the landlord, she said, "You can't put me off. I'm not on your property, I'm on city property. The block don't belong to you." Though it rained, Jeffries and her allies remained on the sidewalk for a week, where they even cooked and served meals. The community rallied around those in need, each family contributing what they could. Jeffries noted that this was more than enough, commenting, "We had more to eat out there than we had in the house."[82] Jeffries's action demonstrated to white authorities she not only knew the law, but also could mobilize a neighborhood better than any charitable organization. As a member of the community and Black woman acutely aware of struggles against racism and sexism, Jefferies was better equipped than the city to respond to those in desperate need.

Black women continued to be central to anti-eviction riots, though not always in empowering ways. Diane Gross, a seventy-two-year-old woman, was at the unfortunate center of the city's most infamous anti-eviction riot in August 1931. As the bailiff evicted her from her home on South Dearborn Street, word spread quickly through the South Side neighborhood. Before long, a mostly Black crowd of five thousand residents, curious on-lookers, and members of the UC had gathered. With chants of "Put that furniture back" and "We want something to eat," the throng began to return Gross's furniture into her residence. Police reinforcement moved in, forcing their way "through the dense ranks," trying to arrest whom they perceived to be the ringleaders. Members of the crowd, brandishing sticks, stones, bricks, and reportedly knives descended on the police officers. Reports vary on which side sparked the violence, but the police opened fire, killing John O'Neil, and Abe Gray, both African American men from the South.[83] Gray was an active member of the Communist Party, described as "one of the best Negro organizers in the Party." He had taken a position at the front of the crowd, reportedly saying, "If there is shooting, I expect to be killed, because I shall be on the front rank." Frank Armstrong, Gray's friend and fellow worker, was later found dead near Washington Park, "shot through the head and badly mutilated," indicating he was a fourth victim of the riot.[84] The "Chicago Massacre," as it was soon labeled, "flared up" the Black Chicago community. Some moderate Blacks, such as sociologist Martin Bickman, spent the following days trying to "quiet things down."[85] To prevent any further violent demonstrations, officials immediately ordered a halt to evictions in the city.[86]

The Black working class sensed the time was ripe for further organizing. Immediately, Black neighborhood organizers David Poindexter, Squire Brown, Claude Lightfoot, and Marie Houston began hosting meetings at Washington Park, a community area on the South Side, in the heart of the Black neighborhoods. The park previously was a recreational destination, featuring a swimming pool, athletic field, and playground, however, after the riot, it became known as an "open forum of the Negro Masses." Almost every night, speakers addressed crowds of five to ten thousand, focusing on the recent riots, pervasive unemployment, and meager government relief.[87] The forum was not only for agitated Black workers; Rev. J. C. Austin visited the park and attempted to deliver a sermon on "Christ and Communism." His words mostly were ignored as he noted, "You can't talk religion to a man with an empty stomach."[88] Austin's presence in Washington Park was a rare step for a mainstream Black leader; the Red Squad was known for raiding the area, making it a dangerous location. In one instance in 1933, over one hundred people were arrested in a direct effort of the city to shut down radical organizing.[89] Simply occupying a public space was a threat for the local government and law enforcement, but it was an issue Black radicals continued to push.

While Reverend Austin sought common ground with the Black working class, other Black clergy's reaction to radical organizing was mixed. One minister placed the deaths squarely on the shoulders of the "Russian Communist propaganda," stating that "the hungry homeless Negro is being used as a tool."[90] Though the mainstream press, white politicians, and conservative Blacks continued to deride the radicals, they recognized what drew African Americans to the party. "I can't feed the people," lamented one Black reverend. "If they can feed them, let them."[91] Black churches also recognized the work the Communist Party was doing for racial progress, specifically their involvement in the Scottsboro case. The International Labor Defense, though not technically Communist, carried a leftist connotation that would usually be avoided by Black religious leaders. However, when Scottsboro gatherings took place, churches, from "small store-front congregations to the largest church in the district," gladly hosted meetings. Often, the Black clergy collected donations for the ILD and their continued fight.[92] Centrally located in Black neighborhoods and with traditions of Black activism, churches became essential sites for promoting the Scottsboro cause. Ada Wright, mother of two of the incarcerated youth, spoke at the second largest Black church in the city; once released, four of the young

men on tour stopped by the Metropolitan Community Church to speak in front of a crowd of two thousand people.[93] Eventually, the Chicago division of the Scottsboro Defense Committee included dozens of Black churches.

Reverend Austin proved to be the most accommodating and accepting of the ILD and radicals' presence in his church. A 1934 event featuring Angelo Herndon almost did not take place, as Austin was ordered to not host it. Austin disobeyed, stating the ILD's mission was freedom, "and if to want freedom is to be a Communist, then I am a Communist and will be until I die." In other circumstances, Austin's words would be inflammatory and likely to draw criticism. However, Austin was able to reconcile radical teachings with Christianity. He told the audience, "From all I have learned of Communism, it means simply the brotherhood of man and as far as I can see, Jesus Christ was the greatest Communist of them all."[94] For their part, Chicago Communists worked to incorporate religious themes into organizing. "I Shall Not Be Moved," a song often heard at anti-eviction demonstrations, was a traditional African American spiritual, often sung in church as a hymn. Similarly, in a protest on April 14, 1933, radicals carried a sign paying tribute to another hymn, that read, "Raise your voice high against the onslaught on the Negro people!"[95] A favorite among the Black neighborhoods was "That New Communist Spirit," sung to the tune of "Gimme that Old-Time Religion," a traditional gospel song. The lyrics were often improvised on the spot, but usually included "It was good for Comrade Lenin/And it's good enough for me."[96] Instead of asking Black workers to reject their religion, Communists in Chicago worked to incorporate it. One Black Communist noted that this was intentional, as the majority of Blacks during this time were religious, so they avoided a broadsided attack on the churches.[97] While in St. Louis, Communist leaders expressed their concerns for such a reliance on religion, Chicago radicals actively worked to bring elements of the Black church into the fight. Leaders like Reverend Austin and the city's radical history made these public links of Christianity and Communism conceivable.

As the city reeled from the tragedy of the "Chicago Massacre," organizers mobilized in a few weeks of furious activity. Radical organizing in Black neighborhoods after the August 1931 riot proved successful. A public funeral and parade proceeded down South State Street carrying the caskets of O'Neil and Gray. Thousands of sympathizers gathered to pay their respects and the gathering was peaceful and without incident.[98] In the months following the riot and funeral march, the CPUSA reported that three thousand people signed

up for the Unemployed Councils and nearly 200 for the Young Communist League.[99] Leaders established eight new blocks for the South Side, each with their own Unemployed Council branch. One fourth of the UC membership, numbered around 11,000 in 1931, was African American.[100] Importantly, each local branch was led by a committee made up of local Black workers. As a result, African Americans made up one fifth of UC leadership.[101] In addition, significant numbers of African American activists in leadership roles and in the councils' membership ensured the focus on race and the struggles of the Black working class stayed integral to radical activity in Chicago.

However, participation and membership in the Unemployed Councils did not directly translate to membership in the Communist Party; only 442 out of the 11,000 UC members in Chicago were Communist. Though the events of August 3 and the successful organizing afterward signaled the peak of the Communist influence in the Black Belt and "a new epoch in the Party," it did not necessarily translate into growth of the Communist Party.[102] Many African Americans were content to work with the UC, pursuing their immediate "bread and butter" needs rather than paying dues, attending classes on Marxist theory, or reading lengthy treatises. Furthermore, the party was not always as antiracist as it purported. One party-sponsored dance ended abruptly as white mobsters entered the hall, disproving of Blacks and whites dancing together. Instead of standing by their comrades, white radicals fled, leaving the Black members to be berated and harassed when law enforcement arrived. In the ensuing investigation, party leaders concluded that, despite the large number of African Americans involved in the Communist Party and Unemployed Council activities, white party members had not stepped up to the task of racial solidarity.[103] For the most part, the CPUSA were never quite able to attract large membership numbers in the Black Belt, though, like the UNIA, their influence superseded numbers alone.

Though African American women did not always officially join the CPUSA, they responded enthusiastically to the overall messages of empowerment for Black women. Because these women brought their own notions of racial pride and self-determination from their encounters with Garveyism and other Black nationalist groups, they were able to advance Third Period party ideology for their own needs. During this period, the CPUSA often ran their own candidates in local, state, and national elections. Local political elections were a great vehicle for Black women to assert their influence in their community, as not only voters but also candidates. As early as 1928, African American women

sought election under the Communist title. Elizabeth Griffin Doty ran for
state representative at large in 1928 on the CP ticket. Doty would later go on
to lead a date and fig worker in strike in Chicago, leading CP literature to call
her a "militant fighter."[104] In 1932, Wella Clinton attempted to register for the
West Side alderman race under the Communist Party. When ward election
officials denied her the opportunity, the forty-year old African American hotel
maid did not take the rejection passively. She organized protest meetings in
her neighborhood, calling on her fellow workers to take a stand against such
discrimination.[105] While unsuccessful in her election efforts, she broke all
sorts of expectations by asserting her power as a Black working-class woman
in alliance with the CPUSA. Similarly, Dora Huckleberry, described as a "mil-
itant Negro woman," ran for state representative in 1934. She had drawn the
attention of party officials through her work with the Unemployed Councils,
which often led to her arrest.[106] Like other African American who ran for office
as Communists, Huckleberry's efforts were unsuccessful. Though Chicago had
seen Black politicians before, radical Black women likely repelled mainstream
Black voters. However, these unsuccessful election campaigns do not signify
lack of progress, only another step in African American women exercising and
testing the boundaries of Midwestern Black radicalism in the city.

Though Black women like Elizabeth Griffin Doty, Wella Clinton, and Dora
Huckleberry were often identified as Communists, their official status as party
members is unknown. While they addressed crowds as "comrades" and sup-
ported Communist candidates, they generally fade out of party records after a
brief moment in the spotlight. However, their commitment to Black workers'
rights was never in doubt; Laura Osby, a Black Chicago stockyards worker, ad-
dressed a crowd as an invited speaker at the 1932 Communist Party nominating
convention in Chicago. "First of all, I want to speak to the Negro people most
especially because we have been the most oppressed nationality in the world.
We get the lowest pay, the worst jobs."[107] She "stirred her audience profoundly"
as she proclaimed, "Fellow-workers, you understand we are not only fighting
for that little lousy amount of $15 a week. We are fighting for equal rights and
social equality for all Negroes."[108] Osby was not a one-time party mouthpiece;
like other radical Black women in Chicago, she sought a political office to en-
sure her interests were represented. In 1934, she ran for congressional repre-
sentative of the Fifth Illinois District, but lost to the incumbent democrat.[109]
A life of workplace racism and discrimination, exacerbated by the conditions
of the Great Depression, radicalized many women like Osby to not only ally

with Communists, but to identify as Communist themselves. Though Osby disappears from CPUSA records after 1934, her brief moment in the spotlight demonstrates another facet of Midwestern Black radicalism.

As the Depression dragged on, Black women continued to be on the forefront of the resistance, putting their reputations, employment, and bodies at risk. Lizzie Wilson, a Black maid from Louisiana, discovered the infamous Red Squad was no less gentle to women in a January 1932 protest near a relief station. Wilson, described as a leader of the demonstration, and a white woman were injured in their efforts, as three hundred men and women from the UC, the ILD, and the LSNR gathered outside the Abraham Lincoln Center to demand unemployment insurance, better relief, no discrimination in the distribution of relief, and firing of racist police officers.[110] UC members of both races and genders continued to challenge the government, and in July 1932, directed their attention to Black congressman Oscar DePriest. Fifteen hundred men and women gathered in front of his office, once again battling police as their demands went unheard. Among those arrested for unlawful assembly were five African American women active in the unemployment movement. An anti-eviction demonstration in February 1933 was a close repeat of these events; among the injured were two Black women who suffered scalp lacerations from police violence. They were taken to the hospital and released later.[111] The women who were arrested and injured in these demonstrations directly defied traditional notions of gender roles and challenged the "politics of respectability." As the Depression worsened, traditional notions of modesty, decorum, and civility took a back seat to the pressing needs of daily survival and Midwestern Black radicalism began to flourish.

BLACK WOMEN AND INDUSTRIAL LABOR

As African American women organized and protested on the streets and in the neighborhoods of Chicago, they also looked to secure workplace gains. During the early 1930s, the South Parkway Branch of the Chicago YWCA was poised to assist these women through classes on unions, labor laws, employment, housing, and workplace problems. Thelma McWorter Wheaton, fresh from a master's degree from Case Western Reserve, was hired in 1931 to work with industrial and domestic service workers. While she did not promote a particular union, she taught the value of joining and participating in unions and encouraging workers to speak up for themselves.[112]

The YWCA, though not known for its radical associations, provided a forum for Wheaton to encourage African American women to recognize their organizing potential. Wheaton first recruited these women for these educational meetings by canvassing neighborhoods for women interested in improving their education.[113] Through working directly with these Black workers, Wheaton essentially trained a new vanguard in labor organizing by training them as organizers and educating them of their rights. Some of Wheaton's students were employees at the B. Sopkin and Sons Apron factories on the South Side, factories infamously known for their sweat shop–like conditions.[114] The economic downfall of the Great Depression negatively affected industrial practices across the country, creating dangerous and filthy working environments. In 1933 the U.S. Department of Labor found that "conditions in industry which it was thought had been definitely abolished by law and public opinion" were returning. Long hours, child labor, cheating employees, and labor legislation violation were all rampant in factories.[115] "Literally starvation wages," long working hours, and dirty facilities characterized the Sopkin factories.

The shops' owner, Benjamin Sopkin, was an embodiment of the American dream. A Ukrainian immigrant, he had transformed his once-shared dress-making shop in 1901 to a small empire of six shops in 1933. An immigrant resolute in his labor negotiations, Sopkin was no stranger to labor unrest. When the company broke an agreement for a 10 percent wage increase in 1916, Fannia Cohn, a white Jewish representative from the International Ladies' Garment Workers' Union (ILGWU), led ninety-seven women (presumably all white) on strike in the midst of the clothing industry's busy season.[116] Benjamin Sopkin explained why he reneged on the promise of a wage increase: "We broke off our agreement, but continued our cost survey . . . In view of the fact that our force is increasing and are satisfied they are justly paid, we intend to stand fast."[117] Though the outcome of the strike is not known, Sopkin's unwillingness to negotiate with workers inevitably led him to employ workers who were less likely to organize and the influx of Black Southern migrants gave him a large workers' base to recruit. One year after the 1916 strike, Sopkin called for Black women workers through an article in the *Defender*. Two hundred positions that had previously been held by white women were now open to Black workers, provided they "stay away from trouble." The *Defender* went so far as to advise that women "who have to work"—i.e., sole providers for their family—should stay away, as they were more likely to demand their rights. The article advised,

if the positions were "properly filled with good working girls, [they] will never be turned to whites again."[118] Black women continued to fill white women's jobs in the garment industry as strikebreakers, often working for less and for longer hours, but were less likely to organize.[119] For many Black women, these industrial jobs, though labor-intensive and degrading, were an improvement from domestic service jobs. As the *Defender* commented, "It is the earnest hope of the *Defender* that the girls and women will take advantage of this situation and [learn] something or a trade, so that they won't have to work in a white man's kitchen as a scullion."[120] In the newspaper's opinion, the move from domestic work to industrial labor offered an occupational advancement for Black women. Even if South Side residents described the factories as sweat shops, they were preferential to working in a white family's home.

By 1933, close to fifteen hundred Black women worked in the apron factories scattered on the South Side. Employed mostly in low and semi-skilled jobs, there was little room for advancement or promotion for these women. The Black Sopkin workers were acutely aware their treatment was directly linked to their race. White women employed by Sopkin enjoyed the higher-paying, less labor-intensive positions that were unavailable to Black women. Sopkin made it very clear in his advertisements in local newspapers that only white women should apply for the position of forelady.[121] Black women were frequently hired as cleaners, pinkers, basters, and examiners, earning $1.90 to $7.70 for a full, 52-hour work week; if they were lucky enough to secure skilled work as a cutter or sewer, Black women made between $5.00 and $6.00 per week, compared to white women's wages of $18.00 for the same work.[122] One African American woman worked for three and a half years at the Sopkin factories, but the pay was so paltry, and with her husband unemployed, she was unable to support her three children and depended on relief to supplement her income. Even with financial assistance, she lived in a one-room apartment with no running water, no electricity, and could not afford shoes to work in. A social worker who visited the home could not believe the woman lived in such dirty and unsanitary conditions, and demanded they move residences. However, the Sopkin worker told her, if they move, they will not have money for food.[123] The woman, only identified as "Negro Working Woman," told her story in the *Working Woman* journal, a Communist publication that often featured letters from women around the country. Likely, this woman was not a card-carrying Communist, however her engagement in the Sopkin strike allowed her the

rare opportunity to share her life and lived experiences. Radical publications continued to be an avenue for African American women to make public the injustices they had long suffered.

While the meager wages and blatant racism were enough to spark protest in the Sopkin factories, Black women faced a series of other demoralizing, unnecessary, and unsafe practices. The women were charged to cash their paychecks, detracting from their already starvation wages and imposing additional financial burdens. The injustice was not only economic, as the Black women attested white foremen would enter the poorly furnished women's restrooms at will, denying the decency and respect of privacy.[124] One worker reported that on hot summer days, if a worker faints, she was left on the "filthy floor" until she woke. During the hottest months, the only drinking water was a trickling faucet that hundreds of women shared. The women reported that the boss shouted and cursed at them "like dogs," and treated them as machines; they were not even allowed to smile or look up from their work.[125] An investigation committee made up of University of Chicago professors, a U.S. Department of Labor conciliator, and an editor from the *New Republic* confirmed every rumor about the shops; their practices were "vicious, unscrupulous, and degrading."[126] When the *Chicago Defender* initially advertised work for Black women in the Sopkin factories in 1917, the *Defender* editors expressed their hope that this move to factory work would relieve Black women of the drudgery and indecency of working in domestic service. By July 1933, the newspaper had changed its tune. Institutions that pay such low wages, such as Sopkin's, the editors declared, "are contributors to prostitution and vice. They are enemies to society and to law and order."[127] Industrial work could no longer be described as a "step up" from domestic service as the Sopkin factories showed, indicating the limited opportunities for meaningful employment for Black working-class women.

Through Thelma McWorter Wheaton's lessons at the YMCA, African American workers at Sopkin's factories learned the benefits of unions and labor organizing. However, garment industry unions that allowed Black women in the early 1930s were rare. The International Ladies' Garment Workers' Union had a history of recruiting Black women, but in the early 1930s, the influence of the ILGWU was at an all-time low. The stock market crash had lost the international members, contracts, money, and motivation for strikes.[128] Membership, once in the hundreds of thousands, had dropped to forty thousand, and the organization was over two million dollars in debt.[129] The union's president, Benjamin Schlesinger, had died in June 1932, and the newly elected David Dubinsky

was ready to bury the union.[130] Though the International would eventually re-
cover with support from New Deal legislation and rise to be one of the nation's
most powerful unions, in the beginning months of 1933, there was a large void
in the union movement in the garment industry, especially in Chicago. Local
organizers even admitted their inactivity: "At the beginning of 1933 a number
of our locals practically became inactive."[131] The Communist Party sought to
fill the void in the industry with its radical Needle Trade Workers Industrial
Union (NTWIU), under the Trade Union Unity League (TUUL). Though their
numbers were comparatively miniscule relative to the ILGWU, the NTWIU's
ties to radical organizing attracted attention, which eventually translated into
modest success. Furthermore, the Communist presence in Chicago through the
Unemployed Councils' marches, demonstrations, and the anti-eviction rallies
had helped radicalize Chicago's working-class Black population. The aftermath
of the 1931 riot, the radicalized Black community, the lack of a strong garment
workers' union, and the work of Black women like Wheaton all aligned in the
summer of 1933.

The Sopkin workers had long suffered under sweatshop conditions, how-
ever, the hundreds of workers needed a leader to unite them in organizing.
The beginnings of the strike were spread by word of mouth, and therefore
early organizing records do not exist. Harold Gosnell, a political scientist at
the University of Chicago wrote in 1935 that the strike was organized "under
the leadership of a woman organizer who understood factory conditions and
who had been trained in a workers' school."[132] Some scholars theorize that
Thelma Wheaton began the initial stages of the strike, and while she certainly
understood the poor working conditions and knew the women, she did not
attend a labor school.[133] Wheaton had done important work in educating the
Black women about unions, but Romania Ferguson was a more likely candidate
for the "woman organizer" who first made connections between the CPUSA
and the Sopkin workers. Born Harriet Dayton in Dayton, Ohio, Ferguson had
noticed the organizing potential of Black women ever since her 1928 article
in the *Daily Worker* summarized at the beginning of this chapter. Her official
CPUSA involvement began in 1929 as a member of the Negro Department of
the Communist Party's District 7 and then the American Negro Labor Con-
gress.[134] She traveled throughout the Midwest to lecture on issues related to
African American workers, telling the members of the Young Communist
League in Madison, Wisconsin, "We, the Negroes of this country, are more
oppressed and abused today than we were before the Civil War." From her own

experience organizing Blacks in Chicago, she understood the unique social and political problems African American workers faced. She repeated similar grievances about Black workers being "last hired, first fired," but also added how Blacks were first "pushed to the battlefield when war is declared."[135] Her militant speech mirrored the language of many Black women who expressed the sentiment they were "ready to fight" when the time came.

As her visit to Madison showed, Ferguson was fearless in her public appearances, an attitude that would both penalize her personally, but promote her position in the CPUSA. In 1930 she was sentenced to a fifty dollar fine or thirty days in jail (an unusually strict punishment) for her involvement in an open air antilynching meeting in Chicago.[136] Her tenacity drew the attention of party leaders, and she was soon chosen as the only African American woman representative to the International Lenin School in Moscow during the 1931–1932 academic year. The institute, under control of the Comintern, sought to educate and train international students in Communist theory, politics, and organizing techniques. The Third Period's focus on Black Americans had turned the school's attention toward race, and Ferguson joined eleven African American men in 1931.[137] There, she not only received political training, but experienced freedom and support to examine critical issues regarding race, class, and gender.[138] Ferguson's relationship with her peers was strained; they consistently accused Ferguson of acting like an "Uncle Tom." While she never laid accusations against her white comrades, she was critical of the way Black men in the party held strictly to Black nationalist attitudes and a "harmful" distrust of whites. She thought their emphasis on Black nationalism endangered the movement, and instead looked toward a more conciliatory gesture to ease racial tension.[139] The animosity from her male peers must have been trying, and in the summer of 1932, she officially requested a transfer back to the United States. As she framed it in her transfer request, "I will be the only politically trained Negro woman in the Party at the present time."[140] On returning to the United States, she served as an expert on international Communism, extolling the virtues of the Soviet Union while simultaneously linking Black Americans' experiences to capitalist oppression. In January 1933, she caused quite a stir at the Unitarian church in Evanston, Illinois, where her address was met with vocal anti-Communist protesters. She continued her speech, explaining how the Soviet Union "solved the national minorities program." Encouraging action, Ferguson urged the "Fourteen million Negroes in the United States . . . to follow the revolutionary methods of [Soviet] workers."[141] Her speech was strictly in line

with Communist Party doctrine, as she portrayed Soviet politics and culture in only a positive light. Unlike other African American women who were never confirmed party members, Ferguson definitely "towed the line" when it came to party doctrine, including her unabashed support for the Comintern and Soviet Russia. In this, she was not alone, as a number of other Black women, deeply impressed with the Communist Party's methods, looked toward the Soviet Union in hopeful anticipation.[142] At all times, however, Ferguson related Communist theory back to her own lived experience as an African American working-class woman, highlighting issues like Scottsboro, rampant racism in the North, and Black worker exploitation.

In 1933, Romania Ferguson was the most well-trained African American Communist woman in Chicago, if not the country, and within the first week of the strike, she had made good contact with the Sopkin workers.[143] The radical NTWIU had caught wind of the impending strike and sent their best organizers, Abe Feinglass and E. B. Girsch from New York City, to make sure the workers organized under the TUUL union. Together, they worked with local Communist leaders such as Claude Lightfoot and Jack Kling who already had deep roots and connections in the community.[144] Feinglass, Girsch, Lightfoot, Ferguson, and Kling, under the auspices of the NTWIU, held the first Sopkin workers meeting where more than two hundred workers attended. The group of majority African American women organized a strike committee and elected one of their own, Ida Carter, as chairwoman. The committee decided to declare a strike and formulate their demands for Benjamin Sopkin. Ida Carter and the workers' committee presented Sopkin with their demands, a list related to working conditions, such as sanitation, access to clean drinking water, private bathrooms, ability to join a union, and medical treatment for ill workers. At the top of the list was a 50-hour maximum workday and a 15 percent wage increase with a six dollar per week minimum.[145] Sopkin ignored these initial demands, unwittingly opening the door to a widely publicized, unpleasant labor strike.

The Sopkin workers arrived at work as normal on Monday, June 19, at 7:30 A.M. Two hours later, the chant "Strike! Strike" echoed through the main factory at 3900 S. Michigan Avenue as members of the strike committee went floor to floor encouraging the women to leave their stations. Three more factories followed suit, and soon approximately fifteen hundred women had walked out of their jobs. The women were mostly African American, ranging in age from fourteen to sixty, though most tended to be young.[146] The more militant strike leaders, such as Ida Carter and Ferguson, were worried that women in

other factories would not respond to the strike call. However, as the strike committee went from factory to factory, they were "greeted with cheers" and "all of the shops came out on strike."[147] On the streets, the women began to gather, discussing their wages and demands with each other as well as the press. One woman told the *Chicago Defender* that the working hours were "too long for any human being to work in one day."[148] As mass picket lines assembled outside the Michigan Avenue plant, Benjamin Sopkin looked down from his third-floor office. He could not understand why the women struck, telling reporters, "We have always been good to our employees." He added that Sopkin and Sons factories were among the first to hire Black women, stating the policy started "back in 1915." He neglected to mention these women were brought in as strikebreakers. Sopkin threatened to close all his factories and move out of Chicago if the strike persisted. To deter any sense of the strike's success, Henry Sopkin, Benjamin's son and heir to the company, called the police only fifteen minutes after the strike began.[149] The Chicago Police Department responded with their usual force. Charged with "keeping the peace," the police "kicked, mauled, and slugged and cracked the heads of the women."[150] Many injured women were taken to the hospital, only to return to the picket line once they were treated.[151] The women were undeterred by physical violence, and continued their militant presence in front of the factories. On Tuesday, the second day of the strike, four policemen were knocked down and a fifth was reportedly bitten on the arm by strikers.[152] By the end of the week, workers at the final two Sopkin shops had gone on strike, and police were tasked with patrolling six different locations. The main factory was the location for the most violence and saw up to five hundred demonstrators on the sidewalks each day. The Black press sympathized with the workers and denounced the violence, as the *Defender*'s headlines screamed "Wage-Starved Girls Beaten by Police in Shop Strikes" and "Police Brutally Beat Girls Who Strike." Mary Sallee was a local white woman who had been drawn to the picket lines because she "was in sympathy" with the workers as she had "been a slave" all her life. She described how "hired thugs" beat her and dragged her into a police car, calling her dirty names and then held her for three days in a prison cell. She was then released and charged twenty-five dollars for breaking her umbrella over one policeman's head. As result of her injuries, Sallee was unable to hear out of one ear, a condition she reported to *Working Woman*.[153] Despite the highly publicized violence, Sopkin continued to resist and within the second week of the strike, had begun to hire strikebreakers who came by trolley. The presence

of "scabs" only spurred violent encounters. One afternoon on the picket line, two Black Sopkin workers, Anna Bundy and Dorothy Moore, urged a mob of about one hundred workers to storm the trolley and pull the strikebreakers out of the car. As police approached, the crowd of workers began throwing bricks and stones at the trolley car's windows; one woman thrust her fist through a window, severely cutting her arm. The crowd did not disperse until the officers drew their weapons.[154] The striking women were remarkably courageous in their confrontations with the Chicago police, even when events turned violent, which endeared them to the public and the Communist leaders.

During arbitration with Sopkin, Ida Carter and her fellow workers were resolute in their demands and refused to abandon any measure, which encouraged picketers' continued militant resistance to police. However, the spectacle of violence alarmed local South Side community leaders. Moderate leaders from the Urban League, Young Women's Christian League, local Black politicians, social workers, and clergymen formed an arbitration committee in an effort to convince the Sopkin strikers to compromise. After two meetings, the committee had failed to bring the two sides to an agreement. In one meeting, the women would only entertain suggestions from the committee if prominent Black Communist James Ford was present.[155] Ford was born in Alabama, moved to Chicago after serving in WWII, and then moved on to New York City and was a leading voice for African Americans in the party. He was so impressive that the CPUSA chose him as their official vice-presidential nominee in 1932, 1936, and 1940, making him the first African American in the twentieth century to be on the presidential ticket. After threatening to walk out of negotiations unless Ford was present, the committee of moderate Black leaders allowed Ford to enter the negotiations. However, even with James Ford's influence, the two sides could not reach an agreement.

Another meeting featured local Black politician Oscar DePriest, whom Funsten management and city officials hoped could connect to the Black women. Standing at a podium in a large lecture hall, DePriest suggested that the women settle. Unexpectedly, E. B. Girsch, a white NTWIU organizer from New York, stormed to the platform and confronted him. The workers began to voice their support for Girsch over DePriest, shouting, "We want Gisch! We want Girsch!" The crowd's momentum grew, and soon the hundreds of African American women left the meeting hall with the white Communist, leaving DePriest alone on stage. Even as a primary CPUSA organizer on the South Side, Claude Lightfoot had to admit, "I never dreamed that I would see an event like that."[156]

DePriest, the reoccurring villain for the radical leftists in Chicago represented the moderate approach, a position the Black Sopkin workers could easily identify in their negotiations. By choosing Girsch over DePriest, they ultimately rejected moderate Black politics in favor of Black radicalism.

Eventually, Ida Carter and her workers' committee's persistence and militancy paid off; after two weeks of striking, the Sopkin workers won all their demands, including a 17.5 percent wage increase, a forty-seven-hour work week, a guaranteed nurse and social worker on premises, proper restrooms, water during hot weather, the right to unionize, and no charging for cashing checks. Among the most important agreements was that Sopkin agreed to pay African American and white women the same wages. Along with the arbitration committee and Benjamin Sopkin, the agreement was signed by more than a dozen Black Sopkin workers, signifying a remarkable step these women took to declare and affirm their rights as working-class African American women.[157] Only a few months prior, promoting this type of self-interest most certainly would have ended in a worker's termination. However, trained by Thelma McWorter Wheaton, organized by Romania Ferguson, and led by Ida Carter, the Sopkin workers exhibited remarkable courage and conviction, and demonstrated a commitment to action informed by Midwestern Black radicalism.

After the successful end to the strike, it became apparent that the radical NTWIU was not the only union in town. Though the strike was organized under NTWIU leadership, the settlement the workers and Sopkin reached allowed for any union representation. Ultimately, this was a complete failure for the Communists, as they preferred sole bargaining rights for the radical union. However, the Black Sopkin women were not necessarily swept up with the promises of radical unions. Though radical Black women extolled the virtues of the TUUL and CPUSA, the workers had their own futures and livelihoods to consider. The TUUL and NTWIU specifically had small memberships and funding, and, it was rumored, the ILGWU was gaining momentum. In fact, less than one month after the Sopkin strikers settled, the ILGWU, bolstered by the recently passed National Recovery Act of 1933, organized a national industry-wide strike. The strike centered on the garment factories in New York City, workers around the country responded, and by the end of the summer, the ILGWU reported nearly 60,000 participants. Over 7,500 garment workers in Chicago alone walked out of their work, including many African American women. Five hundred Black women joined the union as a result of the strike, taking to the pulpits of churches near factories and instituting other

education-spreading campaigns.[158] The July 1933 Sopkin strike was not, then, an aberration on the part of Black women in Chicago advocating for their rights as workers, but an indication for their future unionizing success in the garment industry.

While the TUUL's NTWIU was a part of the national strike, radical unionizing was hard to sustain, and its claim of 15,000 members was likely exaggerated.[159] However, the Sopkin workers laid a groundwork for future union organizing in the city, even if it was not with the NTWIU. In 1934, Frank Crosswaith, a Black Socialist organizer from New York approached the Sopkin workers about organizing under the ILWGU. Crosswaith knew he needed to have a personal connection with the women, so he employed local Black activist Thyra Edwards. Edwards, though born in Texas, had called Chicago her home for the past five years, and, as a social worker, she better than anyone understood the plight of the Black working class. As well, her labor education was extensive. Through a scholarship with the BSCP, Edwards attended Brookwood Labor College in Katonah, New York, where she studied economics, labor history, public speaking, and journalism under the direction of noted labor organizer, minister, and pacifist, A. J. Muste.[160] The school trained workers to become experienced labor organizers, and in small classes, students read extensively on labor history and the present conditions of workers throughout the world. Thanks again to A. Philip Randolph and the BSCP, she received additional funds to attend the International People's College in Elsinore, Denmark, for six months. As opposed to Romania Ferguson's Communist-centered education abroad, Edwards attended lessons on literature, sociology, anthropology, and Danish history and politics.[161] She also traveled to Moscow, extensively reporting on her journeys to the Associated Negro Press.[162] This labor education, both stateside and abroad, helped provide a historical and theoretical foundation for problems Edwards had already encountered. When she returned to Chicago, Edwards brought with her a deeper understanding of the history of labor as well as practical solutions for organizing Black workers.

When Crosswaith and Edwards entered the Sopkin factories in 1935, they found conditions had not improved much from conditions before the 1933 strike. Though the agreement had allowed unions, none had been formed. Experienced workers were fired without notice, replaced by low-wage unskilled workers without any union representation and therefore recourse. Upon learning the details of the situation, Edwards turned to her journalistic impulse. In the March 1935 issue of *Crisis*, she published a scathing article sarcastically

titled, "Let Us Have More like Mr. Sopkin."[163] The reason there was no union representation in the Sopkin shops, according to Edwards, was Ben Sopkin's sparing "neither pains nor money" to see that workers would never join any union other than his own company union. The Sopkin company union could limit the workers' rights, and under Sopkin's watchful eye, the workers served more as propaganda than people.[164] Sopkin instituted a "Loyalty Week," where large white posters took over South Side restaurants and shops reading:

> Be Loyal to Your Family.
> Be Loyal to Your Friends.
> Be Loyal to Your Community.
> Be Loyal to Your Government.
> Be Loyal to Your Church.
> But Most of All
> BE LOYAL TO YOUR JOB.[165]

When the ILWGU began a national drive to organize garment workers in early 1935, Sopkin "intensified his counter-union drive" and hired a publicist to create the appearance that the women were satisfied with the company union. African American workers paced every day in front of the factories with placards that read, "We Are Satisfied with Our Jobs . . . Wages . . . Hours . . . Working Conditions . . . Employer. AGITATORS, KEEP AWAY!"[166] They were forced to wear armbands that branded them employees of Sopkin, and if they were seen after working hours without them, were subject to disciplinary action. Sopkin's reach extended beyond the factory walls to a desire for complete submission from his workers. He even brought in Black church leaders during lunch hours to preach to the women with sermons titled, "Loyalty to Mr. Sopkin," who, for twenty-five years had "been like a father to the Negro women on the South Side." He even let them work in his factories on his machines. Edwards, in her no-holds-barred journalistic style sardonically comments, "Well, so did 'ole massa' in slavery. What of it?" Throughout her critique, Edwards was quick to liken the Black women workers' situation to slavery. In a second article on the topic, she noted the accommodationist tactics of local Black leaders, such as former congressman Oscar De Priest, social worker Jennie Lawrence, and religious leaders who were quick to side with Ben Sopkin. Their efforts, she argued, directly undermined the struggle and sacrifice of the workers, keeping them uninformed and divided. She accused these Black leaders of tolerating rather

than challenging unjust racist practices, much like the Uncle Tom character in history. She noted, "Uncle Tom did not originate in fiction. Nor did he die with the Emancipation Proclamation. He is perpetuated and immortalized in the type of leadership that sells the Negro for a few sound American dollars."[167] Her scathing condemnation echoed Communist critiques of Black moderates, such as Oscar DePriest. In bringing the idea of complacent and tolerant African American leaders to the front of the protest, Edwards again asserted the radical notion that Black working class women should control their own destiny.

Edwards's words no doubt drew the attention of Ben Sopkin, whose obsessive need to control the Black working women drove him to respond. However, his contribution could not be obvious, and therefore it was J. Welling Evans, a Black cutter in the Sopkin factories, who wrote "Thumbs Down on Unions!" in the following issue of *Crisis* as a defense. Evans declared Edwards to be "disinterested" and a pawn of Crosswaith and the ILWGU, as her article was "so far extended that it far over-reaches its purpose and dips impotently into fable."[168] Evans's ad hominem attack contained little discussion of Edwards's substantial accusations regarding the nature of Black labor. When Edwards responded the next month, she was sure to continue her discussion of the conflict between Black and white labor, citing the history of Black workers as strike-breakers.[169] She also continued her critique of the concept of shop loyalty. "The girls in the Sopkin shops did not wear Mr. Sopkin's 'loyalty bands' because they love Mr. Sopkin any more than Negroes down South love to ride in Jim Crow cars. It is compulsion and fear born of lack of organized power."[170] Edwards's observations harken back to Romania Ferguson's arguments from 1928, that the absence of Black women in unions was not a sign that they were unable or unwilling to engage in working-class solidarity, only that they needed the guidance and support from trained activists.

Edwards was not naïve enough to think that joining labor unions would solve all the Black working class's problems, but she saw it as an important step for Black workers to reclaim their dignity and agency in the workplace. Though the ILWGU did not make ground in the Sopkin factories in 1935, the workers continued to fight, and finally, in 1937, they were successful in establishing a union.[171] While Edwards's foray into direct union organizing had limited success, her articles show her persistence to the centrality of labor in the struggle for racial justice. Furthermore, her approval of the 1933 Communist-led strike confirmed her attitude that radicalism had its place among Black workers. A few years earlier, she had noted, "From its inception as free labor, Negro labor

had elements of radicalism and of class consciousness."[172] Because she sym-
pathized with Communist-led causes and her rhetoric often mirrored that of
the party, Edwards was often mistaken for a Communist. Edwards, though,
did not identify as a member of the Communist Party, content to align herself
with radical causes in the pursuit of justice.

Thyra Edwards was a bit of an enigma and deserves a bit more attention
in this discussion of Midwestern Black radicalism. Unlike most of the Black
Sopkin workers, Edwards came from a relatively privileged background and
received remarkable education in the United States and Europe. However, her
middle-class background enabled her to reach levels of activism many could
not. After her involvement in the Sopkin strike of 1935, Edwards became a
highly sought speaker at dinners, sorority gatherings, celebrations that wel-
comed international guests, and labor conferences. Edwards spoke to a diver-
sity of audiences, crossing boundaries of race, class, and gender, leading one
newspaper to describe her as "one of the most outstanding Negro women in the
world."[173] Edwards crafted a political ideology that was distinctly her own. Her
scathing critiques of complacent, middle-class Blacks, so-called social workers,
and government relief efforts and her embrace of the European labor models
positioned her as a leading thinker and activist of Midwestern Black radical-
ism. She continually pushed the boundaries of middle-class respectability: she
hosted interracial seminars in the Soviet Union, she traveled as an embedded
reporter with Loyalists during the Spanish Civil War, and her unpublished
autobiography indicates a radical interpretation of sexual liberty.[174] While she
was able to take advantage of opportunities provided by the BSCP and those
adhering to the politics of respectability, Edwards cast aside traditional expec-
tations of Black women. Her involvement in the Sopkin strike was only one
step in her career, but an important one in establishing her political identity.

As the Great Depression wore on, radical non-Communist Black women
in the Chicago area had continued opportunities to work alongside Commu-
nists. One of the great opportunities for women to continue forging these ties
was the establishment of the National Negro Congress (NNC). Members of
the Young Communist League, the NAACP, the BSCP, and other civic and
religious organizations made their way to Chicago for the inaugural NNC
meeting on February 14–16, 1936. Among the illustrious attendees were Rev.
Adam Clayton Powell, poet and author Langston Hughes, James Ford of the
CPUSA, attorney Ben Davis, political scientist Ralph Bunche, and Communist
Angelo Herndon.[175] They gathered at the Eighth Regiment Armory on the

South Side, a building that held significant symbolic importance for the Black community in Chicago, stemming from the welcoming of WWI veterans and UNIA meetings during the 1920s. There, the 750 delegates created a coalition designed to end racial discrimination, lynching terror, and other issues particular to Black communities across the country.[176] Deciding on a pro-working-class agenda and the catchy slogan "Death Blow to Jim Crow," the convention dispersed with A. Philip Randolph as president and John P. Davis executive secretary. Thyra Edwards and hundreds of other African American women attended, and, together, the female delegates composed the NNC's statement on Black women, which declared them to be "subjected to three-fold exploitation as women, as workers, and as Negroes."[177] The NNC's recognition of Black women's "three-fold exploitation" placed the organization among only a few groups that identified the overlapping social identities of Black working-class women. Previously, the Communist Party had been the most vocal advocate against what they would later call "triple oppression," as mainstream civil rights groups such as the NAACP or the Urban League tended to overlook the distinct issues these women faced. Thyra Edwards made sure to draw attention to the particular exploited position of Black working-class women, and as the chair of the Committee on Women's Work she led a discussion on the topic "How Can Negro Women Industrial Workers Solve Their Problems?"[178] Edwards's discussion mirrors Romania Ferguson's *Daily Worker* article from 1928: African American women in industry are ready to organize and fight for their rights in industry, however, need guidance on the first steps. Led by Black women, Communist and non-Communist, trained in industrial organizing, Chicago's Black women in industry began to make considerable progress.

Though many of the Communist ideas of racial oppression and radical organizing were present in the NNC, for the most part, leading Black Chicago Communists were absent from leadership positions in the new organization. Though national Black Communist James Ford was at the forefront of establishing the NNC, Chicago Communists either stayed away or downplayed their radical affiliations in order to combat the perception that the NNC was a Communist organization.[179] Claude Lightfoot and Romania Ferguson, prominent figures among Chicago's party members, stepped away from publicly endorsing the NNC in an effort to promote the organization's broad appeal. As the decade wore on, however, the divisions between the Communists and non-Communists in the NNC would deepen, resulting in A. Philip Randolph's refusal to stay on as president in 1940.[180]

The industrial focus of the NNC allowed African American women to continue working toward union organizing efforts that began in the Sopkin factories a few years prior. In a remarkable display of courage, Chicago-born Eleanor Rye led the effort to educate and organize employees at a metal factory in Chicago. Under the auspices of the Steel Workers Organizing Committee (SWOC) of the Congress of Industrial Organizations, Rye snuck by the police line and climbed a fifteen-foot-high fence to reach the striking workers. Two additional African American women, Fanny Brown and Ola Bell Francis, labeled "ace organizers," joined her, risking their reputations, jobs, and potentially their lives.[181] Their dramatic efforts paid off, as SWOC successfully negotiated a wage increase, forty-hour workweek, overtime pay, and promotion based on merit rather than race. Historian Erik Gellman describes this event as a sign that the culture of labor organizing in Chicago had "noticeably transformed."[182] The Black radicalism that helped propel the Unemployed Councils and the Sopkin strike had made its way into more mainstream organizing techniques, still led by African American women. Black women, from Romania Ferguson to Thyra Edwards to Eleanor Rye had continually pressed Black working class interests to the forefront, and St. Clair Drake and Horace Cayton even noticed the city's acceptance of labor activity, writing, "By 1938, it had become respectable to support a demonstration or boycott in the struggle for Negro rights."[183] With their radical, public activism, these women radically reinterpreted notions of respectability for Black women, as traditional gender, class, and race expectations had limited their involvement in the Black working-class struggle. While climbing fences never became a staple of middle-class respectability, as Drake and Cayton noted, protests, boycotts, and demonstrations did. Ferguson, Edwards, and Rye, each in their unique way, enhanced Black radicalism to suit the needs of their community.

Eleanor Rye continued her work as a "leading sprit" in the local women's auxiliary of the BSCP union, and also the SWOC, the NNC, and as a member of the CPUSA.[184] She had come from a working-class family, born in the shadows of Chicago's infamous stockyards, what one writer called the "Great American Outhouse." Over the course of her life, she held numerous working-class jobs, but none more successful than her role in the Congress of Industrial Organizations (CIO) union building and the NNC. As the CPUSA turned toward the Popular Front era, Rye became more involved with the party.[185] As a leading Black woman in the radical union movement, she performed key roles in recruiting women to the cause. She penned a passionate article in the *Chicago Defender* titled, "Women in Steel," answering the question, "What can the women do?"

In the past, women had encouraged their husbands to avoid striking, because families needed the financial support. However, Rye argued that only with the 100 percent participation of all workers, "regardless of race, color or creed," could workers achieve significant rights. Women, and Black women in particular, she wrote, must encourage their husbands and relatives to join CIO unions, as unions could assure higher wages, shorter hours, and better working conditions. Yet, the repercussions of joining a CIO union extended beyond the factory walls. As Rye argued, "The fight to organize the steel industry in its broader aspects means that the real social, political, and industrial democracy will prevail."[186] Rye's extraordinary mix of eloquence and fearless militancy drew attention from other movements, and she went on to help organize the Furrier's Union, providing an essential link between the BSCP, SWOC, NNC, and other burgeoning labor movements.[187] Despite her CPUSA membership, Rye's ability to create connections and relationships between organizations made her one of the most effective labor organizers in the region. Her tireless efforts, however, took their toll on her personal life. She married Otto Broady, an electrician, and found she was "having a hell of a time with domestic affairs." During 1936, Otto was ill and she was often split between nursing him at home and touring the Midwest to organize steelworkers. In the fall of 1936, she wrote to John P. Davis, executive secretary of the NNC, that she was burned out. "Goddamn this lousy world," she vented.[188] Otto eventually recovered, and Eleanor Rye Broady continued her work with SWOC, the NNC, and other CIO unions, though she continued to fight to find the balance between her personal and political life.

Thyra Edwards and Rye Broady crossed paths as members of the NNC and the Chicago Council of Negro Organizations (CCNO), a liberal organization made up of members of the Urban League, NAACP, and other mainstream Black institutions. Relations between the NNC and CCNO were tense.[189] Although the nature of labor organizing in Chicago had turned more radical, the established Black middle class was still suspicious of Communist involvement. Rye Broady accused the CCNO of "trying to steal thunder from [the NNC]," admitting that "in many instances [they] are succeeding quite well."[190] For women like Rye Broady and Edwards, Midwestern Black radicalism in Chicago meant negotiating spaces between the radicalized working class and the established Black middle class. The CCNO and the NNC, despite their infighting, could agree on one radical point: African American women played an essential role in organizing Black workers.

As the CPUSA entered the Popular Front era, the radical union organizing efforts began to see concrete results. In 1937, the Sopkin factories officially

recognized the ILWGU, signifying the end of a four-year-long struggle to bring justice to hundreds of Black women on the South Side.[191] The victory, however, was insufficient to secure the workers' rights. Louis Sopkin had already begun to move his operations to Fall River, Massachusetts, leaving behind hundreds of Black families on the South Side without work.[192] The Sopkin strikes, however, were not a failure. They provided the opportunity for many women to flex their Black radicalism, creating strong alliances and lasting communities. As a journalist, social worker, activist, and labor organizer, Thyra Edwards was greatly influenced by her involvement in the Sopkin organizing efforts. She continued to vigorously campaign for workers' rights around the world, her travels taking her to war-torn Spain and Mexico. Eleanor Rye Broady continued traveling throughout the Midwest to encourage Black workers to organize. Romania Ferguson continued her activism, though unlike Edwards, distinctly named herself and her activities Communist. In 1934, Ferguson ran for superintendent of public education in Illinois on a full communist ticket; six years later, she ran for state auditor, again on the CPUSA ticket.[193] She served on the advisory committee for the Chicago Workers' School, described as the "central school of the revolutionary working class organizations of the middle west."[194] Though Ferguson's activism in organizing and educating workers mirrored that of Edwards by identifying as an ardent Communist, her influence waned during the Popular Front era and as the country entered World War II. She gradually began to accept forging coalitions with mainstream liberals; in a March 1945 meeting of the South Side's CPUSA, Ferguson suggested the members meet with local democratic congressmen in order to coordinate an upcoming peace conference. Though no definite plans were carried out, Ferguson's willingness to cooperate showed how she perceived the fading influence of the CPUSA.[195]

Ferguson's assertion in 1928 that African American women in industry were ready to fight for their rights proved accurate as the Great Depression propelled them into radical activities. While Chicago offered a more fertile ground for labor organizing than St. Louis or Detroit, the women often faced adversities and challenges that threatened their lives and homes. However, as the Sopkin strikers, Eleanor Rye Broady, Romania Ferguson, Thelma McWorter Wheaton, and Thyra Edwards showed, the ability to connect issues of race, class, and gender distinctly shape their ability to find new alliances and opportunities in the struggle for justice.

CHAPTER 4

"We'll Not Starve Peacefully": Black Women's Revolution and Reform in Cleveland

I n a downpour of freezing rain and sleet, Mary Tabb, an unemployed African American worker, marched to Cleveland City Hall in thin clothing and torn shoes. Fed up with habitual unemployment, hunger, lack of medical care, and unrelenting economic hardship, Tabb broke with traditional norms of Black women's respectability in Cleveland to confront white politicians and, in no uncertain terms, demand improved relief for her own family and thousands of other working-class families.[1] "We'll not starve peacefully!," she declared to Cleveland's mayor and board of aldermen.[2] Prior to the Great Depression, middle-class African American families in Cleveland had enjoyed a relatively prosperous and stable life, embracing traditional values such as respectability and civic reform. However, for Tabb, the era of reform-minded Black club-women and churchwomen had passed, as widespread hardship necessitated Black woman-led militant and public action.

Many other African American women in Cleveland had similar experiences to Tabb during the early years of the Great Depression, choosing to reject the liberal-minded reform of the Forest City in favor of increasingly radicalized activism. Maggie Jones not only joined her local Unemployed Council, but helped lead and organize it into one of the largest councils in Ohio.[3] Six Black women, impressed by the relief efforts of the UC, brought Communist leaders to speak at their church, demonstrating how their commitment to radical activism could complement their faith.[4] Outside of the South and Harlem, Cleveland in the mid-1930s had one of the most active communities in supporting the International Labor Defense and the Scottsboro Boys, and local Black women were some of the most vocal and ardent supporters. The city also provided fertile ground for party leaders to hone their skills; Maude White helped organize

131

women and protest white supremacy in the city, eventually moving on to be-
come a leading Black woman in the Communist Party, Future Outlook League,
and the National Negro Congress. African American women's commitment
to antipoverty measures, employment, and the housing of Black women in
Cleveland during the early Great Depression established a vibrant, dedicated
activist Black community ready to embrace the next chapter of change.

Black women in Cleveland have rarely been on the radar for radical histori-
ans. Due to its northeastern location and perceived liberal social and cultural
history, Cleveland has often been considered an offshoot of New England
regionalism and more closely linked with the upper-class respectability of the
Protestant East Coast rather than the radical militancy of Chicago. The Black
middle class's embrace of liberalism and an emphasis on reform and stability
rather than radicalism birthed an emphasis on mainstream civil rights orga-
nizations and Black clubwomen's activism in the city in the early nineteenth
century. Scholarly works on African American women in Cleveland are scarce;
even works on African Americans in Cleveland during the Great Depression
have been sorely lacking, stopping short of the distinctive years of the decade.
Historians of Cleveland underemphasize Black radicalism, claiming Blacks
were either disinterested in radical organizing or manipulated by whites.[5]
This interpretation, though, ignores multitudes of sources by and about Black
Clevelanders, who not only worked with white Communists, but challenged
reform and liberalism by embracing Midwestern Black radicalism. A local
study, taking into account race, region, class, and gender, reenvisions these
workers as founders of a new form of Black labor and community activism
in Cleveland.[6] In particular, a substantial aspect of this new Black activism
included the role of Black women and community-based Black radicals, es-
pecially in organizations like the Future Outlook League, the Congress of
Industrial Organizations, and the National Negro Congress, which developed
during the mid-1930s.

The postwar Great Migration and the woes of the Great Depression changed
not only the demographic makeup of the "Forest City," but also how Cleve-
landers, white and Black, approached activism and change. No longer content
with liberal reform and depending on government institutions, women like
Mary Tabb, Maggie Jones, and Maude White joined forces with the Unem-
ployed Councils and Black and white Communists to transform their lives
and their city.

FROM "NEGRO'S PARADISE" TO "ALABAMA NORTH"

Though firmly located in the geographic Midwest, Cleveland residents experienced race relations differently from Chicago, St. Louis, and Detroit. As a northern industrial city, Cleveland seemed more in line with New England in terms of racial integration. A strong abolitionist population prior to the Civil War helped foster a liberal attitude toward race, and during the 1830s, many Clevelanders helped fleeing Blacks escape enslavement, providing safe passage to Canada via the Underground Railroad.[7] By the end of the nineteenth century, most public facilities were nondiscriminatory, public schools were integrated, and African Americans enjoyed greater economic opportunity than most urban Blacks in the Midwest.[8] This success was limited to established populations of the Black upper and middle classes, mostly professionals and highly skilled workers. By 1915, established Black elites had made Cleveland their home. Professionals, business owners, and adherents to Booker T. Washington's self-help and accommodationist approach to civil rights, these men and women carved out a place for middle to upper class Blacks in the Midwestern city.[9] Middle- and upper-class Black Clevelanders created local branches of national race organizations as well as new institutions to represent their interests in the city. Jane Edna Hunter, a professional nurse, founded the city's only major secular organization pre-WWI in 1912. Her Phillis Wheatley Association (PWA) sought to ameliorate the woes of homeless girls, promoting education and secure employment. Following in Washington's ideological footsteps, Hunter and the association steered away from integrationist arguments and instead promoted Black self-sufficiency, employment, and political accommodation.[10] Though her work was initially controversial, Hunter gradually won over the Black ministers in the city. The PWA and Hunter's approach to reform in Cleveland adhered strongly to the politics of respectability, working within institutions representing middle-class Black women's interest.[11]

Those dissatisfied with the limited scope of the PWA turned to national organizations. The Cleveland branch of the Urban League, called the Negro Welfare Association (NWA), was created in 1917 to "advance social and economic conditions" of Black Clevelanders. Under the leadership of Black social worker William R. Connors, who held a doctorate from the University of Pennsylvania, the association vigorously pursued a self-help agenda, finding jobs for workers, while exposing the conditions of Blacks in the city through published

research.[12] With economic employment as the association's primary goal, the association excelled; during the first two years of operation, the organization placed over 80 percent of applicants in jobs.[13] Joining the Negro Welfare Association was the local branch of the NAACP, founded in 1914. Membership, however, was small, and leadership in the early years was largely ineffective. While the national NAACP actively organized protests around the racist film *Birth of a Nation*, social events took priority for the Cleveland branch during its early years. By the 1920s, however, an influx of New Negroes took command of the leadership and took a more active role in fighting for racial advancement. Eschewing the accommodationist approach, the reinvigorated NAACP attacked discrimination in the city in the courts, achieving several victories against segregation in theaters and restaurants.[14] Similar to their counterpart chapters in Detroit, the NAACP's battles during the 1920s and 1930s focused on middle to upper class African American communities and concerns, primarily issues regarding segregation. The NAACP, PWA, and NWA faced continuing challenges during the Great Migration, as increasing numbers of African Americans in the city highlighted and exacerbated the city's racial issues. The small Black population in Cleveland found their city inundated with migrants after World War I. In 1910, 8,448 Blacks lived in Cleveland, making up 2.3 percent of the population. By 1920, there were 34,451 (4.3 percent) Blacks in the city, and by 1930, 7.9 percent of the city's nine hundred thousand residents were African American.[15] The city's Black population growth was second only to Detroit in the Midwest, and as in Detroit, the prospect of jobs and racial integration drew Southern Blacks to the city.[16]

Often, Black women led the way to the northern promised lands. Bertha Cowan moved from Lynchburg, Virginia, to Cleveland in 1917 with her family close behind. "And all the flock followed me. I accepted being the leader. All my family came up, lot of my friends, lot of people you knew."[17] As a matriarch to not only her immediate family but also extended community network, Cowan exuded confidence as thousands in her community made their way north. Having community leaders was essential in establishing new communities in the North, as older residents helped newcomers get settled. Recent migrants depended on local institutions, such as the NWA and churches, to help them find housing and employment. Cowan remembered churches being especially helpful, telling migrants "where to shop and how to buy clothes."[18]

The majority of new African Americans in Cleveland, both men and women, came from working-class backgrounds. In 1920, about two thirds of the African

American male population was semiskilled or unskilled, employed in indus-
try; nearly the same percentage of African American women was employed
as domestic workers.[19] However, the Forest City offered something new to
Southern migrants: industrial jobs, though mostly reserved for men. Though
iron and steel were the "backbone of Cleveland industry," the city also of-
fered a diverse manufacturing base.[20] Black men could find jobs in low and
no-skilled occupations in transportation, construction, auto body plants, and
casual labor. However, these industries were susceptible to seasonal fluctua-
tions, and African American men often vacillated between heavy and light
industry and domestic service. Unlike in Midwestern cities such as Detroit,
Cleveland's Black men could easily find casual employment, following better
economic opportunities in the 1920s.[21] African American women, on the other
hand found their employment options limited. While Black women who had
completed high school could find clerical or office work, most middle-class
jobs, such as department store attendants, were off limits.[22] In the late 1920s,
Black women found increasing employment in light industry, such as pressers
in dry cleaners, occupations previously off-limits for them.[23] Yet, domestic
service dominated as Black women's work. From 1920 to 1930, the percent of
African American wage-earning women in domestic service rose from 77 to
86 percent. More than half of Black women worked in household service. Their
representation in these numbers was largely disproportionate to their status
in the city's general population.[24]

The growth in Black population in Cleveland put economic stress on the city
and despite the city's liberal history, created new racial tensions and aggravated
latent ones. Colorism ran rampant in the city; African Americans with lighter
skin were often hired over darker skinned workers. Margie Glass, a migrant
from Alabama, found her options limited to domestic work, but if competing
with thousands of other women was not enough of a challenge, she learned
most employers "wanted mulattos; nobody wanted dark people."[25] One African
American man was told by a train station manager that he was "too Black, too
dark" to be employed.[26] Racism went beyond hiring practices in Cleveland,
extending to public and social life. Southern migrant Sally Hopson moved to
the Fairfax community in the 1920s, an area occupied mostly by white Eastern
Europeans. Finding their neighborhoods threatened by the new migrants,
whites in Fairfax enforced racial segregation in public places, though tech-
nically illegal. Hopson could not swim in the same pools or attend the same
dances as whites in the neighborhood. As more African Americans moved

to the neighborhood, however, the demographic makeup shifted away from mostly Eastern Europeans. Finding a home in the Fairfax community, African Americans established a thriving commercial district, featuring barbers, dry cleaners, laundries, and grocery stores.[27] However, the expansion of Fairfax community, along with other majority Black neighborhoods in the city, came at the expense of intense segregation.

Racial tension often breeds a racial consciousness. De facto segregation and northern racism spurred the New Negro Movement and Black Americans' search for racial advocacy. Like others in Midwestern cities, the Black working class in Cleveland responded positively to the burgeoning Universal Negro Improvement Association. First visiting the city in May 1920, four hundred supporters greeted the "negro savior."[28] Returning in January 1921, the charismatic Garvey thrilled packed crowds and the *Cleveland Advocate* noted he "bubble[d] over" with elements of leadership. "From evidence of approbation given by the hand-clapping at the meetings," wrote the *Advocate*, "it can be hazarded that 'the seed fell on good ground.'"[29] Black Clevelanders seemed to respond eagerly to Garvey's messages of racial pride, African unity, and self-determination. Most of the area's members were interested in how the government failed to fight racism and shut down white supremacist groups, such as the Ku Klux Klan.[30] Reports indicated there were several thousand followers in Cleveland; Garvey, however, reported greater numbers. The UNIA has "strong branches" in Ohio, wrote Garvey in a 1923 letter. He cited 20,000 members in Cleveland, 15,000 in Cincinnati, and 10,000 in the state's capital of Columbus.[31] These membership numbers were likely exaggerated, however; while they may have not registered or paid dues, many African Americans considered themselves Garveyites, following Garvey's teachings and building on his pan-Africanist messages. One Black Clevelander remembered watching a parade on a Sunday afternoon, and "when Garvey rode by in his plumed hat, I got an emotional lift, which swept me above the poverty and prejudice by which my life was limited."[32] Historian Erik McDuffie, in his analysis of the "diasporic Midwest," notes how the pageantry and parades stimulated working class African Americans' sensibilities in how they connected to all people of African descent. Garveyism, as McDuffie argues, provided an essential foundation for working-class Blacks to "weather the racism and poverty" of Cleveland.[33]

From its inception, the Cleveland UNIA membership was mainly Black workers, many recent migrants from the South. The chapter's founder was a former member of the International Workers of the World, though this did

not necessarily mean, within Cleveland's UNIA, champion of the working class. When Garvey and other national leaders visited the city and spoke to thousands of Black workers, labor issues, such as union organizing, were mostly absent. This was not unusual; while the working class made up the rank and file, the UNIA emphasized independent Black economy, which did not support organizing with white workers.

As in other cities, Garveyite women practiced "community feminism," supporting the movement and challenging its masculine hierarchy in a variety of ways. Lavinia D. M. Smith, a public school teacher, wrote an article for the *Negro World* in 1921 titled, "What Does the Garvey Movement Mean for Negro Womanhood?" She appreciated Garvey's message, stating it gave Black women an "opportunity to stand shoulder to shoulder with the men in the great cause for the redemption of Africa."[34] Echoing the sentiments of Garveyite women around the world, Smith acknowledges the opportunities the UNIA movement provided for Black women. Though they may not have been directly "shoulder to shoulder" with the men in the organization as Smith declared, Cleveland Garveyite women served important roles as members of the Black Cross Nurses, fundraisers, lady presidents, and other community service. In doing so, they fundamentally shaped the way Black radicalism operated in the city.

The year 1923 marked the height of the division's influence in the city, but the original spark that attracted thousands to the movement died out in the second half of the 1920s. By 1930, following trends in other Midwestern cities, the UNIA's influence waned after Garvey's incarceration. As well, Cleveland's chapter experienced local inter-organization disputes, sexism and class division, and local political conditions that threatened its survival.[35] Garveyism would rise again in the city in 1940 when Cleveland became the UNIA's national headquarters, laying important groundwork for civil rights and Black Power movements in the region. Certainly, Garvey's teachings survived through the Great Depression, but they manifested in other radical organizations.

For Cleveland, an industrial city, the economic collapse of 1929 signaled a massive and catastrophic change in employment opportunities for the working class. Close to forty-one thousand Cleveland workers were jobless in 1930, and one year later, the total reached one hundred thousand.[36] Mostly employed in industrial labor, working-class Black men were the first to be laid off or assigned to part-time work as factories responded to economic pressures. Natalie Middleton's father was unemployed for nearly ten years, only able to find odd jobs here and there. During the Depression, her family resorted to "one pot

meals," where a chicken stewed with leftover vegetables all day. Middleton's family did all they could to cut costs; they took in boarders and, as a young girl, she was compelled to forego education for a paycheck. Still, they had to make significant lifestyle changes in order to survive. She remembered "sitting in one room, everybody, that included some of the roomers. . . . We'd sit in one room and burn one light."[37] Families, friends, and neighbors had a tendency to maintain working-class solidarity, often providing for the neediest in their community. As another girl who lived through the Depression, Ethel Woodward remembered her family believed "very much in sharing." Although her family had little as it was, her mother would still share food, shelter, and clothing. As Woodward noted in an interview later in life, "People seemed to share a lot then."[38]

As communities rallied around each other, African American workers sought any source of income or employment. Natalie Middleton's mother, who had previously stayed home to tend to the family, ventured out and was fortunate enough to find employment as a cook. She was not alone; thousands of Black women who previously stayed at home sought work during the Great Depression. However, as the NWA reported, "opportunities for this type of work were so limited" that they placed only 298 Black women in domestic jobs in 1930. There were simply no jobs available. The NWA reported that requests from employers wanting workers went from 10,241 in 1929 to 3,442 in 1930.[39] As in other cities, African American women bore the brunt of these limited opportunities. Any gains made in light industry were lost, as white women's employment took precedence.[40] With increasing unionization in light industry, Black women were blocked from any involvement in organizing. Even though the New Deal NRA codes aimed to improve the lot of all workers, the NWA found that "with the enactment of minimum wage laws, which as a rule increase wages, there are further decreases in opportunities for colored women workers."[41] While cities like Chicago and St. Louis had workers devoted to increasing labor education among Black working-class women, Cleveland lacked the resources to help the women fight against discrimination in the industrial workplace. The NWA even acknowledged its "lack of equipment for this work."[42] Therefore, if African American women wished to participate in the class struggle, they would have to find means outside labor organizing.

The plummet of employment opportunities and wages wreaked havoc on the segregated Black communities. In 1929, 90 percent of Blacks lived in a small neighborhood, east of downtown Cleveland, known as Central Area.[43] Densely

populated, ill kept, and often without modern facilities, the Central Area district became known as a home to gambling, sex work, and theft.[44] Sickness ran rampant, as access to health care was limited. The NWA tied poor health conditions directly to inadequate housing and miseducation about disease.[45] Blacks living in the so-called "Colored belt" were at a significantly greater health risk. The highest causes of death among Blacks in the area were tuberculosis, pneumonia, and syphilis, treatable and preventable diseases.[46] From 1929 to 1933, the area experienced almost 80 infant deaths per 1,000 live births. For whites in the city of Cleveland, , the number was only 53.[47] The disparity between white and Black working-class Clevelanders, while present prior to the Great Depression, were only made more blatant by the Great Depression.

Outsiders knew the dismal living conditions of the African American working class. Charles W. Chesnutt was an influential Black attorney in Cleveland who wrote short stories and novels about racial and social identity after the Civil War. In 1930, he published an article regarding the plight of African Americans in the city. He observed that most African American Clevelanders were poor, "some of them very poor," living in "drab, middle or low class houses, none too well-kept up," far from their white counterparts.[48] The physical separation between Blacks and whites and the established Black upper and lower class only increased racial tensions. Restrictive covenants and racist housing practices kept the African American working class bound to Central Area for housing, though residents often traveled out of the area for work. To control and physically confine the influx population of Black workers, white Clevelanders began to impose anti-Black regulations on public facilities and exclusionary policies in private theaters, parks, hotels, and restaurants. Chesnutt noted that there were very few places in downtown Cleveland he could take "a dark-colored man" for lunch (Chesnutt himself was light-skinned). Though Cleveland law still forbade discrimination in public places, de facto segregation ruled the city due to a general sense of helplessness. "One does not care to have to bring a lawsuit or swear out a warrant every time one wants a sandwich or a cup of coffee," Chesnutt sarcastically remarked.[49] In general, the liberal race relations of the previous century were irreparably damaged. Once described as the "Negro's Paradise," Cleveland slowly became a replica of a Southern Jim Crow city, leading local Blacks to call it "Alabama North."[50]

Though the supposedly liberal city displayed obvious racial tensions, middle class African Americans were not overly concerned. Summing up his opinion on Blacks in Cleveland, Chesnutt wrote, "There is a race problem in Cleveland,

but it is not acute. From the Negroes' side it is mainly concerned with a fair living, a decent place to live, making his way in the world on equal terms with others, and living at peace with his neighbors." If an African American plays by the rules, he "makes a very good citizen." However, "Abuse him and he becomes in his own eyes a martyr . . . It might, conceivably make the colored people a fertile soil for socialist or Communist propaganda; for whatever the weakness of Communism, it teaches human equality, which makes an irresistible appeal to those who are denied it."[51] Chesnutt represented the Black upper class's opinion that good citizenship and democracy could pave the way for a better future for Blacks. Established Black community leaders like Chesnutt believed if working-class Blacks turned to radicalism in the form of socialism or Communism, while understandable due to its appeal for equality, they stood contrary to the principles of democracy. While radicalism might offer immediate solutions, they would be only temporary; instead, African Americans, Chesnutt argued, must place their faith in the government and social institutions that promised eventual, but lasting, equality.[52]

Chesnutt was not the last to recommend Black Clevelanders eschew Communism and other radical ideologies in favor of faithful democratic citizenship. The legacy of liberalism pervaded the middle and upper classes' perception of proper social etiquette in the city, which included reliance on traditional institutions rather than protests. Civic and community leaders, though, would soon find this challenged by the adversities presented by the Great Depression.

BLACK AND WHITE CLEVELANDERS UNITE

Despite the city's perceived liberal heritage, in the early Depression, Cleveland served as an epicenter for American Communism.[53] Communist leaders chose Cleveland as the location for the national convention in 1929 that created the Trade Union Unity League (TUUL) out of the defunct Trade Union Educational League (TUEL). Five years later, the national convention would return, pressing the party's new agenda of participating in a united effort of the Popular Front movement. Though liberal reform historically dominated the politics of the city, radical groups had always protested Cleveland's public and private institutions, albeit in small numbers. One of their main grievances was unemployment, and even before the Unemployed Councils organized, Cleveland radicals had been active in rallying the unemployed. The origins of the activism can be traced back to 1921, when members of the American Federation of Labor, the Industrial

Workers of the World (Wobblies), and the Communist Party came together to protest unemployment and starvation wages.[54] However, these groups largely ignored the Black working class, who, at the time, instead turned to Garveyism. By the late 1920s, however, the UNIA's organizational presence in Cleveland was largely nonexistent, leaving a large void in functional groups that could appeal to the city's Black working class. Activists of Third Period Communism quickly stepped up, and by 1931, Cleveland had eight Unemployed Councils.[55] One was located within the heart of the Central Area on East Forty-sixth Street, near Woodlawn Avenue and the highly concentrated African American neighborhood.[56] African Americans were certainly drawn to radical organizing due to the promotion of racial equality and class solidarity. However, beyond these long-term social goals, the working-class sought alleviation of their immediate woes, namely food, housing, and jobs. These "bread and butter" issues were not unique to Cleveland, and the city's organizers followed the organizing techniques that proved successful in other urban areas. As in Chicago, St. Louis, and Detroit, the Councils' daily activities included organizing soup kitchens, helping people get on relief, speaking out for unemployment relief, providing free lodging for the homeless, providing free food for schoolchildren, staging anti-eviction protests, and running workers' schools. Morris Stamm, section organizer in Cleveland, noted the councils' activities: "Our almost daily activity was the bread and butter of getting people on welfare, or relief as we called it who had been refused or kept off, and rallying the neighbors where an eviction had taken place and putting the furniture back. We also worked to get light, gas and water turned back on."[57] These activities necessarily happened near Black workers' homes, as working in Black neighborhoods to combat these immediate woes positioned the UC as community organizers rather than alien agitators.

Other Black elites noted the influence and allure of the UC and the Communist Party. Black churches, it became more and more apparent, were not the only ones preaching the benefits of community and solidarity during challenging times. Reverend Wade McKinney, pastor of the Antioch Baptist Church in the Central Area, observed that CP and UC leaders offered a "program of criticism, fellowship, and gospel of sharing." He lamented that membership in radical organization was becoming more appealing; in fact, he estimated that radical membership was increasing far more rapidly than that of "all the churches combined." The mutual support and immediate aid of the UC and Communist Party fulfilled the need many African Americans sought. McKinney noted, "Thousands of once devout readers of the Bible have closed the book

of books to read Communistic literature."[58] Communist literature offered Black Clevelanders something the Bible could not: relevancy to their lives as they experienced unemployment, hunger, discrimination, and labor exploitation as well as an immediate plan for organized protest. During the 1920s, Black churches had a monopoly on civic engagement and social structure. Yet, as Reverend McKinney noted, by the 1930s times had changed.

The inclusion of women in religious institutions and the UNIA during the 1920s helped train and position them as vocal advocates in the Great Depression. Due to their positions as mothers, caregivers, workers, and often solo breadwinners, African American working-class women could appreciate the interracial efforts of the UC and the CPUSA. The direct and radical challenges to existing welfare institutions empowered many women to take an active role in procuring relief for their family. Often, Black women had found it difficult to secure sufficient aid from local charities, private or public. One Cleveland woman, representing a household of eight members, received only three dollars per week to provide for groceries.[59] Meanwhile, in their pamphlet *A Suggestive Budget for Families on Small Incomes*, the Associated Charities (AC), a branch of the city's community fund, maintained that an adult could subsist on $2.50 a week and a child $1.45.[60] The funds the charities were able to provide could simply not address the need of African American families. Another "Negro Woman Worker" declared her local community fund was "just enough to keep us alive, and we are in rags." Her demands were simple: "We want relief from this hunger, we want clothes." Traditional aid organizations, such as the ACs, were limited by government budget cuts and did not offer a mode of activism for these women to become involved. The African American women recruited to the UC and Communist-sponsored radical activities did not enter as beggars asking for handouts, but rather militant activists ready to organize and fight. As one woman declared, "Every working woman should join the Unemployed Council if she is not working. I certainly will be ready to fight because I am hungry and so are my children."[61] With assistance from white organizers, a group of thirty Black women, most of whom were on relief, formed a club called the "Woman Willing Workers Club." Their demands, like those of many other working-class families, were simple and specific: Associated Charities should give soap, brooms, and sheets to families in need and, workers' houses should be painted and have bathtubs. Black Cleveland working-class women, mostly restricted to the Central Area neighborhoods, lived in run-down, ill-kempt homes often lacking the most rudimentary facilities. "Bread and butter" issues

of simple life necessities, such as soap, running water, and clothes, were front and foremost in their minds. Hundreds of African American women joined the WWW clubs, participating in not only local relief efforts but also larger organizing in women's day demonstrations.[62] This enthusiastic response showed city officials that the battle for adequate relief must address issues specific to Black women and families.

One earnest recruit of the UC was Mary Tabb. She lived south of Central Area in a highly industrialized area, and like most of her neighbors was out of work. She had not held a steady job in over one year and found she could not provide adequately for her family. She had not heard of the Unemployed Councils until one day, organizers came through her neighborhood and signed her up. Tabb quickly become an active member, organizing membership drives to attract others in her neighborhood. In January 1931, she marched with hundreds of others to city hall to confront the mayor and city council about deteriorating conditions for the working class. The day was chilly with freezing rain and sleet, and Tabb only had torn shoes and thin clothing that her charity had provided her. Nonetheless, she declared she was ready to fight for unemployment relief.[63] When she reached city hall, Tabb was chosen as a delegate to meet with Mayor Miller in his office, and told him directly, "We'll not starve peacefully."[64] She was direct and quite confrontational in her approach, accusing other white city councilmen of never having to face issues of hunger. "Your kids go to high schools and colleges," she said with tears rolling down her face, "while I must tell my little boy every day to go to school without his breakfast."[65] Though Mary Tabb had likely never before spoken in front of an audience of political elites, she summoned courage, drawing on her life experiences as an unemployed worker, mother, and provider. The surging energy of Midwestern Black radicalism empowered Tabb to confront her white elected officials in an unprecedented way.

An impressive speaker and organizer, Mary Tabb persisted in agitating for working-class rights on a personal, local, and national scale. UC leaders chose Tabb as a delegate to the national march for the Unemployed Insurance Bill in Washington, D.C., accompanied by major radical leaders. She was on her way to a mass planning meeting with William Z. Foster, CPUSA general secretary, when she was struck by a speeding car.[66] Tabb was taken to Mt. Sinai Hospital to treat her broken leg and hip, but was refused assistance because she was unable to pay. She was shuttled back and forth between the waiting room and the examination room, until finally she received a cheap crutch and a scolding from

hospital attendants. Leaving the hospital, she was "more determined than ever to fight for the working class—and as soon as she could hobble, she came to the Council." Her trials did not end there; due to her injury, she faced even more difficulty in feeding her family. She approached her son's school and asked if they could provide him a free lunch, only to be told it was impossible. With as much fortitude as she showed in the city council chambers, she declared, "All right, then, I'll get my Unemployed Council to fight with me." Tabb's cautionary words were enough to alarm the school, and the next day, her son received his free lunch. Though she could not attend the march in Washington, D.C., she worked diligently in local elections for Communist candidates.[67]

Though her story was remarkable, Mary Tabb was not the only African American working-class woman involved in Cleveland's Unemployed Council. Mary Lindsey, an unemployed factory worker and mother of four, was an active and committed member of the UC, so much so that in 1934, she ran under the Communist ticket for county auditor. Similarly, Eliza Deadwiley, a Black worker involved in the ILD, UC, and the CPUSA, ran for state representative as a Communist. Though their campaigns were not successful, their alignment with radical politics signaled their commitment to assert themselves publicly as agents of Midwestern Black radicalism. The CPUSA election platform was consistent across states, so African American women interested in running for office could easily identify whether the party's issues were in line with their own. Citing the "broken promises" of the Democrat, Republican, and Socialist parties, the election platform specifically appealed to Black women. Old age and maternity pensions, maternity leave, equal work and wages for Black workers, abolition of child labor, education, free food, and clothing for children of the unemployed consistently appeared on the party platform.[68] Lindsey and Deadwiley, picking up on these important themes, embraced Communist doctrine as their own. Like other working class African American women, their histories with radical activities are only briefly documented, and how their campaigns affected the rest of their lives is unknown. Their entry into politics as members of the CPUSA demonstrated how Black women shifted and negotiated their roles in the context of the Great Depression. Political elections were just one more unexplored avenue for these working class women.

Political elections and protests in public spaces are often categorized as masculine; however African American women like Tabb, Lindsey, and Deadwiley defied these traditional gendered notions of space. While much of the radical organizing took place in Black neighborhoods, female activists did not shy away

from taking their demands to traditionally white-dominated public spaces. A 1932 flyer announced a women's demonstration at Public Square, a site that took on a political meaning that reflected the liberal tradition of the city. After the Civil War, returning Union veterans were welcomed with a heroes' parade in the square, while one hundred thousand mourners visited Lincoln's coffin that lay in state; in 1918, the city erected a monument to former mayor and noted progressive Tom Johnson, who had welcomed all people into public parks.[69] In a sense, Public Square had become a physical embodiment of the liberal reform the city promoted. The space also provided a strategic point of access: a few blocks north stood the recently constructed city hall. Housing the mayor's office and city council chambers, the beaux-arts building was often a target of protesters throughout the 1920s and 1930s. As well, the private charity the Associated Charities' Wayfarers Lodge, which provided temporary housing and relief for those in need, as well as a target of radical frustration, was located only a few blocks away.[70] At the Public Square, protesters demanded unemployment and maternity insurance, drawing inspiration from the UC's general demands for unemployment insurance and compensation for working women several months after giving birth. At the same demonstration, the women protested against dairies that were pouring milk into sewers to keep prices stable, while "64,000 children starve."[71] These women interjected themes of womanhood and motherhood in the traditionally liberal male spaces, radicalizing the space. Mothers' interests, such as children without food, shelter, or shoes, orphans and widows, and married female workers, increasingly made their way into radical posters and advertising. "We will organize," one flyer promised, "and struggle and fight for bread, for heat, for homes, for light and for the very lives of our children."[72] In Cleveland, radical women often used the gendered role of motherhood to portray their message. During one protest, about twenty-five women visited a local charity office banging pots and pans (symbolizing hunger and inadequate relief), making such a din that soon three hundred more workers had joined them. Defying police orders, the women gave speeches and demonstrated for two-and-a-half hours until they received the relief order they sought. Interestingly, the charity office said that they did not usually deal with women's committees, instead preferring to speak with the men.[73] Only a few days later, about one thousand women and children gathered in front of city hall to again draw attention to inadequate relief, where they were joined by three thousand male workers. Children were brought in by the truckload and several women pushed baby carriages. Huge signs repeated their accusations:

"Babies are dying for milk!" and "Babies are starving!"[74] This style of protest mirrored the community-emphasis organizing of the Funsten Nut Pickers' strike, where striking workers brought their families to the picket lines. In Cleveland, too, militant mothers embraced the public aspects of their activism, challenging traditionally masculine spaces.

Though there are no specifics on the racial makeup of this "pot and pan" protest, an editor of *Working Woman* reported in a memo to the International Women's Secretariat that more and more Black women were joining these types of demonstrations. It was difficult to draw African American women to public protests, the editor noted, as it was "something new [for them] to display themselves to the eyes of the by-standers and on-lookers for these demonstrations."[75] This reflected middle-class concerns over the politics of respectability exemplified during the New Negro era. As the Depression wore on, however, concerns over respectability ran second to issues like poverty and hunger. Women often went against the wishes of their family and joined the UC; some, like Mary Tabb, went on to lead and organize. Their activism did not always take front stage, but often operated at the neighborhood level. As Tabb's experience showed, door-to-door recruitment was often effective for reaching African American women who were not familiar with the UC or CPUSA. In an effort to keep these women in their comfort zone, UC organizers would often have backyard meetings, where fifteen to twenty women would gather in a neighbor's yard to discuss issues. One report stated that six church-going African American women arranged for party members to "speak directly from the pulpit" at their church, as well as announcing demonstrations, having lectures, reading the *Working Woman,* and "in general to organize them in struggles for relief."[76] Women's activism, then, operated in the traditional, "feminine," local, small-scale public sphere, relegated to churches, neighborhoods, and community organizing. But at the same time, with diligent recruitment, the UC and Communist Party were able to provide support for women in the larger, political public sphere.

In general, the liberal citizens of Cleveland, while sympathetic toward the UC's actions, did not fully support radical activity. In February 1930, after a scuffle between the police and over one thousand protesters on the steps of city hall left five injured, the *Cleveland Plain Dealer* published an editorial titled "The Wrong Way," which sympathized with the unemployed, but regretted their "shortsightedness in attack officers of the law." The blame, the editors argued, was laid completely on the shoulders of white Communists. "For the

Communist leaders who are endeavoring to capitalize business depression and excite the jobless to violence it has nothing but censure."[77] The editorial went on further to acknowledge the problem of unemployment, but assured readers that "there is no cause for special uneasiness over the facts as they are." Charitable organizations were designed to take care of unemployment and other issues, and the organizations "have been depleted and are insufficient for that purpose they must be replenished." According to the editorial, public and private agencies would address issues regarding unemployment, but the unemployed must have a proper regard for the process and for law, echoing sentiments of Charles Chesnutt. Again, the city elites showed their reliance on liberal democracy and reform. "The true friends of labor in this country are taking no leaves from the Communist manifesto." In short, the unemployed and poverty-stricken working-class Clevelanders must reject Communism, be patient, and trust in the system. In fact, the editorial opined, in 1930, "It is fair to assume the worst is over."[78] The middle and upper classes of Cleveland showed a great tolerance for radical activity in their city, as long protests and rallies remained nonviolent. For elected officials and politically moderate and liberal citizens, the city would never submit to revolution. In their opinion, the UC, Communists, unaffiliated radicals, and the unemployed posed no real threat to the established community. However, they underestimated the organizing power, militancy of the Black working-class, and the potentially explosive tensions between law enforcement and protesters.

Black women involved in the Unemployed Councils and Communist-affiliated activities had already shown their militancy and complete commitment to fighting for economic justice. Because African American women participated and often led these activities, they often risked their lives in pursuit of their ideals. In July 1934, Mrs. Vinnie Williams joined a group of protesters organized by the Unemployed Councils to march en masse to the local office of Cuyahoga County Relief. The relief office had been the target of many protesters before and Williams decided to join in. A migrant from Georgia, Williams was a widowed mother of three children, the youngest seven years old. Despite her best efforts, the family was living on charity, which barely covered her basic expenses.[79] When Williams and a crowd of around three hundred demonstrators gathered around the relief office, jittery administrators called police to control the large assembly. When one crowd member grabbed a police officer's firearm, law enforcement opened fire, ultimately shooting and killing Williams. Four others had been shot, including Sam Arsenti, who also

died from his wounds.[80] The public was outraged, though mostly blamed the violence on radical agitation. The African American community, however, understood the blame lay elsewhere, and rallied to support the fallen. A few days later, members of the city's Unemployed Councils as well as the Communist Party sponsored a funeral for the two slain workers. The coffins, draped in red and Black colors, were displayed outside of the Central Avenue Unemployed Council headquarters. There, hundreds of mourners paid their respects.[81] This show of grief helped to publicly demonstrate how Black women were active, militant participants in the working-class struggle. Williams, who paid the ultimate price for asserting her demands as a working-class African American woman, became a symbol for Midwestern Black radicalism in Cleveland.

EVICTIONS AND BEYOND

Across the Midwest, the Unemployed Councils' anti-eviction measures reverberated with African American workers, and Cleveland was no different. The eviction numbers in Cleveland were staggering: in 1928, four thousand families were evicted. By 1931, that number had more than doubled, and in 1932, the *Cleveland Press* estimated 14,500 families had been evicted that year.[82] As in Chicago, Detroit, and St. Louis, the UC in Cleveland made a specific effort to protest these evictions. Cleveland's first large-scale anti-eviction protest occurred only a few weeks after Chicago's deadliest protest. On August 27, 1931, 150 people gathered outside of the home of two Cleveland families, and with their presence, Sheriff John Sulzman chose not to proceed in the eviction. "I know it's illegal and against the law and the courts will issue mandates ordering me to put people out of their homes, but I won't do it," Sulzman stated the next day in the *Cleveland Plain Dealer*. Sulzman's charitable intentions did not last long; city officials transferred removal duties from the sheriff's office to the Cleveland Police Department, and evictions went on as scheduled.[83] The decision to continue evictions delivered fatal consequences. On October 5, 1931, a parade of African Americans marched on Cleveland city hall to gain access to a city council meeting, demanding jobs and expressing dissatisfaction with relief efforts. Some two thousand gathered at city hall, but only six hundred entered the hall and filled the city council chamber. There, the protesters confronted Mayor Raymond Miller with speeches and jeers. When police attempted to clear the hall, women "screamed, scratched, hissed at the policemen as they fought their way through." The *Cleveland Plain Dealer* reported an elderly Black

woman "kept crying that she hadn't enough to eat, hadn't a place to sleep."[84] The crowd cleared out with minimal chaos, but residents left, unsatisfied.

The anger and frustration over evictions came to a head the next evening. Three hundred people gathered at one of the Unemployed Councils meeting halls in the heart of the Central Area on East Forty-Sixth Street and Woodland Avenue. There, protesters listened to speakers who encouraged the crowd to make their way to East Forty-Seventh Street where the Harp family currently faced displacement.[85] "Harangued by Communist leaders, the crowd moved on the house where a Negro family was being evicted and commenced carrying the furniture back into the house," reported the *Chicago Tribune* the next day.[86] The police who had gathered reported that the crowd, though unarmed, started attacking the officers. When tear gas bombs did not fully disperse the crowd, police began to fire, purportedly for protection. More than one thousand people had gathered to bear witness to the event; nearly the entire crowd was African American.[87] John Grayford, fifty-four, and Edward Jackson, forty-five, both African American residents of the Central Area were killed, and four others, included a police lieutenant were injured. The *Cleveland Plain Dealer* was clear in noting that Grayford had been a participant in the riot, antagonizing the police, and Jackson had been found with a jackknife and Communist literature in his pocket.[88] In the view of most mainstream press, Grayford and Jackson's involvement in radical activities labeled them agitators and miscreants, and therefore their deaths were justifiable under the police's code of conduct.

The reactions to the riot and deaths were varied. Among the Unemployed Councils and Communist Party, Grayford and Jackson were celebrated as martyrs. Flyers advertising mass meetings described the two as "heroic fighters" who were killed in an "unprovoked police attack . . . murdered for the 'crime' of demanding that unemployed families shall not be turned out on the streets to freeze." The police and Cleveland city government were "killers" and perpetrators of "bloody terror" in the city.[89] Another flyer, slightly less inflammatory, noted the racial implications of the riot and that the "attack is especially aimed against the Negro masses. Jim Crowed and segregated they suffer most [under] the brutality of boss terror. . . . Let this attack be answered by the mightiest solidarity of Negro and White workers in Cleveland."[90]

The advertising, both rhetorically divisive and racially inclusive, succeeded in stimulating interest in the victims' funeral. On October 11, some three thousand gathered at Thirty-Eighth Street and Scovill Avenue where William Montgomery Brown, a former Episcopal bishop, conducted the services.[91] The crowd

then proceeded to Harvard Cemetery where the mourners listened to speeches by several Black Communists, included Herbert Newton from Chicago, League for the Struggle of Negro Rights organizer I. O. Ford, and local UC organizer Maggie Jones. After Grayford and Jackson had been lowered into the graves, many of those present repeated an oath, pledging to "carry on the struggle of our comrades who have died," to "demand there be no more evictions," and join the revolutionary class.[92] The riot left Grayford and Jackson as heroes to not only Cleveland Blacks facing eviction, but also to the larger revolutionary class. The Communist Party, through Newton, Ford, and Jones, tied the specific struggle of Blacks in Cleveland to the larger struggle of the proletariat, Marxist theory, the party, and the world revolution.

Expectedly, the reaction from the mainstream press was decidedly more critical. An editorial in the *Cleveland Plain Dealer* regretted that Grayford and Jackson had died, but commended the police on their actions, noting that the police were outnumbered one hundred to one. The issue, though, was not that simple, and the newspaper urged the community to consider the undue burden upon Cleveland's Black working class. The Depression left many Black workers unemployed, hungry, cold, and in despair, which "opened the door to the Communistic agitators, always glad to exploit those who have real or fancied grievances against the capitalistic system."[93] The editorial noted that though Black protesters "may have never heard of Karl Marx and known little of Russia, but they do know when they are hungry and cold, when they are pushed out of even low wage employment, and finally evicted from dwellings which their white neighbors spurned long ago."[94] The editorial, typical of the *Cleveland Plain Dealer*, tended to overlook the roles African Americans had in organizing eviction protests and supporting the Communist Party. Women like Mary Tabb had initially embraced the UC and Communist-affiliated activism due to "low wage employment" and evictions; however, their militant commitment and willingness to challenge racism and classism indicated they understood far more of Midwestern Black radicalism than the newspaper gave them credit for. For the *Plain Dealer* and other moderates in the city, Black UC members like Tabb and Grayford were not radicals who understood working class solidarity and radical theory; they were simply drawn in by the radicals' alluring promises of shelter and food. And though the writers were sympathetic to the Black working class's woes, they could not imagine Black Clevelanders having any knowledge or appreciation of Communist theory, instead imagining that they acted on survival instincts alone.

Led by Maggie Jones, the work Black UC members did in the aftermath of the riot challenged the notion that Blacks were simply using the UC for food and housing, or that they were being duped by the CPUSA. Hundreds of workers joined the councils in the months following the deaths of Grayford and Jackson, seeing that the UC and Communists were the only organization to take the riot's deaths seriously. Maggie Jones was a member of her local UC, but took her radical activism to a level beyond the traditional membership drives. After witnessing the riot's violence, Jones observed that "our women realized that we must be prepared to take care of our comrades who are injured in battles with the capitalist police." She helped organize a corps of female nurses a few weeks later. The group, which started with sixteen women and doubled in number in three months, studied first aid and emergency care. Jones asserted, "We hope that all unemployed women and wives of unemployed workers will join the Unemployed Councils, so that we can fight together with our men against hunger and starvation and for unemployment insurance." In her estimation, more than half of the eleven hundred members of Unemployed Council No. 8, were women. These women specifically, she argued, must be prepared to support "comrades" in the unemployed struggle.[95]

As well as being the leader-organizer for the largest UC in Cleveland, Jones was also an ardent supporter of the Communist Party. She strictly followed party doctrine, identifying herself as a "soldier" in the battle against the capitalist class. Her special role in the funeral for Jackson and Grayford showed the party valued her as a reliable representation of Communism. Instead of a nameless Black woman swept up in the movement, Jones led the fight, chanting the workers' slogan "Long live the unity of the Negro and white workers." Though little is known about Jones after the eviction riot, her militancy during the time showed she was not a poor Black woman, manipulated by the Communist Party. Instead, she understood the fight for unemployed workers as a battle in the long war against capitalist exploitation and could definitively find her place in that struggle. By organizing women to learn first aid, leading the Unemployed Councils, and demonstrating her grasp of Communist theory, Maggie Jones inserted herself and her work in the Black radical tradition.

Midwestern Black radicals faced many challenges in the liberal city of Cleveland; while middle- and upper-class citizens mostly tolerated their private and public organizing, the government showed reticence in reaching compromises. This often led to violence and even death, wherein Black women were not

even unaffected. As the Great Depression wore on, Black radicals and their white allies began to look to alternatives, and even moderate ways to have their demands met.

COALITION BUILDING

For Communists in Cleveland and around the world, the transition to the Popular Front era meant working with groups the party had previously shunned, opening their radical causes to groups like the Urban League, the NAACP, and moderate labor unions. In Cleveland's African American community, this change in party policy had immediate and reverberating consequences. Through protests, marches, and organizing drives, the Unemployed Councils had primed Black residents for radical action, and many moderate leaders in the community joined the National Negro Congress (NNC). As well, the new Scottsboro Defense Committee combined the efforts of several Black organizations, such as the NAACP, to bring awareness to the Scottsboro trials. Black radicals, sensing a new era of cooperation, began to work with the organizations that promoted capitalism while fighting racism, such as the Future Outlook League. Cleveland's liberal history, combined with successful radical organizing, energized a new interpretation of coalitional activism.

Scottsboro was an issue that spread to every Black community in the United States, but because of the large Southern migrant population specifically from Alabama, Black Clevelanders took an early and special interest in the Scottsboro Boys, and the Communist Party was able to capitalize on this interest and cater to Blacks in the city early. The day the ILD took over the case, Communists in Cleveland gathered to form the largest protest outside of New York. There they crafted a protest statement and the Midwestern city began to mobilize.[96] The same month the young men were arrested, the party in Cleveland hosted a mass meeting in the heart of Central Area. Advertisements for the meeting declared that "the brutal slave drivers of Alabama, acting through a Ku Klux Klan judge and jury, and influenced by boss prejudice, are about to murder eight Negro youths." The party then connected the "lynch murder" of the Black youths to the workers' struggle in Cleveland, as they are "confronted with the same misery and starvation."[97] Associating the Scottsboro case with Cleveland was vital for the Communist Party, as, without a personal connection, their campaign could peter out and die. However, by reaching out to African Americans within Central Area with flyers, images,

and public meetings, they were able to bridge not only geographical gaps, but ideological ones as well.

Mass meetings and protests continued through the spring and summer of 1931. Every piece of advertising the Communists circulated appealed to both Blacks and whites and framed the Scottsboro case as one of "boss terror" and "lynch murder."[98] Incendiary drawings of nooses and lynch mobs accompanied, in all caps, "STOP THE MURDER!"[99] These meetings often occurred at the Unit 21 party location in Central Area or the Cleveland party headquarters on Prospect Avenue, only a few blocks from Central Area. No longer utilizing the public forum of Public Square, the Communists took the protest and the battle for the Scottsboro Boys directly to the African American neighborhoods, an intentional effort on the part of the party to bring the struggle to the streets and neighborhoods of Black workers.[100] Locating meetings and protests for the Scottsboro Boys near or in Central Area also served to reach out to nonradical Black organizations. No longer just a Communist issue, the Scottsboro case in Cleveland represented a key moment in uniting liberal organizations with radicals. Local party officials encouraged the neighborhood units to invite nonparty members and explain to them the political importance of the Scottsboro case. Leaders assigned pairs of one white party member and one Black party member to visit Black organizations and churches to campaign for the Scottsboro Boys.[101] In preparation for International Scottsboro Day in 1932, all units were instructed to mobilize "especially in Negro neighborhoods, going to every street, every house, distributing leaflets and selling special literature on the Negro question," mainly the pamphlet, "They Shall Not Die."[102] As Cleveland's Black radicals continued to protest and organize on behalf of the Scottsboro Boys, they began to draw national attention. Joseph Brodsky, ILD attorney for the Scottsboro case, visited in 1934 in a mass antilynching protest at the Public Auditorium. Harry Haywood, a well-known Communist, stopped over a few months later to reiterate the theme of protest against segregation and Jim Crow. Angelo Herndon, a political prisoner who was also represented by the ILD, toured Cleveland in 1934 and 1935 (in his later visit, he came with a replica of the cage he was held in). In 1937, after three of the Scottsboro Nine were released, two gave speeches in local Cleveland churches.[103] Cleveland was, as one historian described it, a "hotbed of Scottsboro activity."[104]

The Scottsboro mothers' tour of the United States helped publicize the plight of the young men and draw sympathy from white and Black women alike. The mothers of the imprisoned boys received the opportunity to address northern

audiences as experts on the Jim Crow South as well as Black motherhood. In September 1934, the Cleveland office of the ILD brought Ida Norris, mother of imprisoned George Norris, to Central Area with Angelo Herndon, and led a massive parade through the neighborhood.[105] Once, radical women in Cleveland brought their strollers and children to city hall and Public Square to demonstrate their needs as mothers. In the Scottsboro campaign, mothers like Mrs. Norris and Mrs. Wright took their message directly to the neighborhoods, emphasizing how the Black community needed to unite on this issue.

Ada Wright, mother of the imprisoned Andy and Roy Wright, traveled the world with the ILD from 1931 to 1934.[106] In April 1934, she returned to Jim Crowism not in her home state of Alabama, but in "Alabama North." On a Saturday, Ada Wright visited Mills Restaurant on Euclid Avenue, near downtown Cleveland, where the pro-Nazi owner refused to serve her. After the owner threw her out, word about the injustice spread around the Central Area neighborhood. A group of protesters returned later, led by an African American woman, Mrs. Thompson, and the district secretary of Cleveland's ILD, demanding that the restaurant's owner serve Blacks. Mrs. Thompson used the weight of the massive working class to pressure the owners, saying to them that "the workers of Cleveland will see that the doors of this restaurant will shut tight if you do not end your jim crow [*sic*] policies now." After management refused, the delegation, now in the hundreds, sat down at tables and did not stir. A crowd of almost one thousand gathered outside the restaurant, listening to speeches from the ILD, while police looked on helplessly. Eventually, the restaurant owner acquiesced, the protesters were served, and a triumphant cry circulated among the protesters outside.[107] Though Ada Wright was a newcomer to the city, Mrs. Thompson was not; well aware of the local racism and the power of organized resistance, Thompson tapped into social networks established by Black radicals of the Unemployed Councils. Previous Black radicalism bred an awareness and acceptance of the Black community's ability to organize successfully.

African Americans who wanted to get involved with the ILD or Communist Party had many opportunities as affiliated organizations continually sponsored social and political events. A workers' picnic in 1934 featured a play, games, clowns, pony rides, and baseball in order to raise money for the Workers' School, a program that taught a Marxist-Leninist interpretation of events, including rights for Black workers.[108] National party leaders visited Central Area to rally Black workers as well; an "overflowing" and "enthusiastic crowd" gathered in

November 1934 to listen to general secretary Earl Browder rally voters in the upcoming election.[109]

Though the Communist Party continued to address residents of the Central Area directly, the party's transition to the Popular Front era marked the wane of the Communists and the ILD's lone influence on Black Cleveland workers. By 1934, the ILD's resources were stretched thin and the organization grudgingly moved to collaborate with mainstream and moderate leaders to form the Scottsboro Defense Committee, which marked the end of the party's sole control over the Scottsboro defense.[110] Local ILD offices followed suit; the Cleveland Committee for the Joint Defense of the Scottsboro Boys was organized by leaders among the African American, liberal, and radical communities in Cleveland. Members of the American Civil Liberties Union, local Methodist churches, democrats, attorneys, neighborhood associations, and the editor of the *Call and Post* joined forces with ILD officials. The *Cleveland Call and Post* described the new activism: "The colored residents have banded themselves together and formed an organization whereby they expect to help the community in every legitimate way."[111] The *Call and Post* encouraged all organizations to "combine your forces and work for one common cause and without political favors to some, but to all the people."[112] One new organization, the Future Outlook League, was not a political one, but instead a civic one. With twelve associates, recent migrant John Holly founded the Future Outlook League, with the slogan "The Future Is Yours." The group's intention was "to strengthen the backbone of existing Negro enterprises" in Cleveland.[113] Similar to the *Chicago Whip*'s call in the early 1920s for boycotts on stores that did not employ Blacks, Holly encouraged Black Clevelanders: "Don't Spend Your Money Where You Can't Work." The idea behind the slogan and activism emphasized a sense of collective power for the Black unemployed, one that had previously been seen in Cleveland in the activism of the Unemployed Councils. Though the UC focused on housing and hunger, they nonetheless shared a similar ideology with the Future Outlook League that collective action, continued pressure, and a racial understanding of the issues were necessary for change in Cleveland.

The early days of the FOL were marked by hostility from the African American middle and upper classes and from local Black clergy. The FOL expressed discontent with the current African American organizations and their treatment of the unemployment issue.[114] The *Cleveland Gazette*, a pro civil rights African American newspaper, editorialized, "F.O.L. members who are so glibly

criticizing the old Cleveland colored residents are making a foolish mistake by not promoting harmony among our people that is so essential to the success of any effort in their behalf."[115] For the more established Black population of Cleveland, the FOL represented divisiveness within the Black community, something they could ill afford during an economic depression. William O. Walker broke with this notion. As managing editor of the new African American newspaper the *Call and Post* he disagreed with the *Gazette* and was one of the FOL's first and most influential supporters.[116] In an interview later in his life, Walker attributed the hostility from the middle and upper classes to the fact that most of the founding leadership of the league were recent migrants from the South.[117] Walker often heard the criticism, "They [the members of the FOL] want to reform City Hall and don't even know where it is located."[118] The church ministry also took exception to "that young radical Holly" and prevented the league from addressing congregations and holding meetings in local churches.[119] Holly, limited by this reception and likely guided by his working-class background, targeted and rapidly attracted Black workers and the unemployed as radicals transition to the Popular Front era.

Better than anyone else, Maude White represented the link between the Third Period Communists and the new Popular Front movement and the FOL. White came to Cleveland in 1934, where she was an organizer with the Unemployed Councils. Howard University-educated, Communist-trained, and a gifted writer, White represented a new rank of a radical Black woman in Cleveland. She was born in McKeesport, Pennsylvania, a coal-mining town near Pittsburgh. Through encouragement of a white progressive teacher, White moved to Chicago, joined the party, and visited the Soviet Union on the party's invitation.[120] Unlike Mary Tabb or Maggie Jones, White started at the top with organizing. After returning from the Soviet Union, she settled in New York City. There, she was the only African American woman on the leadership board of the Needle Trade Workers Industrial Union and the Trade Union Unity League, and the editor of the *Harlem Liberator.*[121] Though a devout member of the Communist Party, she had no qualms about fiercely challenging racism among party and union members. Her 1931 article "Against White Chauvinism in the Philadelphia Needle Trades" lambasted "Negrophobia" in union organizing as well as general party membership.[122] When she was assigned at age twenty-eight to Cleveland as a section organizer, White was posed to lend her radical organizing experience to the city's working-class Blacks.

Shortly after her 1934 arrival in Cleveland, White began work as a party organizer and social worker. Cleveland offered White a return to her industrial roots, and the smaller city offered opportunities for closer relationships with moderate organizations. White forged relationships with the NAACP, the Negro Welfare Association, the YMCA, and even local churches, despite her well-known status as a Communist. Through work with settlement houses, she created cultural programs for African American youths and adults.[123] Her membership in the Future Outlook League was her chance to be more influential in the new city. She was elected to the FOL's executive board, served as editor for their yearbook, took part in political debates, and hosted fundraising as well as social events.[124] White took her activist training and put it to use, holding sessions for women on how to organize picket lines and boycotts. These training sessions were highly successful, and during protests, women were often employed to send food to picketers and serve as "shock troops," who filled in gaps in the lines. This sort of support and organization led former FOL member Marge Robinson to remark years later, "Black women were the FOL."[125]

When Maude White joined the FOL, she would have been among the minority who had a college education and experience in organizing workers. She was active in organizing protests for Black employment; her neighborhood committee successfully forced local A and P stores to employ Black workers and often picketed racist storeowners and organized boycotts.[126] However, White was not content to limit her activism to employment only; in 1935, she, along with several other women, organized a committee to protest a segregated swimming pool. With the slogan "Make the Woodhill Swimming Pool Safe for Colored People or Close It," they inspired the community to stir into action. Since its opening in 1927, the Woodhill Pool had been a contested site, where several fights left African American swimmers beaten and banned from the pool. With "untiring zeal," White gained the endorsement from fourteen Hungarian organizations and a dozen African American organizations, proving her skills as a coalition builder.[127] White went on to lead the Mt. Pleasant Neighborhood Committee, which continued to fight racism in coordination with the FOL. White often addressed FOL members at mass meetings, explaining her committee's work and how the organizations could work together.[128] In one spirited meeting, she debated politics with members of the Republican and Democratic parties, presenting a very convincing argument as to why Blacks should join the Communist Party.[129] With her organizing experience,

education, and training, White was the bridge between radical and moderate groups, exemplifying the Popular Front era of cooperation.

While White was working with the FOL to fight for employment and non-discrimination, she remained in the Communist Party, continuing her fight against white chauvinism, labor exploitation, and capitalism. As secretary for Cleveland's division of the League of Struggle for Negro Rights, she led a crowd of several hundred people to a council member's door, demanding a new trial for Walter Thomas, a Black man accused of robbery and fined the exorbitant amount of two hundred dollars. As well, echoing the demands of the Unemployed Councils, White's committee demanded an investigation regarding discrimination against African Americans on relief, a police shooting of a local Black man, and a study on the poor conditions of houses and public schools in the Central Area. With the assistance of white attorney Frank Lyons, White was able to procure a new trial for Thomas, as well as promises for investigations into other racial injustices.[130] Confronting a councilman at his home was not a move in the FOL's playbook, but was a common activity among Communists. Cleveland's past with Black radicalism helped prime the city for more coalitional politics, even if presented by such a staunch Communist like White.

White's involvement with the liberal FOL did not prevent her from participating in the more radical League of Struggle for Negro Rights, however leadership in the LSNR would shift as the party dissolved the LSNR in 1936. LSNR resources, such as the leadership and organizational talents of Maude White, were folded into the nascent National Negro Congress. White was one of the first proponents of the NNC in Cleveland; on February 10, 1936, she spoke with other members of the Cleveland sponsoring committee at Bethany Church to rally support for the organization.[131] A few days later, accompanied by twenty-three other delegates, she made her way to Chicago for the inaugural convention of the NNC, attending as a member of the National Executive Council.[132] Much like Thyra Edwards from Chicago, White's contributions during the first official proceedings are not known. She likely helped craft the NNC's official declaration on African American women, recognizing the importance of Black women in the struggle for workers' rights.

On returning from the convention, White was dedicated to pressing the NNC's vision. She attended several meetings at the local Housewives League to report on the NNC, spoke at a mass meeting of the Ethiopian League, and hosted a banquet in honor of well-known Black Communist Louise Thompson.[133] By not limiting her activism to only radical operations, White embraced

and excelled at the CP's Popular Era coalition-building. She continued to work on behalf of the NNC, and was appointed labor chairman of the Cleveland Council of the NNC.[134] In June of 1936, the Cleveland Council sponsored a national meeting of the congress, with the intent to follow up on resolutions made in the February convention. White wore many hats at the meeting, as the labor chair, as the representative of the Cleveland Teachers' Union, and as featured speaker. Among those she spoke to were former vice-presidential candidate James Ford, Angelo Herndon, representatives from the board of directors of the NAACP, workers' unions, and members of the Future Outlook League.[135] Her inclusion in such a well-known panel of speakers showed how important her voice had become to radical and mainstream organizations. The NNC represented the best efforts of Communists during the Popular Front era, and Maude White was an active contributor.

Her devotion to the working class soon found her heavily involved in the burgeoning CIO movement. White was one of the many Communists the CIO pursued for leadership roles; the Unemployed Councils had showed progressive labor organizers that the Communists' broad base appeal to the working class, especially the Black working class, was incredibly beneficial. The Steel Workers Organizing Committee (SWOC) in particular welcomed Communists, as they had been active in large steel cities with large populations of Black industrial workers, like Cleveland, Pittsburgh, and Chicago.[136] White, well known for her work in Cleveland, was selected to work with the SWOC. There were a large number of Black steelworkers in Cleveland that, in some cases, were earning fifteen to twenty-five cents less an hour than white workers in the same job.[137] This injustice spurred White to action, joining SWOC chairman Philip Murray as he toured the industry-heavy cities to address all-Black crowds on the importance of unions. White toured the Midwest with Murray, and her commitment and public appearances soon convinced Black workers to elect her secretary of the National Conference of Negro Organizations convention in February 1937 in Pittsburgh.[138] Likely, White exchanged notes with other prominent Black women like Thyra Edwards, who was present at the same convention.[139] As well, White likely worked with other Black women in SWOC, like Eleanor Rye Broady, based out of Chicago. White and Rye Broady helped organize what historian Ahmed White calls "the last great strike" among steelworkers in 1937. Although the strike was unsuccessful, it did bring together 80,000 steelworkers and over 10,000 CIO union members and sympathizers across the Midwest.[140] Though not steelworkers themselves, Maude White, Eleanor Rye Broady, and

other hardworking Black women in the union movement fearlessly stood by their male comrades, as they had for almost a decade. Though White moved from Cleveland to New York in the early 1940s, she continued to draw on her experiences in the Midwest.

Mary Tabb and Maude White represent best the ways in which Black radical women engaged in radical activities during the worst years of the Great Depression. As a longtime resident of Cleveland, Tabb served as an example of a Midwestern working-class woman struggling to provide for her family. She entered on the ground floor of the radical hierarchy, and only after proving herself through unemployed activism did she rise through the ranks to publicize her lived experience. Though she too had a Midwestern background, White's experience differed greatly. With an advanced education, Communist training, and organizing experience, White entered at the top and continued to have party support her entire career. The experiences of Tabb and White show the diverse ways in which African American women encountered the Communist Party. Neither woman could claim a stronger interpretation of Midwestern Black radicalism, but ultimately, both made the party work for them.

The Unemployed Councils and the Communist Party's targeting of African Americans, and Black women in particular, was not unique to Cleveland. But the radical organizing in Cleveland was starkly different from that seen in Chicago, St. Louis, or Detroit. The tradition of liberalism provided radicals with both physical and social space in which to protest. Yet at the same time, reform-minded civic officials tended to tolerate radicals, indifferent to their demands for aid by women like Mary Tabb. Riots and protests, even ones that ended in death, received condemnation rather than solutions. Revolution, it seemed, had to come wrapped in the more benign package of reform, a methodology radicals like Maude White exemplified. The beginning of the Popular Front era in Cleveland, rather than marking an end to radical community and labor organizing, forced radicals and their allies to reconsider best ways to serve the city. The fundamentals of Black radical activity endured in organizations like the Future Outlook League, the NNC, and organizing around the Scottsboro Boys: traditions of protests, strikes, sit-ins, and commitment to racial and class equality at all costs prevailed.

Conclusion:
Midwestern Black Radicalism Matters

In 1967, Rose and Joseph Billups took part in an interview designed to highlight Black workers' roles in the formation of the UAW. The interviewer focused his questions on Joseph and the Black men who helped organize the Ford Motor Company. After patiently waiting for her husband to relate his experiences, Rose spoke up, asking, "May I say that women played a great part in organizing at Ford?" As Rose explained to the interviewer, she and others in the auxiliary played an essential role in helping African American women convince their husbands to join the union. Without the support of the wives, most Black men would not have dared to join the union efforts. The interviewer allowed Rose to tell her story, and then turned back to Joseph. While history has recorded her importance, the interview skims over Rose's contributions to focus the men's contributions.[1] Rose's experience in 1967 mirrors the experiences of Black radical women throughout history. They are ignored or forgotten, their stories assigned to the margins or footnotes. This neglect, intentional or not, differs with each individual studied here. Rose faced the difficult challenge of living in the shadow of her activist husband, something apparent in her oral histories. Elsewhere, personal obligations, personal limitations, or political affiliations forced these women from their due historical spotlight. Some women were able to adapt their Midwestern Black radicalism to leave an enduring legacy in leftist organizations and publications. Others left no trail of their lives after their brief interaction with the CPUSA or UC. Their actions, words, and lived experiences demonstrate the multitude of ways they engaged with Midwestern Black radicalism and how we must continue to fight to keep their stories and legacies intact.

A Brick and a Bible reconstructs the stories of these women, some more brief than others. While all Black radical women in the Midwest deserve their

own biographical study, only a few have left enough records behind to write a conclusion for their extraordinary lives. Women who joined the CPUSA are more likely to have left records and documents to help historians retell their stories. African American women who officially joined the party were aware of the risks to their reputations, jobs, and even lives. The post-WWII Red Scare heightened that risk to the point where the women had to take extreme measures. As a top organizer in the Chicago area, Eleanor Rye Broady and her husband stayed loyal to the Communist Party, eventually moving to California. There, Rye Broady lived on the run for a year under a fake identity to elude the FBI. After Nikita Khrushchev revealed the extent of Stalin and Soviet Communism's crimes, she left the party in 1956, along with thousands of others. Though she abandoned Stalinism and the Comintern, Rye Broady refused to renounce her revolutionary convictions. She joined the Socialist Workers' Party in Los Angeles, participating in many 1960s civil rights protests. She lived through the Watts Riots of 1965, supported Malcolm X, and defended the Black Panthers.[2] Her nephew, Abdul Alkalimat (born Gerald McWorter), remembered her sharing "stories and music from the struggle, especially about her friends W. E. B. Du Bois and Paul Robeson."[3] When she died in 1970, the Social Workers' Party magazine the *Militant* published an endearing obituary, honoring her life of revolutionary activism.

Rye Broady likely worked with Maude White during their time in the CPUSA; like Rye Broady, White, too, left the party. White found that the party's promises of race and gender equality often fell short of reality. In a 1981 interview, three years before her death, she noted, "In spite of stated programs of the radical party . . . women were relegated to Jimmie Higgins work." "Jimmie Higgins work," named after the novel by Upton Sinclair, meant the unromantic side of organizing, rarely taking the podium to speak or writing the front-page column. She continued, "Very few were accepted into leading positions. For Black women it was especially blatant."[4] While she parted ways with the CPUSA, she continued to consider herself a Socialist and radical, and fought for working-class Black women her entire life. In 1940 she moved to New York to better center her radical work and married Arthur Katz, a white Communist. In 1949, she joined thousands of African American women around the world in advocating for the release of Rosa Lee Ingram, a Black sharecropper in Georgia who, with her two sons, killed her would-be white rapist in self-defense. When Ingram and her sons were convicted of murder and scheduled to be executed, the leftist community rallied much like they had a decade earlier

with the Scottsboro Boys. White Katz joined the united front to defend the Ingrams and led a delegation of women who visited Rosa Lee in Georgia. The journey was sponsored by the National Committee to Free the Ingram Family, of which White Katz was the national administrative secretary. The delegation planned to collect one million signatures demanding the family's release and present it to President Truman on Mother's Day.[5] Though far from her roots in the industrial Midwest, White Katz continued to emphasize coalition building and how intersecting identities can inform Black women's radical activism. Her efforts in pursuit of justice were relentless: in the 1960s, she joined the Negro Women's Action Committee, wrote for the leading Black publication on politics and culture, *Freedomways,* and led the fight to end racism in New York City public schools.[6] Though she, like Rye Broady and many others, faded away from the CPUSA, her militant fight for race, class, and gender equality would never fade. While White Katz accomplished great feats in her life, for her, the Great Depression was particularly memorable. "The period of the thirties was a fruitful one for me and I have no regrets," she said in a later interview.[7]

Romania Ferguson's experience with the party differed from her comrades. She had married Ray Hansborough, a leading Black Chicago Communist who helped pen the pamphlet, "The Communist Position on the Negro Question." Despite Romania's and her husband's commitment to the CPUSA throughout the 1930s and 1940s, the party mostly neglected them by the McCarthy era. Hansborough grew ill and died in 1950, after which Ferguson bitterly complained that the party had abandoned them.[8] After her husband's death, Ferguson fails to appear in Communist records, likely left behind in the chaos of the Red Scare. Hansborough, on the other hand, is celebrated among Illinois labor historians and his grave has a special place alongside the monument of the Haymarket martyrs in Forest Home Cemetery in Forest Park, Illinois.[9] Romania Ferguson's burial site is unknown.

African American women who had brief interactions with the Communist Party in the 1930s have stories more difficult to tell. Carrie Smith, vocal and militant in her efforts to organize the nut pickers, left the factories in 1940 and began working as a laundress in her own home.[10] She no longer had opportunities to speak to the mayor or on the steps of city hall, limiting any records of her. Maggie Jones, Cora Lewis, Mattie Woodson, Renelda Gumbs, and others, once ardent public supporters of the Black working-class struggle, fail to appear again in newspapers or CPUSA records. We are left to only wonder about these remarkable women. Whatever path their lives took, the Black women

radicals studied here all lived and experienced the Great Depression and Midwestern Black radicalism differently. To conflate the experiences of all these working-class women into one story of resistance reduces their struggles and flattens the many dimensions of their lived experiences. Rather, the thousands of African American women involved in Communist-organized protests and strikes participated in different capacities and for a variety of reasons with various success. Some women, like Carrie Smith and Ida Carter, took on leadership roles to rally workers around specific workplace issues. Other women, like Mattie Woodson and Maude White, were dedicated Communists and their actions fell in line with party doctrine. Many women, such as Rose Billups and Maggie Jones, played a supporting role, cooking for hungry workers or helping organize women's auxiliaries. And many other women stayed silent, but carried signs, fed the homeless, or refused to go to work. All these actions, large or small, public or private, make up the rich, multidimensional history of Midwestern Black radicalism.

While once an important force for Black liberation in the 1930s and 1940s, many believed that by the 1950s, the Communist Party ceased to be the formidable champion for racial justice it once was. While race still had an important part in the party platform, the party itself was almost obliterated by the Red Scare. The CPUSA's collapse, though, Robin D. G. Kelley argues, "does not necessarily signify the destruction of a movement or the eradication of traditions of radicalism."[11] Black radicalism lived on in individuals, such as Maude White, Rose Billups, and Mattie Woodson, Black women closely involved in the Unemployed Councils who took the lessons learned in the early 1930s and applied them to midcentury movements. Other women, also radicalized by communist activism during the Great Depression, persevered through McCarthyism and the Cold War era. Erik Gellman documents how Black women in the NNC were often tasked with "holding down the fort" during the war, influencing the next generation of Black women activists as they entered the Civil Rights Movement.[12] Famous activists of the 1960s, such as Rosa Parks and Ella Baker, active and educated in Depression-era protests, continued to push for reimagining how to fight for racial justice.[13] Black Power advocates in the 1970s, such as Angela Davis, and Black feminists of the 1980s of the Combahee River Collective, drew connections with their forebears and paid tribute in scholarly works.[14] The 1990s and 2000s brought their own challenges to Black radicalism with conservative backlash and publicized police violence, but African American women again adapted through new coalition building.[15]

In turn, those women taught, trained, and inspired the next generation of Black radicals, who have in turn influenced today's activists in the Black Lives Matter movement.

To claim continuity between 1930s labor and community organizing and the Black Lives Matter movement might seem like an intellectual stretch. However, as a social force, Black radicalism continues to advance. As Cedric Robinson argues, "Each generation assembles the data of its experience to an ideology of liberation."[16] Black radicalism continues to resist systems of oppression in activists who, consciously or unconsciously, claim 1930s activism and other eras as their political ancestors. As we enter the third decade of the twenty-first century, the United States is in something of a renaissance of Black radicalism, where its proponents are vocally and persistently addressing issues of race, class, and gender. The "freedom dreams" of activists during the Great Depression are in renewal, locally, nationally, and globally. There are differences, of course. Technology and social media are among the most obvious departures, but the Black radical movement has shifted in other ways. While activists of the 1930s considered racism a biproduct of capitalism, protesters today identify racism as the main perpetuator of economic, political, social, and institutional violence. The movement today is more interracial than ever and composed of all generations. Issues affecting the LGBTQ+ community have taken on their own importance in the movements. The struggle is now visibly global, and people on every continent except Antarctica have shown public solidarity with the BLM activists. The Rebellion of 2020 broke records for Americans protesting. The *New York Times* estimated that on June 6, the height of the protests, around 500,000 people participated in demonstrations in nearly 550 locations in the United States. By July, the *Times* estimated that anywhere from 15 to 24 million people had publicly protested against police brutality and violence.[17] The names of George Floyd and Breonna Taylor are known in every town and home in America.

The millions who have marched likely do not realize their actions are in the tradition of Black radicalism. But by placing systemic racism and intersectionality at the core of state-sanctioned violence, Black Lives Matter and the larger Movement for Black Lives (M4BL), a coalition of individuals and organizations with a shared vision for racial justice, embrace radical anticapitalist critiques. "Defund the police" placards have replaced the chants of "We want food—not bullets," but the sentiment is the same: police violence is operating as an instrument of the white supremacist capitalist state and undermining democratic

principles of equality and justice. Just as Sopkin apron factory strikers were beaten brutally in the streets of Chicago in 1933, nonviolent protesters today face tear gas, clubs, and rubber bullets. Just as Mary Tabb could not find adequate health care for her broken leg, African Americans are disproportionately contracting and dying from COVID-19.[18] And the same story can be told of the gap between unemployed Black and white workers during the Great Depression and today.[19] Protests in Midwestern cities have been some of the most explosive: Minneapolis, Kansas City, Chicago, Detroit, and Kenosha, Wisconsin, all saw large-scale protests and resulting police violence. And, as they always have, Black women lead the way as national and local leaders. Alicia Garza, Opal Tometi, and Patrisse Khan-Cullors continue to be active on social media, organizing protests and demonstrations, and continue to challenge police brutality, white supremacy, mass incarceration, and more. On a smaller, but no less significant, level, Black women across the United States agitate in their communities, addressing regional issues. They are active in electoral politics, support for the unemployed, food banks, local policing, and much more. At all levels, these activists embrace the beliefs asserted by Black leftist feminists for decades. As Barbara Ransby describes, the movement is "politically and ideologically grounded in the U.S.-based Black feminism tradition, a tradition that embraces an intersectional analysis while insisting on the interlocking and interconnected nature of different systems of oppression."[20]

Terms like "intersectionality" and "institutional racism" were not in the vocabulary of women like Rose Billups or Carrie Smith. However, racism, classism, and sexism were something they experienced every day as Black working-class women in the Midwest. Their activism, often overlooked or underplayed, was essential in shaping a Black radical tradition in Midwestern cities that helped give rise to the Black Lives Matter movement today. With chants, slogans, and methods of protest like those of Carrie Smith or Eleanor Rye or Maude White, BLM activists have taken up the call for Black radicalism in the twenty-first century. Whether the movement will be a continuity or a rupture in the Black radical tradition remains to be seen.

APPENDIX

NOTES

BIBLIOGRAPHY

INDEX

BLACK POPULATIONS IN SELECTED CITIES

Chicago's Black Population:

Year	Total Population	Black Population	Percent Black
1910	2,185,283	44,103	2%
1920	2,701,705	109,458	4.1%
1930	3,376,438	233,903	6.9%
1940	3,396,808	277,731	8.2%

Cleveland's Black Population:

Year	Total Population	Black Population	Percent Black
1910	560,663	8,448	2.3%
1920	796,851	34,451	4.3%
1930	900,429	71,133	7.9%
1940	878,336	84,320	9.6%

St. Louis's Black Population:

Year	Total Population	Black Population	Percent Black
1910	687,029	43,960	6.4%
1920	772,897	69,560	9%
1930	821,960	93,703	11.4%
1940	816,048	108,534	13.3%

Detroit's Black Population:

Year	Total Population	Black Population	Percent Black
1910	465,766	5,589	1.2%
1920	993,678	40,740	4.1%
1930	1,568,662	120,786	7.7%
1940	1,623,452	149,457	9.2%

Compiled from: Bureau of the Census, *Thirteenth Census of the United States, 1910* (Washington, DC: US Government Printing Office, 1913); Bureau of the Census, *Fourteenth Census of the United States, 1920* (Washington, DC: US Government Printing Office, 1922); Bureau of the Census, *Fifteenth Census of the United States, 1930* (Washington, DC: US Government Printing Office, 1932); Bureau of the Census, *Sixteenth Census of the United States, 1940* (Washington, DC: US Government Printing Office, 1943).

NOTES

INTRODUCTION

1. "A Starving Negro Woman Worker Who Is Ready to Fight," *Working Woman* (May 1930): 3.

2. Fichtenbaum, *Funsten Nut Strike*, 80.

3. R. Douglas Hunt, "Midwestern Distinctiveness," in Cayton and Gray, *The American Midwest*, 163–64.

4. The Ohio River is an appropriate marker for the Black Midwest. Many African Americans referred to the river as the "River Jordan" as it symbolized the passage from the slave South to the free North. For more on geography, see Trotter, *River Jordan*, McDuffie, "A New Day Has Dawned for the UNIA," and McDuffie, "The Diasporic Journeys of Louise Little."

5. John Dewey, "The American Intellectual Frontier," *New Republic* 30 (10 May 1922): 303–05. Dewey was attacking Illinois-born Nebraska politician and anti-evolution advocate, William Jennings Bryan.

6. Campney, *Hostile Heartland*, 2.

7. Howard, "American Tradition."

8. U.S. Bureau of the Census, "Principal Cities," 61. See Appendix.

9. Trotter, *Black Milwaukee*, 55.

10. See Pierce, *Polite Protest*.

11. Delton, "African American Identity in Minneapolis," 420.

12. Robinson, *Black Marxism*, 73.

13. Ibid., xxx.

14. Ibid., 1.

15. Robin D. G. Kelley, "The Black Radical Tradition." (Discussion for African American Intellectual History Society Annual Conference, Austin, Texas, March 7, 2020).

16. McDuffie, *Sojourning for Freedom*, 15.

17. Farmer, *Remaking Black Power*; Keisha Blain, *Set the World on Fire*; Andrews, *Thyra J. Edwards*; Blain and Gill, eds., *To Turn the Whole World Over*.

18. Boyce Davies, *Left of Karl Marx*; Gilyard, *Louise Thompson Patterson*; Ransby, *Eslanda*; Perry, *Looking for Lorraine*; Andrews, *Thyra Edwards*.

19. For more on intersectionality, see Crenshaw, "Mapping the Margins"; Hill Collins, *Black Feminist Thought*; and Davis, *Women, Race, and Class*.

20. Mary Helen Washington, "Alice Childress" in *Left of the Color Line*.

21. McDuffie, *Sojourning for Freedom*, 5.

22. For more on respectability politics, see Wolcott, *Remaking Respectability* and Higginbotham, *Righteous Discontent*.

23. Harris, "Running with the Reds," 32.

24. Blair, *I've Got to Make My Livin'*, 86.

25. Harris, *Sex Workers, Psychics, and Number Runners*, 32.

26. Harris, "#SayHerName.

27. "Body of Woman Reds Say Was Hurt in Riot Taken to City Hall," *St. Louis Globe-Democrat*, August 21, 1932.

28. "Police Brutally Beat Girls," Chicago Defender, July 1, 1933.

29. Terkel, *Hard Times*, 408.

30. "Throw Eggs in Sopkin Dress Plant Strike" *Chicago Defender*, April 3, 1937.

31. Young, "1928 Comintern Resolution," 31.

32. Kelley, *Race Rebels*, 114.

33. Young, *Comintern*, 19.

34. McDuffie, *Sojourning for Freedom*, 44.

35. Light industry, such as food processing, was a common occupation for Black women in cities like Chicago and St. Louis, which will be explored in later chapters.

36. "Start Campaign to Help Negro Women's Strike," *Daily Worker*, October 9, 1926; "Two More Women Jailed by Cops in Date Strike," *Daily Worker*, October 6, 1926; "Something New—Negro Women Strikers," *Daily Worker*, October 19, 1926.

37. "The Negro Working Woman," *Daily Worker*, March 8, 1926.

38. The TUUL came out of the Trade Union Education League (TUEL), which sought to influence mainstream union organizations like the AFL by "boring from within."

39. *Labor Unity*, September 14, 1929.

40. Terkel, *Hard Times*, 298.

41. Ibid., 295.

42. Chandler, *America's Great Depression*, 47, 49.

43. Leab, "United We Eat," 304.

44. Martin, *Angelo Herndon Case*, 12.

45. Martin, *Angelo Herndon Case*, 12; Kelley, *Hammer and Hoe*, 78–91; Solomon, *Cry Was Unity*, 219–21; Davis, *Communist Councilman*, 53–81.

46. Harris, "Running with the Reds," 30–32.

47. Painter, *Narrative*.

48. Kelley, *Hammer*; Naison, *Communists in Harlem*.

49. Klehr, *Heyday of American Communism*, 171.

50. Isserman, *Which Side*, 12.

51. McDuffie, "A New Day," 76.

52. See McDuffie, "Chicago" and Blain, *Set the World*.

53. See McDuffie, *Sojourning for Freedom*; Gore, *Radicalism at the Crossroads*.

54. For Black radicalism and space, see Tyner, *Geography of Malcolm X*.

55. See Wolcott, *Race, Riots, and Roller Coasters*; Mitchell, *Right to the City*; Wilste, *Contested Waters*; Sugrue, *Sweet Land of Liberty*.

56. Seawell, "Black Freedom Movement," 3–4.

57. "The right to the city" was coined by French theorist Henri Lefebvre but has taken on new meaning in regard to race and social activism. See Mitchell, *Right to the City*.

58. Denver Nicks, "How Ferguson Went from Middle Class to Poor in a Generation," *Time Magazine*, August 18, 2014, http://time.com/3138176/ferguson -demographic-change/; Heather Long and Andrew Van Dam, "U.S. unemployment rate soars to 14.7 percent, the worst since the Depression era," *Washington Post*, May 8, 2020, https://www.washingtonpost.com/business/2020/05/08 /april-2020-jobs-report/.

59. Ransby, *Making All*, 11.

60. Kelley, *Freedom Dreams*, 7–9.

1. "LOSE YOUR FEAR"

1. "Brother David Moore and the Ford Hunger March," *Political Affairs*, March 7, 2007, http://www.politicalaffairs.net/brother-dave-moore-and-the-ford-hunger -march/.

2. "Four Killed in Detroit Job Rush," *Chicago Defender*, March 13, 1932.

3. Keeran, *Communist Party and the Autoworkers Union*, 96; Wolcott, *Remaking Respectability*, 3.

4. See, for example: Keeran, *Communist Party and the Autoworkers Union*; Meier and Rudwick, *Black Detroit*.

5. See, for example: Wolcott, *Remaking Respectability*; Moon, *Untold Tales*; Thomas, *Life for Us*; Bates, *Making of Black Detroit*; Dillard, *Faith in the City*; Shockley, "We, Too, Are Americans"; and Miller, *Managing Inequality*.

6. Thirteenth Census of the United States, 1910, vol. 3, 178; Fourteenth Census of the United States, 1920, vol. 3, 40–41; Fifteenth Census of the United States, 1930, vol. 3, part 1, 61; Sixteenth Census of the United States, 1940, vol. 2, part 2, 114. For more detail, see appendix.

7. Mayor's Inter-racial Committee, *Negro in Detroit*, 16.

8. Ibid., 10.

9. Boykin, *Hand Book*, 54.

10. Moon, *Untold Tales*, 37.

11. Bates, *Making of Black*, 22–23.

12. Bates documents how the five dollars for eight hours of work program was much more complicated than it seemed, involving an investigation from the FMC's Sociological Department as part of Ford's Americanization plan, which sought to mold Ford's version of a perfect American worker (22–28).

13. Oral history interview with Frank Marquart, July 1968, Black Workers in the Labor Movement Oral Histories, Walter Reuther Library, Wayne State University (hereafter BWLMOH, WRL-WSU), 4.

14. Moon, *Untold Tales*, 96.

15. Ibid.

16. Oral history interview with Rev. Charles Hill by Robert McBride, May 1967, BWLMOH, WRL-WSU, 3.

17. Compiled from Fifteenth Census of the United States, 1930: Occupations vol. 4, 803, quoted in Thomas, *Life for Us*, 44.

18. Bates, *Making of Black Detroit*, 158.

19. Moon, *Untold Tales*, 92–93.

20. Young and Wheeler, *Hard Stuff*, 21.

21. Compiled from Fifteenth Census of the United States, 1930: Occupations, vol. 4, 805, quoted in Thomas, *Life for Us*, 44.

22. Thomas, *Life for Us*, 32.

23. "1920 Report," n.d. Detroit Urban League Papers, box 1, folder 4, Bentley Historical Library, University of Michigan (hereafter BL-UM).

24. Compiled from Fifteenth Census of the United States, 1930: Occupations, vol. 4, 805, quoted in Thomas, *Life for Us*, 44.

25. Mayor's Inter-racial Committee, *Negro in Detroit*, 27.

26. Wolcott, *Remaking Respectability*, 171.

27. Mayor's Inter-racial Committee, *Negro in Detroit*, 28.

28. Moon, *Untold Tales*, 114.

29. Ibid., 115.

30. Washington, *Negro in Detroit*, 57–58.

31. "Outline for the Adult Education," n.d. Detroit Urban League Papers, box 1, folder 2, BL-UM.

32. "Urban League and Its Work and Its Achievements," c. 1920s, Detroit Urban League Papers, box 1, folder 3, BL-MU.

33. Thomas, *Life for Us*, 32.

34. Wolcott, *Remaking Respectability*, 82.

35. Thomas, *Life for Us*, 21, 35.

36. Thomas, *Life for Us*, 230.

37. Bates, "A New Crowd," 340–77.

38. Thomas, *Life for Us*, 139–40.

39. Oral history interview with Arthur McPhaul by Norman McPhaul, April 5, 1970, BWLMOH, WRL-WSU, 6.

40. Oral history interview with Beulah Whitby by Jim Kenney and Roberta McBride, September 16, 1969, BWLMOH, WRL-WSU, 1.

41. Thomas, *Life for Us*, 198.

42. Smith-Irvin, *Footsoldiers*, 48.

43. Wolcott, *Remaking Respectability*, 126.

44. Bates, *Making of Black Detroit*, 70.

45. *Marcus Garvey, vol. 5*, 661–63.

46. Moon, *Untold Tales*, 51. Diggs would later go on to represent Michigan as the state's first Black congressman.

47. Wolcott, *Remaking Respectability*, 127–28.

48. Blain, *Set the World*, 12, 36.

49. Smith-Irvin, *Footsoldiers*, 59.

50. Taylor, *Veiled Garvey*, 2.

51. Boykin, *Hand Book*, 45.

52. "Garvey Thrills UNIA with Message," *Detroit Tribune*, March 6, 1933; "Detroiters Hold Protest Meeting," *Detroit Tribune Independent*, August 3, 1935.

53. Rolinson, *Grassroots Garveyism*, 23.

54. Bates, *Making of Black Detroit*, 158.

55. Ibid.

56. Lorence, *Organizing the Unemployed*, 4.

57. "Thousands in Need of Work Make Their Way to Detroit," *Chicago Defender*, March 13, 1932.

58. "Letter to Glen Cason from John C. Dancy," November 29, 1929. Detroit Urban League Papers, box 1, folder 29, BL-UM.

59. "Letter to John C. Dancy from Eleanor Shamwell," November 5, 1930. Detroit Urban League Papers, box 32, folder 1, BL-UM.

60. "Letter to Eunice Smith from John C. Dancy," January 23, 1932. Detroit Urban League Papers, box 32, folder 2, BL-UM.

61. Annual Report of the Detroit Urban League for the Year Ending December 31, 1930, January 20, 1931, 1. Detroit Urban League Papers, box 62, BL-UM.

62. "17th Annual Report of the Detroit Urban League," February 21, 1933, 10. Detroit Urban League Papers, box 62, BL-UM.

63. William J. Norton, "The Relief Crisis in Detroit," *Social Service Review*, 7.1 (March 1933): 5–6.

64. Robinson, *Race, Religion*, 97.

65. Miller, *Managing Inequality*, 185.

66. Bates, "New Crowd," 340–77.

67. Bates, *Making of Black Detroit*, 228.

68. White, "Who Owns the Negro Churches?" 176–77.

69. Robinson, *Race, Religion*, 102.

70. White, "Who Owns the Negro Churches?" 176–77.

71. Hill, May 1967, WRL-WSU.

72. Conot, *American Odyssey*, 279.

73. Taylor, *Promise of Patriarchy*, 4; Evanzz, *The Messenger*, 61–69.

74. Taylor, *Promise of Patriarchy*, 4.

75. Majeed, "Clare Evans Muhammad," 218.

76. Ibid., 224.

77. Beynon, "The Voodoo Cult," 903; "The Islam Issue in Detroit," *Detroit Tribune Independent*, April 28, 1934.

78. Wolcott, *Remaking Respectability*, 187.

79. "The Islam Issue in Detroit," *Detroit Tribune Independent*, April 28, 1934.

80. Beynon, "The Voodoo Cult," 897.

81. Boykin, *Hand Book*, 46.

82. Oral history interview with Shelton Tappes by Herbert Hill, October 27, 1967, BWLMOH, WRL-WSU, 26.

83. Young and Wheeler, *Hard Stuff*, 38.

84. Oral history interview with David Moore, January 1984, BWLMOH, WRL-WSU, 2.

85. Ibid.

86. Keeran, *Communist Party and the Autoworkers Union*, 8.

87. "Police Break up Red Meeting," *Detroit News*, November 29, 1931, 1; "Reds to Parade Here on May Day," *Detroit News*, April 26, 1932, 37; "Police Called to Quiet Reds," *Detroit News*, May 11, 1932.

88. Keeran, *Communist Party and the Autoworkers Union*, 66.

89. "Negro Workers Most Exploited," *Auto Workers News*, June 1929.

90. Robert Woods, "Winning the Negro Masses in Detroit," *Daily Worker*, November 2, 1929. For more about Blacks in the AWU, see Meier and Rudwick, *Black Detroit*.

91. Tappes, interview, BWLMOH, WRL-WSU, 12.

92. Myra Page, "Cleveland—A Mass Story," *Working Woman*, December 1929, 2.

93. "Women Workers Face Unemployment," *Working Woman*, April 1930, 3.

94. "Labor Laws Violated," ca. March 1933," CPUSA, fond 515, reel 247, delo 3161, frame 20.

95. Tappes, interview, BWLMOH, WRL-WSU, 12g.

96. Ibid.

97. "2,000 Reds Are on Party Rolls," *Detroit News*, March 10, 1933; "Brother David Moore," March 7, 2007.

98. Oral history interview with Joseph and Rose Billups by Robert McBride, September 9 1967, BWLMOH, WRL-WSU, 13–14.

99. Ibid.

100. "Brother David Moore," *Political Affairs,* March 7, 2007, http://www.political affairs.net/brother-dave-moore-and-the-ford-hunger-march/.

101. "Detroit Cops in Melee with Reds over Woman's Eviction," *Chicago Defender,* August 22, 1931.

102. Billups, interview, BWLMOH, WRL-WSU, 6.

103. Ibid., 7.

104. Marquart, interview, BWLMOH, WRL-WSU, 7.

105. Young and Wheeler, *Hard Stuff,* 37.

106. Tappes, interview, BWLMOH, WRL-WSU, 26.

107. U.S. House of Representatives, Subcommittee of the Committee on Un-American Activities, *Communism in the Detroit Area,* 82nd Cong., 2d sess., 1952, 11–12. Tappes had no qualms about "naming names" during the House Un-American Activities anti-Communist hunt during the 1950s.

108. Young and Wheeler, *Hard Stuff,* 44.

109. "Communists Hold Meeting," *Detroit News,* August 2, 1930.

110. "Communists in Detroit Demand for Dole for Jobless and Taxing All Incomes More than $5000," *Great Fall Tribune,* October 25, 1930, 3.

111. Oral history interview with Joseph and Rose Billups and Shelton Tappes by Robert McBride and Herbert Hill, October 27, 1967, BWLMOH, WRL-WSU, 9.

112. Billups, interview, BWLMO H, WRL-WSU, 10.

113. Billups and Tappes, BWLMOH WRL-WSU, 9.

114. Ibid., 10.

115. "From Detroit, Michigan," *Working Woman* (January 1934): 12.

116. 1930 Census, Detroit, Wayne, Michigan, digital image *s.v.* "Mattie L Woodson," *Ancestry.com.*

117. U.S. Congress, House of Representatives, Committee on Un-American Activities, *Communism in the Detroit Area—Part 1,* 11–12.

118. U.S. Congress, House of Representatives, Committee on Un-American Activities, *Communism in the Detroit Area—Part 2,* 3230.

119. "FBI Agent Describes 'Selling' Himself to Reds," *Detroit Free Press,* February 26, 1952, 5; "Identification of Communists Incomplete," *Detroit Free Press,* February 26, 1952.

120. Roger Didler, "Denounces DuBois, Miller, and Pickens as 'Worst Enemies,'" *Pittsburgh Courier,* June 4, 1932.

121. Didler, "Denounces DuBois"; Mabel Byrd, "Colored Workers Take Prominent Part in Communist Convention," *Baltimore Afro-American,* June 4, 1932.

122. "Our Delegates to the Paris Congress," *Working Woman* (August 1934): 3.

123. "The Jobless Organize," *Working Woman* (February 1935): 8.

124. Baskin, "The Ford Hunger March–1932," 334.

125. Maurice Sugar, "Bullets—Not Food—for Ford Workers," *Nation,* March 23, 1932, 333.

126. Ibid., 334.

127. Youth Communist League, *Youth in the Ford Hunger March*, 1.

128. Sugar, *Ford Hunger March*, 36.

129. "Working-Class Heroes," *New Force* 1.3 (March/April 1932): 5.

130. Gosman Scarborough, *Whirlwinds of Danger*, 27.

131. Billups, BWLMOH, WRL-WSU, 3.

132. Ibid.

133. Bates, *Making of Black Detroit*, 163.

134. Tappes, BWLMOH, WRL-WSU, 18.

135. Keeran, *Communist Party and the Autoworkers Union*, 90.

136. "Detroit Workers Win Strike Demands," March 2, 1933, CPUSA, fond 515, reel 247, delo 3161, frame 36.

137. "Auto Workers Union," January 22, 1933, Henry Kraus Papers, box 1, folder 32, WRL-WSU; "Stand Solid behind the Briggs Strike—Don't Scab," c. 1933, Henry Kraus Papers, box 1, folder 32, WRL-WSU; "Briggs Workers!," c. 1933, Henry Kraus Papers, box 1, folder 32, WRL-WSU.

138. Phil Raymond, "The Briggs Auto Strike Victory," *Labor Unity* (March 1933): 21–23.

139. Keeran, *Communist Party and the Autoworkers Union*, 91.

140. Rubenstein, *Making and Selling Cars*, 138.

141. The UAW was officially founded in 1935 under the American Federation of Labor (AFL) and in 1935 John L. Lewis formed the Congress of Industrial Unions under the AFL. Only a few months later the congress was suspended from the AFL and separated to form its own rival labor federation. For more on the formation of the UAW, see Barnard, *American Vanguard*.

142. Black workers in the UAW often challenged white liberals who occupied leadership roles in the UAW, leading to longstanding disagreements. Even Black workers who supported the union, expressed doubt about their white colleagues. For example, Moore said, "We just didn't trust the UAW," while Joseph Billups said Black workers "figured they would be used—used by white people, and then kicked out." (Bates, *Making of Black Detroit*, 223). See also Lewis-Colman, *Race against Liberalism*.

143. Lewis-Colman, *Race against Liberalism*, 22, 26

144. Billups and Tappes, interview, BWLMOH, WRL-WSU, 7.

145. The history of white women involved in the UAW during this period has been well documented, but there are few works devoted to Black women in the union. See Dollinger, *Not Automatic*; Bromsen, "'They All Sort of Disappeared'"; Baugh-Helton, "A Women's Place"; Gabin, "'Penalty on Womanhood.'"

146. Marquart, interview, BWLMOH, WRL-WSU, 10.

147. "Brother David," *Political Affairs*, March 7, 2007, http://www.politicalaffairs.net/brother-dave-moore-and-the-ford-hunger-march/.

2. "WHY CAN'T WE GET A LIVING WAGE"

1. Carrie Smith and Cora Lewis, "We Strike and Win," *Working Woman* (August 1933): 8; *1930 U.S. Census*, St. Louis, St. Louis City, Missouri, digital image *s.v.* "Carrie Smith"; *Ancestry.com*; Stevens, *History*, 80.

2. See Lang, *Grassroots at the Gateway*; Dowden-White, *Groping toward Democracy*; Jolly, *Black Liberation*; Johnson, *Broken Heart of America*; and Ervin, *Gateway to Equality*.

3. Johnson, *Broken Heart of America*, 5.

4. Fichtenbaum, *Funsten Nut Strike*, 12.

5. Oral history interview with Reba Mosby with Richard Resh, July 9, 1970, BCL-SHSM. Mosby went on to receive her doctorate in sociology and teach at the historical Black college Harris-Stowe Teacher's College in St. Louis.

6. Oral history interview with Nannie Mitchell Turner, July 1970, BCL-SHSM. Turner was president of the *St. Louis Argus*, the city's leading Black newspaper.

7. Oral History Interview with Sidney Redmond by Richard Resh and Franklin Rother, July 6, 1970, BCL-SHSM.

8. Primm, *Lion of the Valley*, 441; *Thirteenth Census of the United States, 1910*, vol. 3, 178; *Fourteenth Census of the United States, 1920*, vol. 3, 40–41; *Fifteenth Census of the United States, 1930*, vol. 3, part 1, 61; *Sixteenth Census of the United States 1940* vol. 2, part 2, 114. See appendix.

9. Jolly, *Black Liberation*, xiv.

10. Ira Reid, "A Study of the Industrial Status of Negroes in St. Louis," 1934, box 9, series 8–13, 20, Health and Welfare Council, Western Historical Manuscripts Collection, University Missouri St. Louis (hereafter WHMC-UMSL).

11. Interview with Charleszetta Waddles in Hill, *Black Woman Oral History Project*, vol. 7, 68.

12. Primm, *Lion of the Valley*, 441; Reid, "A Study of the Industrial Status of Negroes in St. Louis," 1934, box 9, series 8–13, 7, Health and Welfare Council, WHMC-UMSL.

13. Gordon, *Mapping Decline*, 70–71; Johnson, *Broken Heart*, 252–53.

14. St. Louis would further be at the center of national attention for the housing debate when the Shelley family bought a house in Northeast St. Louis, unaware of the racially restrictive covenant that prevented them from ownership. The resulting 1948 Supreme Court case, *Shelley v. Kraemer*, held that racially restrictive covenants were not legally enforceable per Johnson, *Broken Heart*, 253.

15. Lumpkins, *American Pogrom*, 2–3, 8.

16. Jolly, *Black Liberation*, 7.

17. Oral history interview with David Grant by Richard Resh, BCL-SHSM.

18. Johnson, *Broken Heart*, 260. The quote is from Margaret Bush Wilson, a well-known activist for civil rights in the city.

19. "Prof. Garvey to Speak in St. Louis," *St. Louis Argus*, December 15, 1916; "Prof. Marcus Garvey," *St. Louis Argus*, December 22, 1916.

20. "Garvey Movement Is Growing Here," *St. Louis Argus*, February 8, 1921.

21. "The Marcus Garvey Movement Steadily Grows in St. Louis," *St. Louis Argus*, March 11, 1921.

22. "Garvey Movement Rapidly Gaining in Saint Louis," *St. Louis Argus*, April 8, 1921.

23. "Garvey Movement Issues Warning," *St. Louis Argus*, May 20, 1921. Only a week later, Rev. William A. Venerable was charged fifty dollars for "disturbing the peace" and allegedly attacked a UNIA field representative during a UNIA meeting at Free Baptist Church. "Negro Pastor Fined after Row in Meeting at Church," *St. Louis Post-Dispatch*, May 27, 1921. There were no additional details on this incident.

24. "Garvey Ready to Co-Operate With Leaders," *St. Louis Argus*, March 3, 1922; "Marcus Garvey, African Republic Advocate, Here," *St. Louis Post-Dispatch*, October 1, 1924; "Report by Bureau Agent Emil A. Solanka, March 6, 1922" in Hill, *Marcus Garvey*, vol. 4, 529–30.

25. "Rosy Picture of Negroes in Own Republic Painted," *St. Louis Post-Dispatch*, February 9, 1925.

26. "Negro Improvement Society Opens Convention Here Today," *St. Louis Post Dispatch*, July 21, 1927.

27. "Report by Bureau Agent Emil A. Solanka, March 6, 1922," in Hill, vol. 4, 530; "Garvey Movement Rapidly Gaining in Saint Louis," *St. Louis Argus*, April 8, 1921.

28. Blain, *Set the World*, 28–33.

29. Blain, *Set the World*, 31–32; Taylor, *Veiled Garvey*, 45.

30. "St. Louis Div. News," *Negro World*, January 27, 1923; Blain, *Set the World*, 31–32.

31. "St. Louis, Div. 249," *Negro World*, November 14, 1931.

32. "Negro Workers Gather Here," *Daily Worker*, October 24, 1925; "American Negro Labor Meet Opens with Gigantic Mass Demonstration in Chicago, *Daily Worker*, October 26, 1925; "ANLC Hits at Jim Crowism in Trade Unions," *Daily Worker*, October 27, 1925.

33. "The American Negro Labor Congress Radicals," *Negro World*, July 16, 1927.

34. Johnson, *Broken Heart*, 268.

35. "National Anti-Lynching Meet Here November 15th," *St. Louis Argus*, November 7, 1930; "Negro Labor Congress Ends," *St. Louis Argus*, November 21, 1930; Solomon, *Cry Was Unity*, 190.

36. Kelley, *Race Rebels*, 120.

37. "Negro Improvement Society Opens Convention Here Today," *St. Louis Post-Dispatch*, 1927.

38. Gertrude Mann, "Working Women Take Part in ANLC Convention," *Working Woman* (December 1930): 6, 8.

39. Primm, *Lion of the Valley*, 467–68. Feurer, "Nutpickers' Union," 28.

40. "John Clark to Ruth Word," May 1933, Urban League of St. Louis, series 1, box 9, University Archives, Department of Special Collections, Washington University Libraries (hereafter UA–WU).

41. Tuberculosis and Health Society of St. Louis, letter to the Honorable Board of Estimate and Apportionment, December 12, 1932, "Data Relative to Negro TBC Patients," State Historical Society of Missouri, collection S0530, folder 715.

42. "1929 Annual Report," Industrial Department, Women and Girls, Urban League of St. Louis, series 7, box 1, UA-WU.

43. "Monthly Report November 1931," Industrial Department Report, Urban League of St. Louis, series 4, box 4, UA-WU.

44. "Monthly Report April 1933," Industrial Department Report, Urban League of St. Louis, series 4, box 4, UA-WU.

45. B. K. Gebert, "How the St. Louis Unemployed Victory Was Won," *Communist* (September 1932): 791.

46. B. K. Gebert, "The Struggle for the Negro Masses and the Fight against the Social Demagogs," *Party Organizer*, June 1932, 15.

47. Paul Dennis Brunn, "Black Workers and Social Movements of the 1930s in St. Louis" (PhD dissertation, Washington University, 1975), 102.

48. "Report," CPUSA, fond 515, reel 135, delo 1773, frame 6.

49. "Report," CPUSA, fond 515, reel 135, delo 1776, frame 3.

50. "6 Held in Fight over Eviction of Negro Family," *St. Louis Post-Dispatch*, November 21, 1930.

51. "10 Interfere with Eviction; Arrested," *St. Louis Post-Dispatch*, December 9, 1930.

52. "Four Anti-Eviction Demonstrators Fined," *St. Louis Post-Dispatch*, December 22, 1930.

53. *1930 U.S. Census*, St. Louis, St. Louis City, Missouri, digital image *s.v.*, "Florida Williams," *Ancestry.com*.

54. "Alleged Disturbers Freed," *St. Louis Post-Dispatch*, January 28, 1931.

55. "Girl Agitators Active Here," *St. Louis Post-Dispatch*, November 26, 1930.

56. "Police Rout Riotous Crowd of Unemployed in City Hall Crash," *St. Louis Globe-Democrat*, January 17, 1931; "Tear Gas Drives 500 Unemployed from City Hall," *St. Louis Post-Dispatch*, January 17, 1931; "Four Reds Fined for Disturbance at City Hall," *St. Louis Post-Dispatch*, January 19, 1931.

57. "Four Reds Fined for Disturbance at City Hall," *St. Louis Post-Dispatch*, January 19, 1931.

58. *1930 U.S. Census*, St. Louis, St. Louis City, Missouri, digital image *s.v.*, "Lizzie Jones," *Ancestry.com*.

59. Hershel Walker, 1989, "A Strong Seed Planted," Oral Histories, box 1, Missouri Historical Society (hereafter SSP-MHS).

60. "Reds Storm City Hall," *St. Louis Globe-Democrat*, July 12, 1932; "Police Forbid Any More Meetings of Communists Here," *St. Louis Post-Dispatch*, July 12, 1932; "Remmers Forbids Meetings of Reds Following Riot," *St. Louis Globe-Democrat*, July 12, 1932; "The City Hall Riot," *St. Louis Globe-Democrat*, July 13, 1932.

61. "Police Forbid Any More Meetings of Communists Here," *St. Louis Post-Dispatch*, July 12, 1932

62. "Body of Woman Reds Say Was Hurt in Riot Taken to City Hall," *St. Louis Globe-Democrat*, August 21, 1932.

63. Catherine Risch, "The Effects of Communist Propaganda upon Negroes of St. Louis" (MA thesis, Saint Louis University, 1935), 17.

64. Devinatz, "Trade Unions," 503.

65. Feurer, *Radical Unionism*, 33.

66. Ibid.

67. Dowden-White, *Groping toward Democracy*, 11; Heathcott, "Black Archipelago," 720.

68. "May 1933," Industrial Department Report, Urban League of St. Louis, series 1, box 9, UA-WU.

69. Ruth Edmonds Hill, *Black Woman*, vol. 7, 289–90.

70. Ibid., 293.

71. "Monthly Report, January 1931," Industrial Department Report, *Urban League of St. Louis*, series 4, box 4, UA-WU.

72. Jones and Childs, *Economy Study*, 77.

73. Funsten advertising pamphlet, *R. E. Funsten Dried Fruit and Nut Co.*, ca. 1910s. John W. Hartman Center for Sales, Advertising, and Marketing History, Duke Libraries, Duke University.

74. Menefee and Cassmore, *Pecan Shellers of San Antonio*, 8.

75. "1929 Annual Report," Industrial Department Report, *Urban League of St. Louis*, series 7, box 1, UA-WU.

76. Senate of 48th General Assembly of Missouri, *Report of the Senate*, 17, 18.

77. Fichtenbaum, *Funsten*, 15.

78. Ibid., 34.

79. Ibid., 16.

80. "Nut Pickers Ask Mayor," *St. Louis Post-Dispatch*, May 18, 1933.

81. Oral history interview with Henry Armstrong, by Richard Resh, April 6, 1970, BCL-SHSM.

82. Fichtenbaum, *Funsten*, 19.

83. Ibid., 19.

84. "Nut Pickers Ask Mayor," *St. Louis Post-Dispatch*, May 18, 1933.

85. Ibid.

86. "Striking Nut Pickers Turn Down New Offer," *St. Louis Post-Dispatch*, May 21, 1933.

87. "500 Negro Women Go on Strike Here for 'Living Wage,'" *St. Louis Post-Dispatch*, May 15, 1933.

88. Fitchenbaum, *Funsten*, 17.

89. *U.S. Census, 1930*, St. Louis, St. Louis City, Missouri, United States, database with images, "Evelina Ford," *FamilySearch*.

90. Feurer, "The Nutpickers' Union," in Lynd, *We Are All Leaders*, 33.

91. "1929 Annual Report," Industrial Department Report, Women and Girls, Urban League, series 7, box 1, UA-WU.

92. "November 1928," Industrial Department Report, Urban League, series 4, box 4, UA-WU.

93. "Strike Is Settled," *St. Louis Argus*, May 26, 1933.

94. Fichtenbaum, *Funsten*, 20.

95. "Nut Pickers Ask Mayor," *St. Louis Post-Dispatch*, May 18, 1933. Fichtenbaum reports that interviews in 1980s revealed that the Funsten Nut Company was actually turning a 10 percent profit during this time (Fichtenbaum, 32).

96. Smith and Lewis, "We Strike," 9.

97. Ervin, *Gateway to Equality*, 37.

98. Ralph Shaw, a local CPUSA leader, identified "C.L." as the instigator of the action in the national Communist publication *Labor Unity*. No other primary sources mention C.L., giving the nut pickers the credit for starting the strike. Both Fichtenbaum and Brunn confirm that there was a familial connection between the UCs and the Funsten workers, but do not name him.

99. Ralph Shaw, "St. Louis' Biggest Strike," *Labor Unity* 8, no. 6 (August 1933): 8.

100. Shaw, "St. Louis' Biggest Strike," 8.

101. Ibid.

102. Ibid.

103. "TUUL Membership, 1930," CPUSA, fond 515, reel 163, delo 2174, frame 20.

104. Smith and Lewis, "We Strike," 8.

105. "Annual Report 1929," Industrial Department Report, Women and Girls, Urban League of St. Louis, series 7, box 1, UA-WU.

106. "Monthly Report, November 1933," Industrial Department Report, Urban League of St. Louis, series 1, box 9, UA-WU.

107. Fichtenbaum, *Funsten*, 44.

108. "Annual Report 1933," Industrial Department Report," Urban League of St. Louis, series 4, box 6, UA-WU.

109. "Annual Report 1933," Urban League of St. Louis, series 7, box 1, UA-WU.

110. Gebert, "St. Louis Strike," 803.

111. "Peter Chaunt to Clarence Hathaway," March 28, 1933, CPUSA, fond 515, reel 254, delo 3265, frame 105. The Pacific Movement of the Eastern World was founded in Chicago but received great support in St. Louis during the Great Depression

when the president of the organization moved to St. Louis. For more, see Allen, "Waiting for Tojo."

112. "Mayor Hears Wage Protest of Nut Pickers," *St. Louis Star and Times*, May 23, 1933.

113. "Peter Chaunt to Clarence Hathaway," March 28, 1933, CPUSA, fond 515, reel 254, delo 3265, frame 106.

114. Fichtenbaum, *Funsten Nut Strike*, 28.

115. Shaw, in *Labor Unity*, wrote that nine hundred walked out on the first day. The *Post-Dispatch* believed the number to be five hundred, and reported that Funsten employed between six and eight hundred workers."500 Negro Women Go on Strike Here for 'Living Wage,'" *St. Louis Post-Dispatch*, May 15, 1933.

116. Smith and Lewis, "We Strike," 8; Gebert, "St. Louis Strike," 802.

117. Smith and Lewis, "We Strike," 8–9.

118. Fichtenbaum, *Funsten Nut Strike*, 25.

119. "500 Negro Women Go on Strike Here for 'Living Wage,'" *St. Louis Post-Dispatch*, May 15, 1933.

120. Smith and Lewis, "We Strike," 9.

121. Ibid., 9. Author's correction of misspelling in original.

122. Fichtenbaum, *Funsten Nut Strike*, 27.

123. Gebert, "St. Louis Strike," 803.

124. "Another St. Louis Food Factory Goes Out on Strike," *Daily Worker*, May 22, 1933.

125. "Strike of Nut Pickers Strong in St. Louis; 2,000 Out for Pay Raise," *Daily Worker*, May 22, 1933.

126. "Woman Nut-Pickers' Strike Continues; Factories Closed," *St. Louis Post-Dispatch*, May 17, 1933.

127. "Another St. Louis Food Factory Goes Out on Strike," *Daily Worker*, May 22, 1933.

128. Shaw, "St. Louis' Biggest Strike," 10. Shaw does not elaborate on what "brick sandwiches" were, but context suggests they were bricks used in self-defense.

129. "Offers More Pay to End Strike of 500 Nut Pickers," *St. Louis Post-Dispatch*, May 16, 1933.

130. "Picket Nut Factories in Strike," *St. Louis Argus*, May 19, 1933.

131. "Mayor Enters Nut Pickers' Strike," *St. Louis Globe-Democrat*, May 23, 1933.

132. Lang, *Grassroots at the Gateway*, 30.

133. "Mayor's Group Take up Strike of Nut Pickers," *St. Louis Post-Dispatch* May 23, 1933.

134. "Mayor Addressing Striking Nut Pickers At City Hall," *St. Louis Post-Dispatch*, May 23, 1933.

135. "Mayor's Group Takes Up Strike of Nut Pickers," *St. Louis Post-Dispatch*, May 23, 1933.

136. Smith and Lewis, "We Strike," 9.

137. "Nut Pickers Strike," *St. Louis Argus*, May 26, 1933.

138. Gebert, "St. Louis Strike," 804.

139. "Mayor Dickmann Again," *St. Louis Argus*, May 26, 1933.

140. Lang, *Grassroots at the Gateway*, 25.

141. Smith and Lewis, "We Strike" 8.

142. Gebert, "St. Louis Strike," 806.

143. Ibid., 804.

144. Kelley, *Race Rebels*, 112.

145. Gebert, "St. Louis Strike," 801.

146. Collier-Thomas, *Jesus, Jobs, and Justice,*, xvii.

147. Kelley, *Hammer and Hoe*, 107.

148. Wilmore, *Black Religion and Black Radicalism,* 11–12.

149. Collier-Thomas, *Jesus, Jobs, and Justice*, xvi.

150. Kelley, *Hammer and Hoe*, 108.

151. Gebert, "St. Louis Strike," 803.

152. Walker, 1989, SSP-MHS.

153. Feurer, "Nutpickers' Union," 37.

154. Fichtenbaum, *Funsten Nut Strike*, appendix 3.

155. Smith and Lewis, "We Strike," 8.

156. Brunn, "Black Workers," 363.

157. "Annual Report 1933," Urban League of St. Louis, series 7, box 1, UA-WU.

158. Reid, "A Study of the Industrial Status of Negroes in St. Louis," 1934, box 9, series 8–13, 49, Health and Welfare Council, WHMC-UMSL.

159. "68 Freed on Peace Charges in Strike of Nut Pickers," *St. Louis Post-Dispatch*, October 13, 1933.

160. Hundreds of FWIU members were laid off during the off season and then not rehired (Feurer,"The Nutpickers' Union," 38).

161. "Free Woman Picket Beaten When Arrested by Police," *St. Louis Post-Dispatch*, October 17, 1933.

162. Lumpkins, *American Pogrom*, 189; Brunn, "Black Workers," 376–78.

163. Feurer, "Nutpickers' Union," 42.

164. Ibid.

165. Ervin, *Gateway to Equality*, 51.

166. "Mother Tells Story of Scottsboro Case," *St. Louis Post-Dispatch*, July 7, 1933.

167. "Unity in Action," S0090 Socialist Party of St. Louis and Missouri, Records, 1909–1964, roll 5, folder 42, SHSM.

168. Socialist Party records, 1933, roll 55, folder 43.

169. Brunn, "Black Workers," 366.

170. "Red Flag Flutters over St. Louis City Hall," *Chicago Defender*, February 24, 1934.

171. Risch, "Effects," 64–70.

172. Brunn, "Black Workers," 368.

173. Ibid., 369.

174. "Anti-Italian Demonstration Broken up by St. Louis Police," *St. Louis Post-Dispatch*, July 30, 1935.

175. "350 in May Day Parade Wave Red Flags and Sing," *St. Louis Post-Dispatch*, 1936.

176. "350 in May Day Parade," *St. Louis Post-Dispatch*, May 2, 1936.

177. Brunn, "Black Workers," 365.

178. "Mayor Hears Wage Protest of Nut Pickers," *St. Louis Star and Times*, May 23, 1933.

179. *St. Louis Argus*, May 26, 1933.

3. "PUT UP A FIGHT"

1. Romania Ferguson, "Must Organize Negro Women to Stop Scabbing," *Daily Worker*, April 21, 1928.

2. Roman, "Race, Politics, and U.S. Students," 65.

3. *Daily Worker*, February 16, 1931, quoted in Gosnell, *Negro Politicians*, 351.

4. "Negro Leaders Lead in Great Lakes Steel Drive," *Pittsburgh Courier*, July 31, 1937.

5. Nelson, *Steve Nelson*, 71.

6. Storch, *Red Chicago*, 14.

7. *Thirteenth Census of the United States, 1910*, vol. 3, 178; *Fourteenth Census of the United States, 1920*, vol. 3, 40–41; *Fifteenth Census of the United States, 1930*, vol. 3, part 1, 61; *Sixteenth Census of the United States 1940*, vol. 2, part 2, 114. See appendix. Drake and Cayton, *Black Metropolis*, 9, 88.

8. Grossman, *Land of Hope*, 4.

9. DeSantis, "Selling," 474; "Why They Leave the South: The Lynching Record for 1916," *Chicago Defender*, January 6, 1917.

10. DeSantis, "Selling," 491; Michaeli, *Defender*, 67.

11. Drake and Cayton, *Black Metropolis*, 174.

12. Rev. L. K. Williams, "A Square Deal for the Negro," *Chicago Whip*, April 3, 1920, quoted in Cooley, "Moving on Out," 488.

13. Wirth and Bernert, eds., *Local Community Fact Book*, 35.

14. Drake and Cayton, *Black Metropolis*, 62.

15. For more on the Chicago Black Renaissance, see Hine and McCluskey Jr.,

Black Chicago Renaissance; Schroeder Schlabach, *Along the Streets*; Tracy, *Writers*; Bone and Courage, *Muse in Bronzeville*.

16. Drake and Cayton, *Black Metropolis*, 102.

17. Haywood, *Black Bolshevik*, 83.

18. Drake and Cayton, *Black Metropolis*, 66.

19. Haywood, *Black Bolshevik*, 1.

20. Chicago Commission on Race Relations, *Negro in Chicago*, 640.

21. Ibid, 647.

22. McDuffie, "Chicago," 129.

23. "Speech by Marcus Garvey," February 6, 1921, in Hill, *Marcus Garvey*, vol. 3, 164.

24. McDuffie, "Chicago," 130; Michaeli, *The Defender*, 123–27.

25. Michaeli, *Defender*, 125.

26. Dolinar, ed. *Negro in Illinois*, 198; Haywood, *Black Bolshevik*, 106; Hill, *Marcus Garvey*, vol. 3, 165.

27. Haywood, *Black Bolshevik*, 106.

28. McDuffie, "Chicago," 133; Haywood, *Black Bolshevik*, 107.

29. Drake, *Churches*, 240.

30. McDuffie, "Chicago," 136.

31. Ibid., 134.

32. Blain, *Set the World*, 21–22.

33. Quoted in Blain, *Set the World*, 51–52.

34. Drake and Cayton, *Black Metropolis*, 752.

35. McDuffie, "Chicago," 138.

36. Arna Bontemps, "What Is Africa to Me?" in Dolinar, *Negro in Illinois*, 198; McDuffie, "Chicago," 138.

37. McDuffie, "Chicago," 138.

38. Ibid., 28.

39. Bates, *Pullman Porters*, 8–11.

40. Chateauvert, *Marching Together*, xiii.

41. Ibid, 18,

42. Reed, *Rise*, 201–202; Charles S. Johnson, "These 'Colored United States,' VIII–Illinois: Mecca of the Migrant Mob," *Messenger* 5 (December 1923): 928, quoted in Reed, *Rise*, 21.

43. Strickland, *History*, 40.

44. Reed, *Rise*, 171.

45. Ibid.

46. Strickland, *History*, 104; Michaeli, *Defender*, 185.

47. Earl B. Dickerson, quoted in Terkel, *Hard Times*, 393.

48. A. L. Foster, "Urban League and the Negro Community: The Eighteenth

Annual Report of the Chicago Urban League, 1932." Chicago Urban League, series I, box I, folder 10, Chicago History Museum (hereafter CHM).

49. "Hold Your Jobs," *Chicago Defender*, December 7, 1929.

50. Drake and Cayton, *Black Metropolis*, 320, 321, 217. Drake and Cayton use the Chicago Housing Authority's "Memorandum on Unemployment in Chicago, 1935" to estimate these numbers.

51. Drake and Cayton, *Black Metropolis*, 9, 88.

52. Dickerson, quoted in Terkel, *Hard Times*, 393.

53. Dr. Martin Bickham, quoted in Terkel, *Hard Times*, 395.

54. Eason, "Attitudes of Negro Families," 369, 215.

55. Drake and Cayton, *Black Metropolis*, 84; Bates, *Pullman Porters*, 112–13.

56. Drake and Cayton, *Black Metropolis*, 84.

57. Drake, *Churches*, 248–49.

58. Drake and Cayton, *Black Metropolis*, 85.

59. Drake and Cayton, *Black Metropolis*, 85; Drake, *Churches*, 256.

60. "Negro Workers Cheer Minor at Open Air Meet," *Daily Worker*, October 15, 1924.

61. Lasswell and Blumenstock, *World Revolutionary*, 45–48; Drake, *Churches*, 258; Storch, *Red Chicago*, 27.

62. Drake and Cayton, *Black Metropolis*, 86; Gosnell, *Negro Politicians*, 320.

63. Gosnell, *Negro Politicians*, 321.

64. Storch, *Red Chicago*, 105.

65. Lasswell and Blumenstock, *World Revolutionary*, 139.

66. McDuffie, "Chicago," 137.

67. "Speech by Marcus Garvey," February 6, 1921, in Hill, *Marcus Garvey, vol. 3*, 164.

68. Reed, *Rise*, 37.

69. "Reds Threaten DePriest," *Chicago Defender*, June 20, 1931; "Police Check Reds' Attack on DePriest," *Chicago Defender*, July 23, 1932; "Radicals Pay Lively Visit to DePriest," *Chicago Defender*, December 31, 1932.

70. McDuffie, "Chicago," 130, 138; Martin, *Race First*, 225–37.

71. Dewey Jones, "Crowd Hears Angelo Herndon Tell of Georgia Jail," *Chicago Defender*, Sept. 29, 1934.

72. Storch, *Red Chicago*, 96.

73. Gosnell, *Negro Politicians*, 348.

74. Ibid., 329.

75. *Chicago Whip*, July 25, 1931, quoted in Gosnell, *Negro Politicians*, 330.

76. Storch, *Red Chicago*, 112–13; Drake and Cayton, *Black Metropolis*, 86.

77. Terkel, *Hard Times*, 408.

78. Drake and Cayton, *Black Metropolis*, 87.

79. "Communist Set Fire to House in Eviction Protest," *Chicago Tribune*, August 18, 1932.

80. Terkel, *Hard Times*, 435.

81. Ibid., 408.

82. Ibid., 401.

83. "Three Negroes Die in Chicago Red Riot," *New York Times*, August 4, 1931; "U.S. Acts to Curb 'Reds,'" *Chicago Defender*, August 8, 1931; "Reds Riot: 3 Slain by Police," *Chicago Tribune*, August 4, 1931. Newspaper accounts alternatively spelled "Gray" as "Grey" and "O'Neil" as "O'Neal."

84. Storch, *Red Chicago*, 100.

85. Haywood, *Black Bolshevik*, 443; Terkel, *Hard Times*, 369.

86. "Negro Evictions Halt after Chicago Riot," *New York Times*, August 5, 1931.

87. "Large Chicago Park Has Changed Hands," *New York Times*, August 9, 1931; "Dear Comrade Browder," August 11, 1931, CPUSA, fond 515, reel 186, delo 2460, frame 53.

88. "Negro Leaders Accuse Reds in Fatal Rioting," *Chicago Tribune*, August 4, 1931.

89. "100 Arrested in Raids on Jobless Forum in Chicago," *Daily Worker*, February 2, 1933.

90. Gosnell, *Negro Politicians*, 354.

91. Drake, "Churches," 260, footnote.

92. Ibid., 261.

93. Ibid., 261; "Scottsboro Boys in Chicago for Mass Meeting," *Chicago Defender*, December 18, 1937.

94. Dewey R. Jones, "Crowd Hears Angelo Herndon Tell of Georgia Jail," *Chicago Defender*, September 29, 1934.

95. Lasswell and Blumenstock, *World Revolutionary*, 139.

96. Ibid., 93; Gosnell, *Negro Politicians*, 338.

97. Gosnell, *Negro Politicians*, 338–39.

98. "Crowd Orderly at Funeral of Slain Rioters," *Chicago Tribune*, August 9, 1931.

99. "Recruiting Party Members During Aug. 3–8th Events in Chicago," *Party Organizer* (Sept.–Oct. 1931): 16.

100. Lasswell and Blumenstock, *Revolutionary Propaganda*, 281; Storch, *Red Chicago*, 122.

101. "Dear Comrade Browder," August 11, 1931, CPUSA, fond 515, reel 186, delo 2460, frame 54.

102. "Dear Comrade Browder," August 11, 1931, CPUSA, fond 515, reel 186, delo 2460, frame 51.

103. Solomon, *The Cry Was Unity*, 136.

104. "Women May Pick Next President," *Edwardsville Influencer*, November 3, 1928; Storch, *Red Chicago*, 46.

105. *Daily Worker*, February 16, 1931, quoted in Gosnell, *Negro Politicians*, 351.

106. Storch, *Red Chicago*, 46.

107. Gosnell, *Negro Politicians*, 351.

108. Ibid., 351. Gosnell cites the *Daily Worker*, which incorrectly calls her "Laura Crosby."

109. "Protest Filed against Minor Party Nominees," *Chicago Tribune*, October 3, 1934.

110. "'Hunger Army' Battles Police," *Chicago Defender*, January 16, 1932.

111. "'Reds' Attack Cops: 10 Hurt," *Chicago Defender*, February 4, 1933.

112. Bates, *Pullman Porters*, 113–15; Walker, *Free Frank*, 2. Wheaton came from a family steeped in a legacy of fighting for racial justice; her great-grandfather, Frank McWorter was enslaved when he purchased his own freedom in 1819. McWorter moved to Illinois and founded the all-Black town of New Philadelphia in 1836, the first African American to found a town. Though the ancestral journey from Frank to Thelma is long, Thelma's daughter, Juliet E. K. Walker connects Frank's remarkable life and "unrelenting efforts" as part of his lasting legacy to his descendants (172, 115).

113. Ibid., 115; Gosnell, *Negro Politicians*, 334.

114. Lightfoot, *Chicago Slums*, 54.

115. "Growth of Sweatshops during the Depression," *Monthly Labor Review* 36, no. 3 (1933): 500.

116. "West Side Workers Go On Strike–Agreement Broken," *The Day Book*, January 31, 1916.

117. "Garment Factory Head Explains Strike of Girls," *Chicago Tribune*, February 3, 1916.

118. "Can Put 200 Women and Girls to Work," *Chicago Defender*, February 24, 1917.

119. Spero and Harris, *Black Worker*, 339.

120. "Can Put 200 Women and Girls to Work," *Chicago Defender*, February 24, 1917.

121. "Foreladies," *Chicago Tribune*, April 16, 1933.

122. Seidman, *The Needle Trades*, 305–306; Thyra Edwards, "Who Is Disinterested?," *Crisis* (June 1935): 174.

123. "Babies Starve," *Working Woman* (July 1933): 14.

124. Gosnell, *Negro Politicians*, 334; Edwards, "Who Is Disinterested?," 174.

125. Goldie Larks, "How Women Act in Strikes," *Working Women* (January 1934): 12; "Thousand Women Start Riot at Apron Factory," *Jacksonville Daily Journal*, June 22, 1933.

126. Edwards, "Who Is Disinterested?," 174.

127. "The Sopkin Case," *Chicago Defender*, July 1, 1933.

128. Tyler, *Look for the Union Label*, 174.

129. Seidman, *Needle Trades*, 198.

130. Tyler, *Look for the Union Label*, 174.

131. "Report of the General Executive Board to the Twenty-Second Convention of the International Ladies' Garment Workers' Union" (Chicago: ILWGU, 1934).

132. Gosnell, *Negro Politicians*, 334.

133. Bates, *Pullman Porters*, 123.

134. Roman, "Race, Politics, and U.S. Students," 65.

135. "Charges A.C. Tried to Ban Radical Meet," *Capital Times*, December 21, 1929.

136. "Girl Sentenced for Denouncing Lynching," *Pittsburgh Courier*, August 23, 1930.

137. Roman, "Race, Politics, and U.S. Students," 65.

138. McDuffie, *Sojourning*, 53–63; Gore, *Radicalism*, 25–26. McDuffie and Gore focus only on the Communist University of the Toilers of the East (KUTV), which operated similarly to the Lenin School.

139. Roman, *Opposing Jim Crow*, 175.

140. Roman, *Opposing Jim Crow*, 256, footnote.

141. "A Blow Starts Evanston Battling over the "Pinks," *Chicago Tribune*, January 15, 1933; "Opponents Turn Barrage of Song on Reds' Meeting," *Chicago Tribune*, January 18, 1933; Dilling, *Red Network*, 39–40.

142. Louise Thompson and Thyra Edwards, both from Chicago, also traveled extensively in the Soviet Union in the 1930s, with mostly positive experiences. (McDuffie, *Sojourning*, 89)

143. Claude Lightfoot, "Report of Section #7 Organizer, Chicago," August 23, 1933, CPUSA, fond 515, reel 253, delo 3266, frame 116; Gebert, "The St. Louis Strike," 806. Gebert does not mention the name of the initial organizer but does write that there was a "Party member working in the shop," likely Ferguson.

144. Lightfoot, *Chicago Slums*, 54.

145. "Police Brutally Beat Girls," *Chicago Defender*, July 1, 1933.

146. Gebert, "The St. Louis Strike," 806.

147. Larks, "How Women Act," 12.

148. Larks, "How Women Act," 12; "1500 Factory Girls Walk Out," *Chicago Defender*, June 24, 1933.

149. "1500 Factory Girls Walk Out," *Chicago Defender*, June 24, 1933.

150. Edwards, "Who Is Disinterested?," 173.

151. Larks, "How Women Act," 12.

152. "Police Battle Strike Pickets at Apron Plant," *Chicago Daily Tribune*, June 22, 1933.

153. "Sweatshops Strike," *Working Woman* (August 1933): 14.

154. "Cops and Strikers Battle," *Chicago Defender,* July 1, 1933.

155. "Police Brutally Beat Girls," *Chicago Defender,* July 1, 1933.

156. Lightfoot, *Chicago Slums,* 54.

157. "Sopkin Yields to Demands in Wage Dispute," *Chicago Defender,* July 15, 1933.

158. Edith Kline, "The Garment Union Comes to the Negro Worker," *Opportunity: Journal of Negro Life* (April 1934): 109–110.

159. "Excerpts from Earl Browder's Speech to Seventeenth C.C. Plenum," *Party Organizer* (November 1933): 1.

160. Thyra Edwards, "Educational Background," n.d., box 1, folder 5, Thyra Edwards Papers, CHM.

161. Andrews, *Thyra Edwards,* 41.

162. The Associated Negro Press was an American news service focused on African American issues. It was founded by Claude Barnett, a personal friend of Edwards's. See Gerald Horne, *The Rise and Fall of the Associated Negro Press: Claude Barnett's Pan-African News and the Jim Crow Paradox.*

163. Edwards, "Let Us," 72, 82.

164. Company unions would soon be declared illegal under the National Labor Relations Act of 1935, also known as the Wagner Act, passed in July.

165. Edwards, "Let Us," 72.

166. Ibid.

167. Ibid.

168. J. Wellington Evans, "Thumbs Down on Unions!" *Crisis* (April 1935); 103.

169. Edwards, "Who Is Disinterested," 173.

170. Ibid., 174.

171. "Throw Eggs in Sopkin Dress Plant Strike" *Chicago Defender,* April 3, 1937; "Union Official, 9 Women Seized in Strike Clash," *Chicago Tribune,* April 7, 1937.

172. Edwards, "Part 2: What Has Happened to Uncle Tom," February 1934, box 1, folder 1, TEP, CHM.

173. "Thyra Edwards Coming to Buffalo with Captain Mulzac," *Amsterdam News,* October 27, 1944.

174. Andrews, *Thyra Edwards,* 55–56. Edwards had several romantic relationships abroad, suggesting a nontraditional interpretation of sex.

175. *Official Proceedings,* 5.

176. Gellman, *Death Blow,* 25.

177. Ibid., 22.

178. Andrews, *Thyra Edwards.,* 81.

179. Gellman, *Death Blow,* 55.

180. Ibid., 134.

181. "Negro Leaders Lead in Great Lakes Steel Drive," *Pittsburgh Courier,* July 31, 1937.

182. Gellman, *Death Blow*, 19–20.

183. Drake and Cayton, *Black Metropolis*, 397.

184. Gellman, *Death Blow*, 36.

185. Della Rossa, "Los Angeles Tribune to Eleanor Broady," *Militant* (October 1970): 16.

186. Eleanor Rye, "Women in Steel," *Chicago Defender*, September 12, 1936.

187. Ahmed, *Last Great Strike*, 94.

188. Gellman, *Death Blow*, 40.

189. Andrews, *Thyra Edwards*, 84.

190. Ibid.

191. "Sopkin Parties Sign Agreement," *Chicago Defender*, July 10 1937.

192. "Will Employ 300 Hands," *Boston Globe*, March 10, 1934.

193. "Communists to Have Full Illinois Ticket for Coming Election," *Chicago Tribune*, September 16, 1934; "State Ballot to Have 5 Parties?" *Moline Dispatch*, September 17, 1940.

194. Dilling, *Red Network*, 245.

195. Federal Bureau of Investigation, "Chicago Rpt, April 4, 1945," Freedom of Information Act, "William Dawson," https://archive.org/details/WilliamLDawson/.

4. "WE'LL NOT STARVE PEACEFULLY"

1. Rose Burt, "Ohio Negro Women Active in State Hunger March," *Working Woman* (June 1931): 3.

2. J. B., "Negro Women Are among Best Fighters for Jobless Relief," *Working Woman* (February 1931): 2.

3. "Negro Working Woman Organizer of Cleveland," *Working Woman* (December 1931): 6.

4. "Letter to International Women's Secretariat," CPUSA, fond 515, reel 247, delo 3163, frame 41.

5. Wye, "At the Leading Edge," in Van Tassel and Grabowski, *Cleveland: A Tradition of Reform*, 123. See also Kusmer, *Ghetto Takes Shape*; Gerber, *Black Ohio*; Giffin, *African Americans and the Color Line in Ohio*; Russell H. Davis, *Black Americans*.

6. Phillips, *AlabamaNorth*, 11.

7. Wye, "At the Leading Edge," 114–15.

8. Kusmer, *Ghetto Takes Shape*, 17.

9. Wye, "At the Leading Edge," 121; Kusmer, *Ghetto Takes Shape*, 152.

10. Kusmer, *Ghetto Takes Shape*, 149–51; Phillips, *AlabamaNorth*, 92–93.

11. Kusmer, *Ghetto Takes Shape*, 150.

12. Wye, "At the Leading Edge," 122; Kusmer, *Ghetto Takes Shape*, 254.

13. Kusmer, *Ghetto Takes Shape*, 255.

14. Kusmer, *Ghetto Takes Shape*, 264.

15. *Thirteenth Census of the United States 1910,* vol. 3, 178; *Fourteenth Census of the United States 1920,* vol. 3, 40–41; *Fifteenth Census of the United States 1930,* vol. 3, part 1, 61; *Sixteenth Census of the United States 1940,* vol. 2, part 2, 114. See appendix.

16. Kimberley L. Phillips, "'But It Is a Fine Place,'" 395–96.

17. Oral history interview with Bertha Cowan, January 16, 1987, St. James African American Methodist Episcopal Church Oral History, box 1, folder 5 (hereafter AAME), Western Reserve Historical Society (hereafter WRHS).

18. Ibid.

19. Kusmer, *Ghetto Takes Shape,* 190.

20. Rose, *Cleveland,* 890.

21. Phillips, *AlabamaNorth,* 81–83.

22. Ibid., 86.

23. "Negro Welfare Association Board of Trustees Meeting minutes, March 9, 1929," Cleveland Urban League Papers, box 3, folder 3, WRHS.

24. Phillips, *AlabamaNorth.,* 85.

25. Ibid., 88.

26. Ibid., 84.

27. Oral history interview with Sallie Hopson, January 30, 1987, AAME, box 1, folder 5, WRHS.

28. McDuffie, "Garveyism in Cleveland," 163.

29. "Garvey Visits and Wins Crowd," January 15, 1921, *Cleveland Advocate.* Reprinted in *Negro World,* February 26, 1921.

30. "Report by Bureau Agent Rocco C. Novario," in Hill, *Marcus Garvey,* vol. 5, 288.

31. "Marcus Garvey to Sen. Frank B. Willis," in Hill, vol. 5, 506.

32. McDuffie, "Garveyism in Cleveland," 168.

33. Ibid.

34. Rolinson, *Grassroots Garveyism,* 138; McDuffie, "Garveyism in Cleveland," 171.

35. McDuffie, "Garveyism in Cleveland," 172.

36. Miller and Wheeler, *Cleveland,* 136.

37. Oral history interview with Natalie Middleton, AAME, box 1, folder 5, WRHS.

38. Ethel Woodard, AAME, box 1, folder 5, WRHS.

39. "Annual Report of the Negro Welfare Association, 1930," Urban League Papers, box 3, folder 3, WRHS.

40. "Annual Report of the Negro Welfare Association, 1933," Urban League Papers, box 3, folder 3, WRHS.

41. "Annual Report of the Negro Welfare Association, 1934," Urban League Papers, box 3, folder 3, WRHS.

42. "Report, January and February, 1934," Urban League Papers, box 3, folder 3, WRHS.

43. Kusmer, *Ghetto Takes Shape*, 165.

44. Ibid., 49.

45. "Negro Welfare Association Report," c. 1935, Cleveland Public Library Digital Library, Cleveland Public Library, Public Administration Library, https://cplorg.contentdm.oclc.org/digital/collection/p128201c0110/id/3498/.

46. "Negro Welfare Association Board of Trustees meeting minutes, March 9, 1929," Urban League Papers, box 3, folder 3, WRHS.

47. "Study of Cleveland's Negro Areas in Connection with the Proposed Capital Accounts Campaign of the Neighborhood Association" (Playhouse Settlement), February 22, 1940, Cleveland Public Library Digital Library, Cleveland Public Library, Public Administration Library, https://cplorg.contentdm.oclc.org/digital/collection/p128201c0110/id/3584/rec/3.

48. Charles W. Chesnutt, "Negro in Cleveland," *Clevelander* 5 (November 1930): 26.

49. Ibid., 26.

50. Phillips, *AlabamaNorth*, 5.

51. Chesnutt, "Negro in Cleveland," 27.

52. Ibid.

53. Part of Cleveland's importance in the American Communist Party was due to the efforts of native Clevelander, and the party's first executive secretary, Charles E. Ruthenberg. Ruthenberg died in 1927, though, before the Third Period. For more, see Millett, "Midwest Origins."

54. Kerr, *Derelict Paradise*, 35.

55. Phillips, *AlabamaNorth*, 201.

56. "2 Slain, 3 Shot When 300 Riot," *Cleveland Plain Dealer*, October 7, 1931.

57. "Speech," undated, Morris and Eleanor Stamm Papers, series 2, box 2, folder 14, WRHS.

58. Quoted in Kerr, *Derelict Paradise*, 90.

59. "No Charity, But Fight for Relief," *Working Woman* (April 1930): 3.

60. Morton, *Women in Cleveland*, 191.

61. "Starving Negro Woman," 3.

62. "W.W.W. Club Wins Relief," *Working Woman* (April 1933): 15.

63. Burt, "Ohio Negro Women," 3.

64. "Working Women Fighting Hard against Wage Cuts, High Costs, Other Miseries," *Working Woman* (May 1931): 1.

65. J. B., "Negro Women," 2.

66. "Woman Delegate to Washington Hurt," *Working Woman* (February 1931): 2.

67. "Ohio Negro Women Active in State Hunger March," *Working Woman* (June 1931): 3.

68. "Don't Waste Your Vote," *Working Woman* (October 1934): 6–7.

69. Miller and Wheeler, *Cleveland*, 76, 106–08.

70. Waite, *A Warm Friend*, 4–6.

71. "Women Workers," c.1930, CPUSA, fond 515, reel 220, delo 2852, frame 4.

72. "Working Class Mothers," c.1930, CPUSA, fond 515, reel 185, delo 3435, frame 1.

73. "Next Step for Women in the Unemployment Campaign," c.1931, CPUSA, fond 515, reel 163, delo 2175, frame 40.

74. Ibid.

75. Ibid.

76. Ibid, frames 43, 41.

77. "The Wrong Way," *Cleveland Plain Dealer*, February 13, 1930. The CPUSA's *Daily Worker* claimed there were over three thousand protesters. "3,000 Workers Meet Brutality with Hot Fight," *Daily Worker*, February 12, 1930; "Jobless Called to Feb. 26 Rally," *Cleveland Plain Dealer*, February 13, 1930.

78. "Wrong Way," *Cleveland Plain Dealer*, February 13, 1930.

79. "Comrades Bare Last Remains of Murdered Couple to Grave," *Cleveland Call and Post*, July 21, 1934.

80. "Man, Woman Slain, 3 Shot in Relief Riot," *Pittsburgh Press*, July 13, 1934.

81. "Comrades," *Cleveland Call and Post*, July 21, 1934.

82. *Cleveland Press*, September 8, 1932; *Cleveland Plain Dealer*, August 27, 1931.

83. *Cleveland Plain Dealer*, August 27, 1931.

84. "600 Put Council in Uproar; Are Routed after Struggle," *Cleveland Plain Dealer*, October 6, 1931; "2,000 Reds Battle Police in Cleveland," *New York Times*, October 6, 1931.

85. "2 Slain, 3 Shot When 300 Riot," *Cleveland Plain Dealer*, October 7, 1931.

86. "1 Dead, 4 Hurt in Cleveland Riot of Negro Reds," *Chicago Tribute*, October 7, 1931.

87. "2 Slain," *Cleveland Plain Dealer*, October 7, 1931; "2,000 Reds," *New York Times*, October 6, 1931; "One Dead, Four Hurt in Riot," *Chicago Defender*, October 10, 1931.

88. "2 Slain," *Cleveland Plain Dealer*, October 7, 1931.

89. "All Out to Mass Funeral," August 1931, CPUSA, fond 515, reel 160, delo 2100, frame 75.

90. "Cleveland Workers," August 1931, CPUSA, fond 515, reel 160, delo 2100, frame 76.

91. "Name Committee to Assist Evicted," *Cleveland Plain Dealer*, October 10, 1931. Brown, former bishop of Arkansas, was unseated for his "conversion to science" and support of Marxism. See Brown, *My Heresy*.

92. "3,000 at Grave of Riot Victims," *Cleveland Plain Dealer*, October 11, 1931.

93. "Behind a Riot," reprinted in *Cleveland Gazette,* October 17, 1931.

94. Ibid.

95. "Negro Working Woman," 6.

96. Carter, *Scottsboro,* 49.

97. "Smash Lynching," April 1931, CPUSA, fond 515, reel 160, delo 2100, frame 24.

98. Ibid.

99. "Stop the Murder!," May 1931, CPUSA, fond 515, reel 160, delo 2100, frames 36.

100. Kerr, *Derelict Paradise,* 47.

101. "Plans for Scottsboro Defense Week, May 2–8," May 1932, CPUSA, fond 515, reel 185, delo 2434, frame 4.

102. "Special Instruction on International Scottsboro Day," April 28, 1932, CPUSA, fond 515, reel 220, delo 2849, frame 41.

103. "Scottsboro Lawyer Speaks Here Saturday, February 10," *Cleveland Call and Post,* February 10, 1934; "To Speak Here," *Cleveland Call and Post,* June 23, 1934; "Parade and Mass Meeting Will Feature Herndon's Visit. Mother Norris Coming," *Cleveland Call and Post,* September 8, 1934; "Angelo Herndon Touring with Replica of Prison Cage—To Be Here August 21," *Cleveland Call and Post,* July 11, 1935; "Scottsboro Boys Will Visit Cleveland, Plan Meeting," *Cleveland Call and Post,* November 25, 1937; "Scottsboro Boys to Appear in Cleveland at St. John's AME," *Cleveland Call and Post,* January 13, 1938.

104. Ross, "Mobilizing the Masses," 55.

105. "Parade and Mass Meeting Will Feature Herndon's Visit. Mother Norris Coming," *Cleveland Call and Post,* September 8, 1934.

106. Miller et al., "Mother Ada Wright," 387–430.

107. "Demonstrate before Mills for Refusal to Serve Mother Wright," *Cleveland Call and Post,* April 21, 1934.

108. "Big Crowd Expected at Workers Picnic Sunday," *Cleveland Call and Post,* August 18, 1934.

109. "Communist Mass Meeting," *Cleveland Call and Post,* November 3, 1934. The CP was running a candidate for Ohio governor as well as other local offices.

110. Klehr, *Heyday,* 339.

111. "Committee for Scottsboro Boys Defense Formed" *Cleveland Call and Post,* January 23, 1936.

112. Clarence L. Simmons, "Only Read and Heard," *Cleveland Call and Post.* March 2, 1935.

113. "Threat of Rent Strike Works in Cleveland," *Baltimore Afro-American,* August 12, 1939; Loeb, *Future Is Yours,* 23–24.

114. Kenneth M. Zinz, "Future Outlook League of Cleveland: A Negro Protest Organization" (MA thesis, Kent State University, 1973), 3.

115. *Cleveland Gazette,* June 8, 1935.

116. Loeb, *Future Is Yours,* 47.

117. Zinz, "Future Outlook League," 3. The criticism was not far-fetched; out of the twelve founding members of the league, eleven were new migrants from the South (Zinz, "Future Outlook League," appendix A).

118. Ibid., 4.

119. Loeb, *Future Is Yours,* 33.

120. Solomon, *Cry Was Unity,* 105–06.

121. Maude White Katz, December 18, 1981, Oral History of the American Left, TL-RWLA. For more on White's travels to the Soviet Union and later activism, see Gore, *Radicalism,* 25, and McDuffie, *Sojourning,* 51–53.

122. Maude White, "Against White Chauvinism in Philadelphia Needle Trades," *Daily Worker,* January 28, 1931; Solomon, *Cry Was Unity,* 123–43.

123. Solomon, "Recovering a Lost Legacy," 9.

124. "Future Outlook League Publishes Year Book," *Cleveland Call and Post,* July 15, 1937; "FOL to Give Night over to Hear Politics," *Cleveland Call and Post,* October 22, 1936; "FOL Unusual Attraction at Trianon Monday," *Cleveland Call and Post,* September 24, 1936.

125. Phillips, *AlabamaNorth,* 207, 209.

126. *Cleveland Call and Post,* February 10, 1934.

127. "Neighborhood Committee Gets Pledges for Fair Play at Woodhill Pool," *Cleveland Call and Post,* April 27, 1935.

128. "The Future Outlook League," *Cleveland Call and Post,* June 13, 1935.

129. "F.O.L. to Give Night over to Hear Politics," *Cleveland Call and Post,* October 22, 1936.

130. "Atty. Lyons Gets New Trial for Walter Thomas," *Cleveland Call and Post,* June 20, 1935.

131. "24 Delegates Leave for Convention," *Cleveland Call and Post,* February 13, 1936.

132. *Official Proceedings,* 40.

133. "Housewives League Activities," *Cleveland Call and Post,* March 12, 1936; "Mt. Pleasant News," *Cleveland Call and Post,* March 12, 1936; "Mount Pleasant News," *Cleveland Call and Post,* May 7, 1936.

134. "Cleveland Makes Preparations for Negro Congress," *Cleveland Call and Post,* May 28, 1936; "In Charge of Arrangements for Negro Congress," *Cleveland Call and Post,* June 18, 1936.

135. "Executive Council of Negro Congress Meets in Cleveland," *Cleveland Call and Post,* June 28, 1936.

136. White, *Great Last Strike,* 85–86.

137. "Wage Rates Vary, Delegates Told," *Pittsburgh Press,* February 7, 1937.

138. "Phil Murray Urges Negro Workers to Join Great Steel Industry Union," *Pittsburgh Courier*, February 13, 1937; "Wage Rates Vary, Delegates Told," *Pittsburgh Press*, February 7, 1937.

139. "Communists Back CIO," *New Journal and Guide*, June 12, 1937.

140. White, *Last Great Strike*, 4.

CONCLUSION

1. Billups and Tappes, interview, AALOH, WRL-WSU, 7.

2. Rossa, "Los Angeles"; Eleanor Broady, "LA Black Power Parley," *Militant* (June 12, 1967): 6.

3. Russell Rickford, "Black Studies, Activism, and Digital History: An Interview with Abdul Alkalimat" *Black Perspectives*, January 8, 2018. https://www.aaihs.org /Black-studies-activism-and-digital-history-an-interview-with-abdul-alkalimat/. Alkalimat is also the great-great-grandson of "Free Frank" McWorter, meaning Rye Broady and Thelma McWorter Wheaton were related by marriage.

4. Oral history interview with Maude White Katz by Ruth Prago, Oral History of the American Left, TL-RWLA.

5. "Women Invade Georgia," *Cleveland Call and Post*, April 9, 1949.

6. Gore, *Radicalism*, 131–32, 141.

7. Interview, White Katz, TL-RWLA.

8. Federal Bureau of Investigation, "Report," Freedom of Information Act "Morris Childs," https://archive.org/details/MorrisChilds, n.p.

9. See http://www.illinoislaborhistory.org/ for a brief biography of Hansborough. Romania is misnamed "Amelia" Ferguson.

10. 1940 U.S. Census, St. Louis, St. Louis City, Missouri, digital image s.v. "Carrie Smith," Ancestry.com.

11. Kelley, *Hammer and Hoe*, 228.

12. Gellman, *Death Blow*, 7. Gellman argues against the notion that the NNC was a failure, calling it instead a "vital" part of the initial stages of the civil rights movement (266).

13. Theoharis, *Rebellious Life*; Ransby, *Ella Baker*.

14. Davis, *Women, Race, and Class*; Taylor, *How We Get Free*.

15. Kelley, *Race Rebels*.

16. Robinson, *Black Marxism*, 317.

17. Larry Buchanan, Quoctrung Bui, and Jugal K. Patel, "Black Lives Matter May Be the Largest Movement in U.S. History," *New York Times*, July 3, 2020. https:// www.nytimes.com/interactive/2020/07/03/us/george-floyd-protests-crowd-size .html.

18. Tabia Henry Akintobi, Theresa Jacobs, Darrell Sabbs, Kisha Holden, Ronald Braithwaite, Neicey Johnson, Daniel Dawes, and LaShawn Hoffman, "Community

Engagement of African Americans in the Era of COVID-19: Considerations, Challenges, Implications, and Recommendations for Public Health," vol. 17, August 13, 2020. https://www.cdc.gov/pcd/issues/2020/20_0255.htm#References.

19. As of August 2020, the Bureau for Labor Statistics showed Black unemployment at 13.2 percent and white unemployment at 6.9 percent. During the height of the pandemic in Spring 2020, the ratio was 2 to 1. Olugbenga Ajilore, "The Persistent Black-White Unemployment Gap Is Built into the Labor Market," Center for American Progress, September 28, 2020. https://www.americanprogress.org /issues/economy/news.

20. Ransby, *All Black Lives Matter*, 2.

BIBLIOGRAPHY

ARCHIVAL SOURCES

Chicago, Illinois
 Chicago History Museum
 Claude Barnett Papers
 Jack Kling Collection
 Thyra Edwards Collection
 Chicago Public Library, Vivian G. Harsh Research Collection
 Horace Cayton Papers
 Illinois Writers Project, "Negro In Illinois Papers"
 University of Chicago, Special Collection Research Center
 Political Pamphlets Collection
 Harold F. Gosnell Papers
 Robert Morss Lovett Papers
 University of Illinois–Chicago
 Chicago Urban League Papers
Cleveland, Ohio
 Western Reserves Historical Society
 Cleveland Urban League Papers
 Morris and Eleanor Stamm Papers
 Ray Miller Papers
 St. James African American Methodist Episcopal Church Oral
 History
 Wade Hampton McKinney Papers
Detroit, Michigan
 Bentley Library, University of Michigan
 Detroit Urban League Papers
 Wayne State University, Walter F. Reuther Library
 Blacks in the Labor Movement Oral History Project
 Ford Hunger March Collection

Maurice Sugar Papers
Henry Kraus Papers
New York, New York
Tamiment Library and Robert F. Wagner Labor Archives, New York
University
Arnold Johnson Papers
Communist Party Ephemera
Communist Party Records
CPUSA Oral History Collection
Files of the Communist Party, U.S.A.
Mark Solomon and Robert Kaufman Research Files on African
Americans and Communism
Oral History of the American Left
St. Louis, Missouri
State Historical Society of Missouri
"A Strong Seed Planted" Oral History
Black Community Leaders Project
Western Historical Manuscripts Collection, UMSL
Health and Welfare Council
Washington University Special Collections, University Archives
St. Louis Urban League Papers
William Sentner Papers

PUBLISHED SOURCES

Allen Jr., Ernest. "Waiting for Tojo: The Pro-Japan Vigil of Black Missourians, 1932–1943," *Gateway Heritage* (Fall 1995): 39–55.

Andrews, Gregg. *Thyra J. Edwards: Black Activist in the Global Freedom Struggle.* Columbia: University of Missouri Press, 2011.

Barnard, John. *American Vanguard: United Auto Workers during the Reuther Years, 1935–1970.* Detroit: Wayne State University Press, 2004.

Baskin, Alex. "The Ford Hunger March—1932." *Labor History* 13, no. 3: 331–60.

Bates, Beth Tompkin. "A New Crowd Challenges the Agenda of the Old Guard in the NAACP, 1933–1941." *American Historical Review* 102, no. 2 (April 1997): 340–77.

———. *Pullman Porters and the Rise of Protest Politics in Black America, 1925–1945.* Chapel Hill: University of North Carolina Press, 2001.

———. *The Making of Black Detroit in the Age of Henry Ford.* Chapel Hill: University of North Carolina Press, 2012.

Baugh-Helton, Tiffany. "A Women's Place Is in Her Union: The UAW's 1944 National Women's Conference and Women's Labor Activism." *Michigan Historical Review* 40, no. 1 (Spring 2014): 73–95.

Beynon, Erdmann Doan. "The Voodoo Cult among Negro Migrants in Detroit." *American Journal of Sociology* 43, no. 6 (May 1938): 894–907.

Blain, Keisha N. *Set the World on Fire: Black Nationalist Women and the Global Struggle for Freedom*. Philadelphia: University of Pennsylvania Press, 2018.

———, and Tiffany M. Gill, eds. *To Turn the Whole World Over: Black Women and Internationalism*. Urbana, IL: University of Illinois Press, 2019.

Blair, Cynthia. *I've Got to Make My Livin': Black Women's Sex Work in Turn-of-the-Century Chicago*. Chicago: University of Chicago Press, 2010.

Bone, Robert, and Richard A. Courage. *The Muse in Bronzeville: African-American Creative Expression in Chicago, 1932–1950*. New Brunswick, NJ: Rutgers University Press, 2011.

Boyce Davies, Carole. *Left of Karl Marx: The Political Life of Black Communist Claudia Jones*. Durham: Duke University Press, 2007.

Boykin, Ulysses W. *A Hand Book on the Detroit Negro*. Detroit: The Minority Study Associates, 1943.

Bromsen, Amy. "'They All Sort of Disappeared': The Early Cohort of UAW Women Leaders." *Michigan Historical Review* 37, no. 1 (Spring 2011): 5–39.

Brown, William Montgomery. *My Heresy; The Autobiography of an Idea*. New York; John Day, 1926.

Brunn, Paul Dennis. "Black Workers and Social Movements of the 1930s in St. Louis." PhD dissertation, Washington University, 1975.

Bureau of the Census. *Fifteenth Census of the United States, 1930*. Washington, DC: US Government Printing Office, 1932.

———. *Fourteenth Census of the United States, 1920*.Washington, DC: US Government Printing Office, 1922.

———. *Sixteenth Census of the United States, 1940*. Washington, DC: US Government Printing Office, 1943.

———. *Thirteenth Census of the United States, 1910*. Washington, DC: US Government Printing Office, 1913.

Burt, Rose. "Ohio Negro Women Active in State Hunger March." *Working Woman* (June 1931): 3.

Campney, M. S. Brent. *Hostile Heartland: Racism, Repression, and Resistance in the Midwest*. Urbana: University of Illinois Press, 2019.

Carby, Hazel V. *Reconstructing Womanhood: The Emergence of the Afro-American Woman Novelist*. New York: Oxford University Press, 1987.

———. "Policing the Black Woman's Body in an Urban Context." *Social Inquiry* 18 (Summer 1992): 738–55.

Carter, Dan. *Scottsboro: A Tragedy of the American South*. Baton Rouge: Louisiana State University Press, 1969.

Chandler, Lester V. *America's Great Depression, 1929–1941*. New York: Harper and Row, Publishers, 1970.

Chateauvert, Melinda. *Marching Together: Women of the Brotherhood of Sleeping Car Porters.* Urbana: University of Illinois Press, 1997.

Chicago Commission on Race Relations, *The Negro in Chicago: A Study of Race Relations and a Race Riot.* Chicago: University of Chicago Press, 1922.

Clark Hine, Darlene, ed. *Black Women in the Middle West Project: A Comprehensive Resource Guide, Illinois and Indiana.* Indianapolis: Indiana Historic Bureau, 1986.

———, and John McCluskey Jr., eds. *Black Chicago Renaissance.* Urbana: University of Illinois Press, 2012.

Collier-Thomas, Bettye. *Jesus, Jobs, and Justice: African American Women and Religion.* New York: Alfred A. Knopf, 2010.

Conot, Robert. *American Odyssey.* New York: William Morrow & Company, Inc., 1974.

Cooley, Will. "Moving on Out: Black Pioneering in Chicago, 1915–1950." *Journal of Urban History* 36, no. 4 (July 2010): 485–506.

Crenshaw, Kimberlé. "Mapping the Margins: Intersectionality, Identity Politics, and Violence against Women of Color." *Stanford Law Review* 43, no. 6 (July 1991): 1241–99.

Daly, Kathryn W. "The International Ladies' Garment Workers' Union in Chicago, 1930–1939." MA thesis, University of Chicago, 1939.

Davis, Angela. *Women, Race, and Class.* New York: Random House, 1981.

Davis, Benjamin. *Communist Councilman from Harlem: Autobiographical Notes Written in a Federal Penitentiary.* New York: International Publishers, 1969.

Davis, Russell H. *Black Americans in Ohio's City of Cleveland: From George Peake, the First Settler, to Carl Stoke, the First Black Mayor.* Washington, DC: Associated Publishers, 1972.

Delton, Jennifer. "Labor, Politics, and African American Identity in Minneapolis, 1930–1950." *Minnesota History* (Winter 2001–2002): 419–34.

Devinatz, Victor G. "Trade Unions as Instruments of Social Change: Does Ideology Matter?" *Journal of Labor and Society* 10 (December 2007): 497–508.

DeSantis, Alan D. "Selling the American Dream Myth to Black Southerners: The *Chicago Defender* and the Great Migration of 1915 to 1919." *Western-Journal of Communication* 62, no. 4 (Fall 1998): 474–511.

Dillard, Angela. *Faith in the City: Preaching Radical Social Change in Detroit.* Ann Arbor: University of Michigan Press, 2007.

Dilling, Elizabeth. *The Red Network: A "Who's Who" and Handbook of Radicalism for Patriots.* Kenilworth, IL: Self-published, 1934.

Dolinar, Brian, ed. *The Negro in Illinois: The WPA Papers.* Urbana, IL: University of Illinois Press, 2013.

Dollinger, Sol. *Not Automatic: Women and the Left in the Forging of the Auto Workers Union.* New York: Monthly Review Press, 2000.

Dowden-White, Priscilla A. *Groping toward Democracy: African American Social Welfare Reform in St. Louis, 1910–1949*. Columbia: University of Missouri Press, 2011.

Drake, St. Clair. *Churches and Voluntary Associations in the Chicago Negro Community*. Chicago: WPA Project, 1940.

———, and Horace R. Cayton. *Black Metropolis: A Study of Negro Life in a Northern City*. Chicago: University of Chicago Press, 1945.

Edwards, Thyra. "Who Is Disinterested." *Crisis* (June 1935): 173–4.

———. "Let Us Have More like Mr. Sopkin." *Crisis* (March 1935): 72, 82.

Ervin, Keona. *Gateway to Equality: Black Women and the Struggle for Economic Justice in St. Louis*. Lexington: University Press of Kentucky, 2017.

Farmer, Ashley. *Remaking Black Power: How Black Women Transformed an Era*. Chapel Hill: University of North Carolina Press, 2017.

Feurer, Rosemary. *Radical Unionism in the Midwest, 1900–1950*. Urbana: University of Illinois Press, 2006.

———. "The Nutpickers Union, 1933–34: Crossing the Boundaries of Community and Workplace." In *We Are All Leaders: The Alternative Unionism of the Early 1930s*, edited by Staughton Lynd, 27–50. Urbana: University of Illinois Press, 1996.

Fichtenbaum, Myrna. *The Funsten Nut Strike*. New York: International Publishers, 1991.

Gabin, Nancy. "'They Have Placed a Penalty on Womanhood': The Protest Actions of Women Auto Workers in Detroit-Area UAW Locals, 1945–1947." *Feminist Studies* 8, no. 2 (1982): 373–98.

Garraty, John. "Unemployment during the Great Depression." *Labor History* 17 (Spring 1976): 139–59.

Gellman, Erik. *Death Blow to Jim Crow: The National Negro Congress and the Rise of Militant Civil Rights*. Chapel Hill: University of North Carolina Press, 2012.

Gebert, Bill. "The St. Louis Strike and the Chicago Needle Trades Strike." *Communist* 12 (August 1933): 800–809.

Gerber, David A. *Black Ohio and the Color Line, 1860–1915*. Urbana: University of Illinois Press, 1976.

Gibson, Dawn-Marie. *A History of the Nation of Islam : Race, Islam, and the Quest for Freedom*. Santa Barbara: Praeger, 2012.

Gilyard, Keith. *Louise Thompson Patterson: A Life of Struggle for Justice*. Durham, NC: Duke University Press, 2017.

Giffin, William W. *African Americans and the Color Line in Ohio, 1915–1930*. Columbus: Ohio State University Press, 2005.

Gordon, Colin E. *Mapping Decline: St. Louis and the Fate of the American City*. Philadelphia: University of Pennsylvania Press, 2008.

Gore, Dayo. *Radicalism at the Crossroads: African American Women Activists in the Cold War*. New York: New York University Press, 2011.

Gosman Scarborough, Mary. *Whirlwinds of Danger: The Memoirs of Mary Gosman Scarborough*. New York: David Walker Press, 1990.

Gosnell, Harold F. *Negro Politicians: The Rise of Negro Politics in Chicago*. Chicago: University of Chicago Press, 1967.

Harris, LaShawn. "#SayHerName: Black Women, State Sanctioned Violence and Resistance." *American Historian*, September 2020. https://www.oah.org/tah /issues/2020/history-for-Black-lives/sayhername-Black-women-state-sanctioned -violence-resistance/.

———. "Running with the Reds: African American Women and the Communist Party during the Great Depression." *Journal of African American History* 94, no. 1 (January 2009): 21–42.

———. *Sex Workers, Psychics, and Number Runners: Black Women in New York City's Underground Economy*. Urbana: University of Illinois Press, 2016.

Haywood, Harry. *Black Bolshevik: Autobiography of an Afro-American Communist*. Chicago: Liberator Press, 1978.

Heathcott, Joseph. "Black Archipelago: Politics and Civic Life in the Jim Crow City." *Journal of Social History* 38, no. 3 (Spring 2005): 705–36.

Higginbotham, Evelyn Brooks. *Righteous Discontent: The Women's Movement in the Black Baptist Church, 1880–1920*. Cambridge: Harvard University Press, 1993.

Hill Collins, Patricia. *Black Feminist Thought: Knowledge, Consciousness, and the Politics of Empowerment*. New York: Harper Collins, 1990.

Hill, Robert A., ed. *Marcus Garvey and Universal Negro Improvement Association Papers*, vol. 3. Berkeley, CA: University of California Press, 1984.

———, ed. *Marcus Garvey and Universal Negro Improvement Association Papers*, vol. 4. Berkeley, CA: University of California Press, 1984.

———, ed. *The Marcus Garvey and Universal Negro Improvement Association Papers*, vol. 5. Berkeley, CA: University of California Press, 1984.

Hill, Ruth Edmonds, ed. *The Black Woman Oral History Project*, vol. 7. Westport, CT: Meckler, 1991.

Horne, Gerald. *Race Woman: The Lives of Shirley Graham DuBois*. New York: New York University Press, 2000.

———. *The Rise and Fall of the Associated Negro Press: Claude Barnett's Pan-African News and the Jim Crow Paradox*. Urbana: University of Illinois Press, 2017.

Howard, Ashley. "An American Tradition." *American Historian*. September 2020, https://www.oah.org/tah/issues/2020/history-for-Black-lives/an-american -tradition/.

———. "Prairie Fires: Urban Rebellions as Black Working Class Politics in Three Midwestern Cities." PhD diss., University of Illinois at Urbana-Champaign, 2012.

Howlett, Charles F. "Organizing the Unorganized: Brookwood Labor College, 1921–1937." *Labor Studies Journal* 6, no. 2 (Fall 1981): 165–79.

Hunt, R. Douglas. "Midwestern Distinctiveness." In *The American Midwest: Essays on a Regional History*, edited by Andrew R. L. Cayton and Susan E. Gray, 162–81. Bloomington: Indiana University Press, 2001.

Hunter, Tera. *To 'Joy My Freedom: Southern Black Women's Lives and Labors after the Civil War*. Cambridge, MA: Harvard University Press, 1997.

Isserman, Maurice. *Which Side Were You On? The American Communist Party during the Second World War*. Middletown, CT: Wesleyan University Press, 1982.

Johnson, Walter. *The Broken Heart of America: St. Louis and the Violent History of the United States*. New York: Basic Books, 2020.

Jolly, Kenneth S. *Black Liberation in the Midwest: The Struggle in St. Louis, Missouri, 1964–1970*. New York: Routledge, 2006.

Jones, Jacqueline. *Labor of Love, Labor of Sorrow: Black Women, Work, and the Family, from Slavery to the Present*. New York: Vintage Books, 1985.

Jones, S. A., and V. C. Childs. *An Economic Study of the Pecan Industry*. Washington, DC: United States Department of Agriculture, 1932.

Keeran, Roger. *The Communist Party and the Autoworkers Union*. Bloomington: Indiana University Press, 1980.

Kelley, Robin D. G. *Freedom Dreams: The Black Radical Imagination*. Boston: Beacon Press, 2002.

———. "The Black Radical Tradition." Discussion for African American Intellectual History Society Annual Conference, Austin, Texas, March 7, 2020.

———. *Hammer and Hoe: Alabama Communists during the Great Depression*. Chapel Hill: University of North Carolina Press, 1990.

———. *Race Rebels: Culture, Politics, and the Black Working Class*. New York: Free Press, 1994.

Kerr, Daniel. *Derelict Paradise: Homelessness and Urban Development in Cleveland, OH*. Amherst: University of Massachusetts Press, 2011.

Klehr, Harvey. *The Heyday of American Communism: The Depression Decade*. New York: Basic Books, 1984.

Kusmer, Kenneth L. *A Ghetto Takes Shape: Black Cleveland, 1870–1930*. Urbana: University of Illinois Press, 1976.

Lang, Clarence. *Grassroots at the Gateway: Class Politics and Black Freedom Struggle in St. Louis, 1936–75*. Ann Arbor: University of Michigan Press, 2009.

Larks, Goldie. "How Women Act in Strikes." *Working Women* (January 1934): 11–12.

Lasswell, Harold D., and Dorothy Blumenstock. *World Revolutionary Propaganda: A Chicago Study*. New York: Alfred A. Knopf, 1939.

Leab, Daniel. "'United We Eat': The Creation and Organization of the Unemployed Councils in the 1930s." *Labor History* 7 (1967): 300–315.

Lewis-Colman, David M. *Race against Liberalism: Black Workers and the UAW in Detroit*. Urbana: University of Illinois Press, 2008.

Lightfoot, Claude, and Timothy V. Johnson, ed. *Chicago Slums to World Politics: The Autobiography of Claude Lightfoot.* New York: New Outlook Publishers and Distributors, 1986.

Loeb, Charles H. *The Future Is Yours: The History of the Future Outlook League, 1935–1947.* Cleveland: Future Outlook League, Inc., 1947.

Lorence, James L. *Organizing the Unemployed: Community and Union Activists in the Industrial Heartland.* Albany: State University of New York Press, 1996.

Lumpkins, Charles E. *American Pogrom: The East St. Louis Race Riot and Black Politics.* Athens, OH: Ohio University Press, 2008.

Majeed, Debra Mubashshir. "Clare Evans Muhammad: Pioneering Social Activism in the Original Nation of Islam." *Union Seminary Quarterly Review* 57, no. 3 (2003): 217–29.

Makalani, Minkah. *In the Cause of Freedom: Radical Black Internationalism from Harlem to London, 1917–1939.* Chapel Hill: University of North Carolina Press, 2011.

Martin, Charles H. *The Angelo Herndon Case and Southern Justice.* Baton Rouge: Louisiana State University Press, 1976.

Martin, Tony. *Race First: The Ideological and Organizational Struggles of Marcus Garvey and the Universal Negro Improvement Association.* Westport, CT: Greenwood Press, 1976.

Mayor's Inter-racial Committee. *The Negro in Detroit.* Detroit: Detroit Bureau of Government Research, Inc., 1926.

McDuffie, Erik S. "'A New Day Has Dawned for the UNIA': Garveyism, the Diasporic Midwest, and West Africa, 1920–80." *Journal of West African History* 2, no. 1 (Spring 2016): 73–113.

———. "Chicago, Garveyism, and the History of the Diasporic Midwest." *African and Black Diaspora: An International Journal* 8, no. 3 (2015): 129–45.

———. "The Diasporic Journeys of Louise Little: Grassroots Garveyism, the Midwest, and Community Feminism." *Women, Gender, and Families of Color* 4, no. 2 (October 2016): 146–70.

———. "Garveyism in Cleveland, Ohio and the history of the Diasporic Midwest, 1920–1975." *African Identities* 9, no. 2 (May 2011): 163–82.

———. *Sojourning for Freedom: Black Women, American Communism, and the Making of Black Left Feminism.* Durham, NC: Duke University Press, 2011.

Meier, August, and Elliott Rudwick. *Black Detroit and the Rise of the UAW.* New York: Oxford University Press, 1980.

Menefee, Seldon C., and Orin C. Cassmore. *The Pecan Shellers of San Antonio: The Problem of Underpaid and Unemployed Mexican Labor.* Works Progress Administration, Division of Research. Washington, DC: University States Government Printing Office, 1940.

Michaeli, Ethan. *Defender: How the Legendary Black Newspaper Changed America, from the Age of the Pullman Porters to the Age of Obama.* Boston: Houghton Mifflin Harcourt, 2016.

Miller, Carol Poh, and Robert Wheeler. *Cleveland: A Concise History.* Bloomington: Indiana University Press, 1990.

Miller, James, Susan Pennybacker, and Eve Rosenhaft. "Mother Ada Wright and the International Campaign to Free the Scottsboro Boys, 1931–1934." *American Historical Review* 106 (April 2001): 1–64.

Miller, Karen R. *Managing Inequality: Northern Racial Liberalism in Interwar Detroit.* New York: New York University Press, 2014.

Millett, Stephen M. "Midwest Origins of the American Communist Party: The Leadership of Charles E. Ruthenberg, 1919–1927." *Old Northwest* 1, no. 3 (September 1975): 253–90.

Mitchell, Don. *The Right to the City: Social Justice and the Fight for Public Space.* New York: Guilford Press, New York, 2003.

Moon, Elaine Latman. *Untold Tales, Unsung Heroes: An Oral History of Detroit's African American Community, 1915–1967.* Detroit: Wayne State University Press, 1994.

Moraga, Cherríe, and Gloria Anzaldúa, eds. *This Bridge Called My Back: Writings by Radical Women of Color.* New York: Kitchen Table Press, 1984.

Morton, Marian. *Women in Cleveland, An Illustrated History.* Bloomington: Indiana University Press, 1995.

Naison, Mark. *Communists in Harlem during the Depression.* Urbana: University of Illinois Press, 1983.

Nelson, Steve. *Steve Nelson: American Radical.* Pittsburgh: University of Pittsburgh Press 1980.

Norton, William J. "The Relief Crisis in Detroit." *Social Service Review* 7, no. 1 (March 1933): 5–6

Official Proceedings of the National Negro Congress. Chicago: National Negro Congress, 1936.

Painter, Nell Irvin. *The Narrative of Hosea Hudson: Life and Times of a Black Radical.* New York: W.W. Norton and Co., 1994.

Perry, Imani. *Looking for Lorraine: The Radiant and Radical Life of Lorraine Hansberry.* Boston: Beacon Press, 2019.

Phillips, Kimberley L. *AlabamaNorth: African-American Migrants, Community, and Working-Class Activism in Cleveland, 1915–1945.* Urbana: University of Illinois Press, 1999.

———. "'But It Is a Fine Place to Make Money': Migration and African-American Families in Cleveland, 1915–1929." *Journal of Social History* 30, no. 2 (Winter 1996): 393–413.

Pierce, Richard. *Polite Protest: The Political Economy of Race in Indianapolis, 1920–1970.* Bloomington: Indiana University Press, 2005.

Primm, James Neal. *Lion of the Valley: St. Louis, Missouri.* Boulder, CO: Pruett Publishing, 1981.

Ransby, Barbara. *Ella Baker and the Black Freedom Struggle: A Radical Democratic Vision.* Chapel Hill: University of North Carolina Press, 2003.

———. *Eslanda: The Large and Unconventional Life of Mrs. Paul Robeson.* New Haven, CT: Yale University Press, 2013.

———. *Making All Black Lives Matter: Reimaging Freedom in the Twenty-First Century.* Oakland, CA: University of California Press, 2018.

Reed, Christopher. *The Depression Comes to the Southside: Protest and Politics in the Black Metropolis, 1930–1933.* Bloomington: Indiana University Press, 2011.

———. *The Rise of Chicago's Black Metropolis, 1920–1929.* Urbana: University of Illinois Press, 2011.

Risch, Catherine. "The Effects of Communist Propaganda upon Negroes of St. Louis." MA thesis, Saint Louis University, 1935.

Robinson, Cedric. *Black Marxism: The Making of a Black Radical Tradition.* Chapel Hill: University of North Carolina Press, 2000, repr.

Robinson, Julia Marie. *Race, Religion, and the Pulpit: Rev. Robert L. Bradby and the Making of Urban Detroit.* Detroit: Wayne State University Press, 2015.

Rolinson, Mary G. *Grassroots Garveyism: The Universal Negro Improvement Association in the Rural South.* Chapel Hill: The University of North Carolina Press, 2007.

Roman, Meredith L., *Opposing Jim Crow: African Americans and the Soviet Indictment of U.S. Racism, 1928–1937.* Lincoln, NE: University of Nebraska Press, 2012.

———. "Race, Politics, and U.S. Students in 1930s Soviet Russia." *Race and Class* 53, no. 2 (2011): 58–76.

Rose, William Ganson. *Cleveland: The Making of a City.* Kent: Kent State University Press, 1990.

Ross, Felicia G. Jones. "Mobilizing the Masses: The *Cleveland Call and Post* and the Scottsboro Incident." *Journal of Negro History* 84, no. 1 (Winter 1999): 48–60.

Rubenstein, James M. *Making and Selling Cars: Innovation and Change in the U.S. Automotive Industry.* Baltimore: Johns Hopkins University Press, 2001.

Seawell, Stephanie. "The Black Freedom Movement and Community Planning in Urban Parks in Cleveland, Ohio, 1945–1977." PhD diss., University of Illinois, Urbana-Champaign, 2014.

Schroeder Schlabach, Elizabeth. *Along the Streets of Bronzeville: Black Chicago's Literary Landscape.* Urbana: University of Illinois Press, 2013.

Seidman, Joel. *Needle Trades.* New York: Farrar and Reinhart, Inc., 1942.

Senate of 48th General Assembly of Missouri. *Report of the Senate Wage Commission for Women and Children in the State of Missouri.* Jefferson City, MO: Hugh Stephens Co., 1915.

Sewell, May Wright. *World's Congress of Representative Women.* Chicago: Rand, McNally, 1894.

Shaw Peterson, Joyce. "Black Automobile Workers in Detroit, 1910–1930." *Journal of Negro History* 64, no. 3 (Summer 1979): 177–90.

Shaw, Robert. "St. Louis' Biggest Strike." *Labor Unity* (August 1933): 8–11.

Shockley, Megan. *"We Too Are Americans": African American Women in Detroit and Richmond, 1940–54.* Urbana: University of Illinois Press, 2004.

Smith, Carrie, and Cora Lewis. "We Strike and Win." *Working Woman* (August 1933): 8–9.

Smith-Irvin, Jeannette. *Footsoldiers of the Universal Negro Improvement Association (In Their Own Words).* Trenton, NY: African World Press, Inc., 1989.

Solomon, Mark. "Recovering a Lost Legacy: Black Women Radicals Maude White and Louise Thompson." *Abafazi* (Fall/Winter 1995): 6–13.

———. *The Cry Was Unity: Communists and African Americans, 1917–1937.* Jackson: University of Mississippi Press, 1998.

Spero, Sterling, and Abram Harris. *Black Worker,* 3rd ed. New York: Atheneum, 1968.

Springer, Kimberly. "Third Wave Black Feminism." *Signs* 27, no. 4 (Summer 2004): 1059–82.

Sterling, Dorothy, ed. *We Are Your Sisters: Black Women in the Nineteenth Century.* New York: W.W. Norton, 1984.

Stevens, George E. *History of Central Baptist Church.* St. Louis: King Pub., 1927.

Storch, Randi. *Red Chicago: American Communism at its Grassroots, 1928–1935.* Urbana: University of Illinois Press, 2007.

Strickland, Arvarh E. *History of the Chicago Urban League,* 2nd ed. Columbia, MO: University of Missouri Press, 2001.

Sugar, Maurice. "Bullets—Not Food—for Ford Workers." *Nation* (March 1932): 333–4.

———. *The Ford Hunger March.* Berkeley: Meiklejohn Civil Liberties Institute, 1980.

Sugrue, Thomas. *Sweet Land of Liberty: The Forgotten Struggle for Civil Rights in the North.* New York: Random House, 2009.

Taylor, Keeanga-Yamahtta, ed. *How We Get Free: Black Feminism and the Combahee River Collective.* Chicago: Haymarket Books, 2017.

Taylor, Ula. *The Promise of Patriarchy: Women and the Nation of Islam.* Chapel Hill: University of North Carolina Press, 2003.

———. *Veiled Garvey: The Life and Times of Amy Jacques Garvey.* Chapel Hill: University of North Carolina Press, 2002.

Terkel, Studs, ed. *Hard Times: An Oral History of the Great Depression*. New York: Pantheon Books, 1970.

Theoharis, Jeanne. *Rebellious Life of Mrs. Rosa Parks*. Boston: Beacon Press, 2015.

———, Komozi Woodard, and Dayo F. Gore, eds. *Want to Start a Revolution? Radical Women in the Black Freedom Struggle*. New York: New York University Press, 2009.

Thomas, Richard. *Life for Us Is What We Make It: Building Black Community in Detroit, 1915–1945*. Bloomington: University of Indiana Press, 1992.

Tracy, Steven. *Writers of the Black Chicago Renaissance*. Urbana: University of Illinois Press, 2011.

Trotter, Joe William. "The Historiography of Black Workers in the Urban Midwest: Toward a Regional Synthesis." *Studies in Midwestern History* 4, no. 4 (November 2018): 1–22.

———. *Black Milwaukee: The Making of an Industrial Proletariat, 1915–45*. Urbana: University of Illinois Press, 1985, 2007, repr.

———. *River Jordan: African American Urban Life in the Ohio Valley*. Lexington, Kentucky: University Press of Kentucky, 1998.

Tyler, Gus. *Look for the Union Label: A History of the International Ladies' Garment Workers' Union*. Armonk, NY: M.E. Sharpe, Inc., 1995.

Tyner, James. *The Geography of Malcolm X: Black Radicalism and the Remaking of American Space*. New York: Routledge, 2006.

US House of Representatives. Special Committee to Investigate Communist Activities in the United States. *Investigation of Communist Propaganda*. 71st Congr. Washington, DC.: US Government Printing Office, 1930.

———. House Committee on Un-American Activities. *Investigation of Un-American Propaganda Activities in the United States*. 75th Congr. Washington, DC: US Government Printing Office, 1938.

———. Subcommittee of the Committee on Un-American Activities. *Communism in the Detroit Area*. 82nd Congr., 2nd sess. Washington, DC: US Government Printing Office, 1952.

Van Tassel, David D., and John J. Grabowski, eds. *Cleveland: A Tradition of Reform*. Kent, OH: Kent State University Press, 1986.

Vorse, Mary Heaton. *Labor's New Millions*. New York: Modern Age Books, 1938.

Washington, Forrester B. *The Negro in Detroit: A Survey of the Conditions of a Negro Group in a Northern Industrial Center during the War Prosperity Period*. Detroit: Research Bureau of the Associated Charities of Detroit, 1920.

Waite, Florence T. *A Warm Friend for the Spirit: A History of the Family Service Association of Cleveland and Its Forebears, 1830–1952*. Cleveland: Family Service Association of Cleveland, 1960.

Walker, Juliet E. K. *Free Frank: A Black Pioneer on the Antebellum Frontier*. Lexington: University Press of Kentucky, 1983.

Washington, Mary Helen. "Alice Childress, Lorraine Hansberry, and Claudia Jones: Black Women Write the Popular Front." In *Left of the Color Line: Race, Radicalism, and Twentieth Century Literature of the United States*, edited by Bill V. Mullen and James Smethurst, 183–204. Chapel Hill: University of North Carolina Press, 2003.

White, Ahmed. *The Great Last Strike: Little Steel, the CIO, and the Struggle for Labor Rights in New Deal America*. Berkeley, CA: University of California Press, 2015.

White, Horace. "Who Owns the Negro Churches?" *Christian Century* 55, no. 6 (1938): 176–7.

Wilkerson, Isabel. *The Warmth of Other Suns: The Epic Story of America's Great Migration*. New York: Vintage Books, 2010.

Wilmore, Gayraud S. *Black Religion and Black Radicalism: An Interpretation of the Religious History of African Americans*, 2nd ed. Maryknoll, NY: Orbis Books, 1983.

Wilste, Jeff. *Contested Waters: A Social History of Swimming Pools in America*. Chapel Hill: University of North Carolina Press, 2007.

Wirth, Louis, and Eleanor H. Bernert, eds. *Local Community Fact Book of Chicago*. Chicago: University of Chicago Press, 1949.

Wolcott, Victoria W. *Remaking Respectability: African American Women in Interwar Detroit*. Chapel Hill: University of North Carolina Press, 2001.

———. *Race, Riots, and Roller Coasters: The Struggle over Segregated Recreation in America*. Philadelphia: University of Pennsylvania Press, 2012.

Wye, Christopher. "Merchants of Tomorrow: The Other Side of the 'Don't Spend Your Money Where You Can't Work' Movement." *Ohio History Journal* 93 (Fall 1985): 40–67.

Young Communist League. *The Youth in the Ford Hunger March: The Story of Bloody Monday*. Detroit, Michigan, 1932.

Young, Coleman, and Lonnie Wheeler. *Hard Stuff: The Autobiography of Coleman Young*. New York: Viking Press, 1994.

Young, Lowell. "1928 Comintern Resolution." In *1928 and 1930 Comintern Resolutions on the Black National Question in the United States*, edited by Lowell Young, 13–21. Washington, DC: Revolutionary Review Press, 1975.

Zinz, Kenneth. "The Future Outlook League of Cleveland: A Negro Protest Organization." MA thesis, Kent State University, 1973.

INDEX

Italicized page numbers indicate figures.

nut pickers' (1935), 82; ILGWU,
122–23; Pullman, 96, 101; Sopkin
dressmakers' (1933), 119–23; Sopkin
dressmakers' (1935), 124–25; steel-
workers,' 159
strikebreakers, 74, 115, 120–21, 125
Sulzman, John, 148
Sweet, Ossian, 27, 31

Tabb, Mary, 131, 132, 143–44, 146, 150,
156, 160, 166
Tappes, Shelton, 33, 36, 38, 40, 44, 45
Taylor, Breonna, 165
Temple Number One, 32
Tennessee, 22, 57, 96
Texas, 64, 67, 123
Third Period, 11, 14, 86, 141, 156; ideol-
ogy, 11, 35, 55, 111, 118
Thomas, Walter, 158
Thompson, Louise (Patterson), 158
Tometi, Opal, 18, 166
Trade Union Education League
(TUEL), 140
Trade Union Unity League (TUUL),
11, 15, 34–36, 45, 58, 69–71, 73, 81–83,
117, 119, 122, 123, 140
triple oppression, 127
Truth, Sojourner, 11
Tubman, Harriet, 11
Turner, Nat, 10
Turner, Victoria Wallace, 54

Unemployed Councils (UC), 11–13,
164; in Chicago, 105, 111, 112; in
Cleveland, 132, 140–143, 147–149,
151–52, 156, 160; in Detroit, 34,
36–38, 42, 45–46; in St. Louis,
60–63, 85
unemployment, 18; in 2020, 18; in Chi-
cago 103–104, 109, 113; in Cleveland,

131, 140–43, 147, 151, 155; in Detroit,
25, 29–32, 33, 36, 46; in St. Louis,
60, 62, 76, 77, 80
unemployment insurance, 36, 42, 75
unions: mainstream, 45; radical, 11,
35, 44, 79, 122, 123, 128, 129
union organizing, 11, 14, 24, 40, 44, 83,
96, 125, 128, 129, 137, 156
United Auto Workers' union (UAW),
21, 34, 40, 45–47, 161
United Brothers of Friendship Hall,
St. Louis, 55
Universal Negro Improvement
Association (UNIA), 16; and Black
women, 28, 54, 100, 137, 142; in
Chicago, *91*, 98–101, 102, 104, 106,
111, 127; in Cleveland, 136–137, 141,
142; in Detroit, 27–29, 32, 33, 34, 47;
in St. Louis, 53–56, 58, 71
University of Chicago, 116, 117
University of Islam, 33

Vesey, Denmark, 10
veterans, 98, 99, 127, 145
voting, 77

Waddles, Charleszetta, 51
Walker, Hershel, 60, 62, 80
Walker, William O., 156
Washington Park, 108, 109
Washington University, 81
Washington, Booker T., 133
Washington, Forrester, 25
Waterford, Lillie, 55
Watts Riots of 1965, 162
welfare offices, 38, 62, 63, 147
Wheat, W.R., 53
Whitby, Beulah, 27
white women: Black women's solidar-
ity with 42, 72, 81, 120, 122, 142, 149,

MELISSA FORD is an assistant professor of history at Slippery Rock University in Western Pennsylvania. She is a former Black Metropolis Research Consortium fellow, and her articles have been published in *American Communist History* and on h-net. She can be reached at www.melissafordphd.com.